A Yellowstone Album

A PHOTOGRAPHIC CELEBRATION OF
THE FIRST NATIONAL PARK

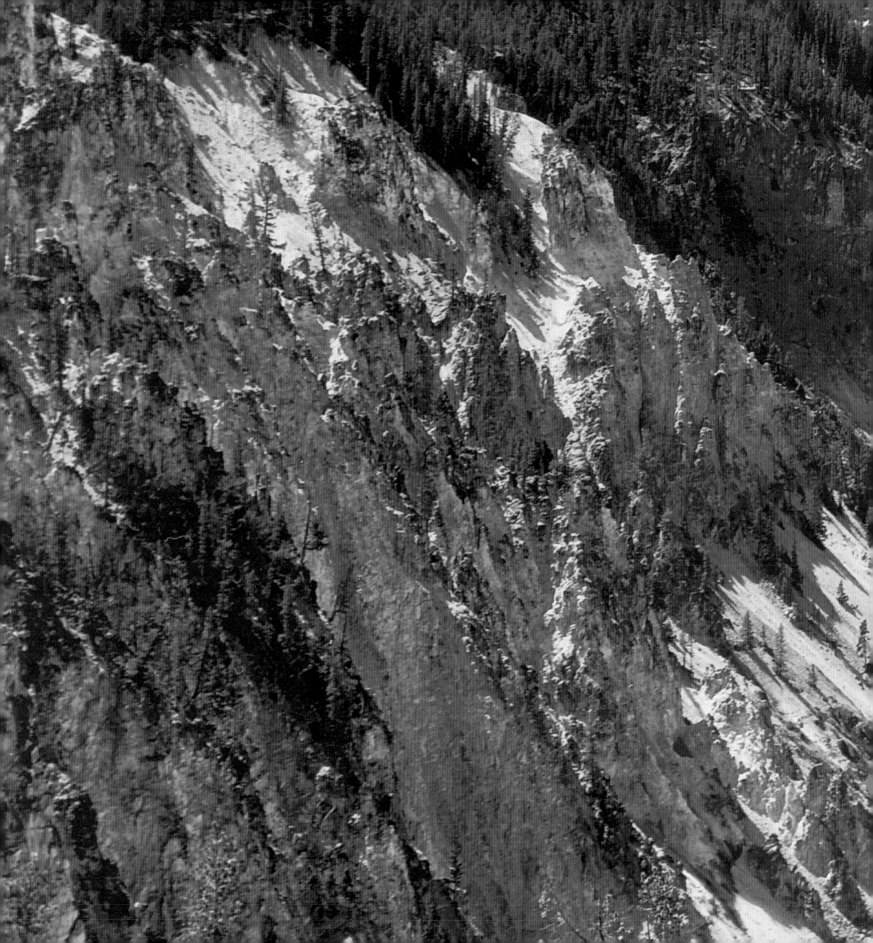

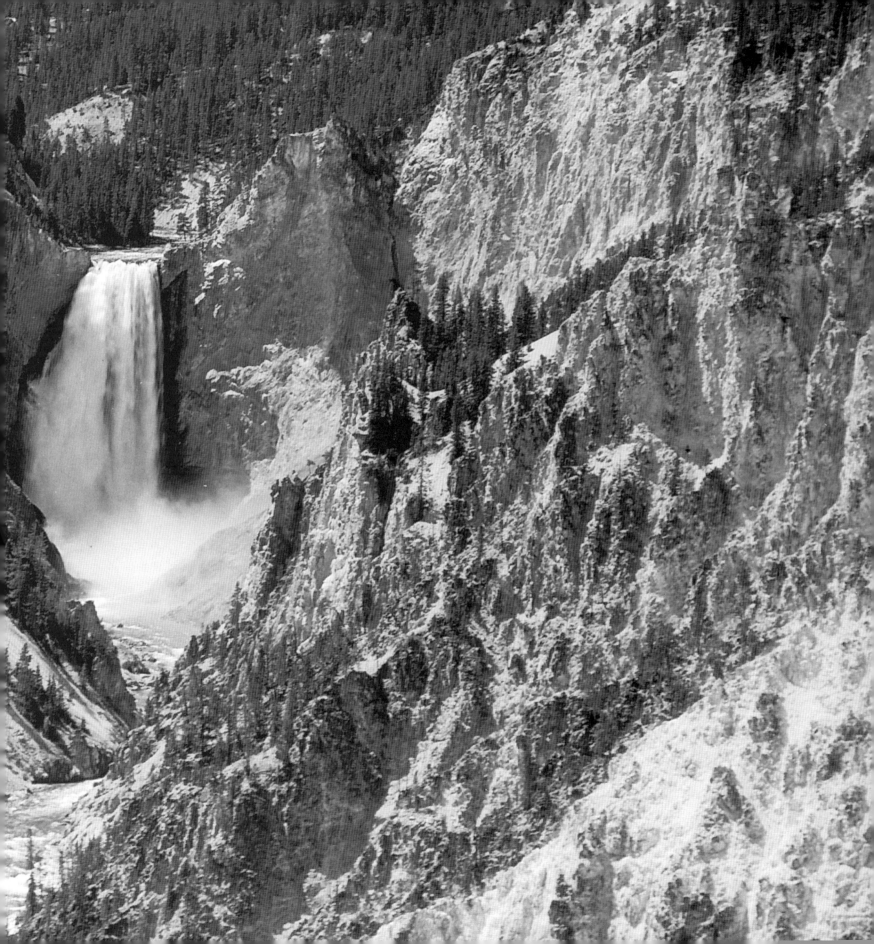

"To all of Yellowstone's friends, past and present,
especially to historian Aubrey L. Haines,
who has done more than any other person to enlighten the world
about their Wonderland."

International Standard Book Number 1-57098-147-7 paper,
1-57098-148-5 cloth
Library of Congress Catalog Card Number 97-65651

Published by Roberts Rinehart Publishers
5455 Spine Road
Boulder, Colorado 80301

Published in the UK and Ireland by
Roberts Rinehart Publishers
Trinity House, Charleston Road
Dublin 6, Ireland

Distributed to the trade by Publishers Group West

Manufactured in Canada by PrintCrafters

Design and production by Megan Rickards Youngquist
Calligraphy by Philip Bouwsma

A Yellowstone Album

A PHOTOGRAPHIC CELEBRATION OF THE FIRST NATIONAL PARK

Commentary by
Lee H. Whittlesey and the Yellowstone staff

Managing Editor
Marsha Karle

Photo Researchers
Susan Kraft, Elsa Kortge, Vanessa Christopher, and Linnaea Despain

Introduction by
Yellowstone Superintendent Michael V. Finley

Published by Roberts Rinehart Publishers
and American Gramaphone LLC
in cooperation with The Yellowstone Foundation

ACKNOWLEDGMENTS

Many people over the past century saved their best moments in Yellowstone history in photographs, and many others helped with the creation of this book, so we have many people to thank. For further information on the pictures presented in this book, contact the Park Historian or Park Curator, P.O. Box 168, Yellowstone National Park, Wyoming 82190.

First, we must thank the countless individuals who have contributed pictures to the Yellowstone collections over the years. One book can only include a small sampling of this wonderful public resource, but all such images have been welcomed and have helped enrich our understanding of Yellowstone. Specifically, at various times since 1930, the following people donated photographs to the Yellowstone collection that were used in this book: Betty Sheild Albers, Humphrey, Nebraska; George Ash, La Jolla, California; Marie Augsburger; Alec Barnard (Mrs. Erik) Thomsen, Houston, Texas; Emiele and Ellen George Bloch; Helene Boettcher, Rockville, Maryland; Robert Bower; Buffalo Museum of Science, Buffalo, New York; Mrs. Harry Child, Yellowstone Park; Jack Crellin, Salt Lake City, Utah; Grand Canyon National Park, Arizona; Grant Curry, Swissville, Pennsylvania; Jack and Susan Davis, Bozeman, Montana; Linda DeLowry-Fryman, East Liverpool, Ohio; B.J. Earle, Buffalo, Wyoming; Barbara Sheild Guenthner, White Bear Lake, Minnesota; Aubrey L. Haines, Tucson, Arizona; The Haynes Foundation of the Montana Historical Society; Michelle, Marty, St. Paul, Minnesota; Joan Jackson, Twenty-nine Palms, California; William Henry Jackson, Washington, D.C.; Mary McCarthy, Ypsilanti, Michigan; Dale and Loretta McMinn, Wendell, Idaho; Jack and Helen Meldrum, Buffalo, Wyoming; Edward T. Merry, Mobile, Alabama: George Petrach, Minneapolis, Minnesota; Leslie and Ruth Quinn, "T.W. Recreational Services Transportation Division," Yellowstone Park; Diane Ihle Renkin, Gardiner, Montana; Therese Ricciardi, Reno, Nevada; R.R. Robinson, Yellowstone Park; Albert B. Schwab, Medford, Oregon; Clarence Scoyen, Gardiner, Montana; Jeff Selleck, "NPS," Denver; John M. Sheild, Madison, Wisconsin; Robert C. Sheild, Minnetonka, Minnesota; Mrs. Geneva Sherwood; Mike Stevens, Simi Valley, California; Phillip J. Theisen, "T.W. Recreational Services Transportation Division," Yellowstone Park; and Lee Whittlesey, Yellowstone Park.

Second, we want to acknowledge the park staff's many photographers over the years. Hundreds of administrative, research, public event, and law enforcement pictures have been taken in the routine business of operating Yellowstone Park over the past 125 years, and many of these images have now taken on values never imagined by their creators. (In a great many cases, the name of the photographer has not even survived, so routine a part of Yellowstone's operation has photography become.) In recent years, the park has also benefitted from the work of full-time staff photographers, especially William Keller in the 1960s and 1970s, and Jim Peaco since the 1980s.

Many people provided informational support to this project: Bob Berry, Huntsville, Texas; Renee Evanoff, "NPS," Yellowstone; Don Fraser, Livingston, Montana; John Lounsbury, "NPS," Yellowstone; Larry Loendorf, Red Lodge, Montana; Mary Meagher, "NPS," Yellowstone; Peter Nabokov, University of Southern California; Rocco Paperiello, Billings, Montana; John Pretty-on-Top, Crow Agency, Montana; Paul Schullery, "NPS," Yellowstone; Smokey Sturtevant, Billings, Montana; Carson Walks Over Ice, Crow Agency, Montana; and the staffs of the Montana State University Renne Library, the University of Wyoming Library, and the Montana Historical Society.

The book would not have been possible without the administrative support of the leadership of the Yellowstone Center for Resources, especially Director John Varley and Chief of Cultural Resources Laura Joss. Curator Susan Kraft and Curatorial Assistants Elsa Kortge, Vanessa Christopher, and Linnaea Despain performed the immense task of locating the needed images. In the Yellowstone public affairs office, administrative assistant Stacy Churchwell provided essential support with many details.

Former Park Historian Aubrey L. Haines gave the entire caption manuscript a thorough reading and provided many lengthy comments and suggestions that improved the presentation. Tim Hudson, Laura Joss, Beth Kaeding, Jean Nuetzel, and Paul Schullery, all of Yellowstone, also provided many helpful comments on the manuscript.

Chip Davis and the entire team at American Gramaphone, Omaha, Nebraska, whose generosity has made the production of this book possible, have endeared themselves to Yellowstone permanently by their warm enthusiasm for all things relating to the park and by their great generosity. Chip and his group Mannheim Steamroller have donated more than half a million dollars in proceeds from their CD and concerts entitled "Yellowstone: The Music of Nature" to Yellowstone fire recovery. Their support of this book project is just another indication of their belief in the importance of Yellowstone in today's world.

The staff at Roberts Rinehart embraced this difficult project enthusiastically and produced a book that Yellowstone and all its friends can be proud of for many years to come.

CONTENTS

INTRODUCTION

\mathcal{Y}ou hold in your hands the foremost photographic celebration of Yellowstone's rich and eventful history ever published. Selected from the tens of thousands of images in Yellowstone National Park's museum collections, these pictures represent our collective national memory of the grand old park. The Yellowstone story is more than anything else the story of people: the more than 100 million people who have come here for the beauty, wonder, and inspiration that this unique place provides so generously. This book celebrates that beauty, wonder, and inspiration as interpreted by many photographers, from the most distinguished pioneering professionals to the countless snapshot-makers who conduct personal explorations of their own in the park every year. Together, they have left us an extraordinary legacy, and the park's 125th anniversary provides us with the perfect opportunity to celebrate and share that legacy with you.

Some of these images have been chosen for their artfulness—the revealing way they capture the essence of some park feature or visitor experience. Many others preserve little-remembered parts of the Yellowstone experience: monumental old hotels, stagecoaches, and other objects that we have relegated to nostalgic recollection with no appreciation for how eminently practical they were in their time. Other images are more accidental history, in which the photographer's original intention may have been overshadowed by some aspect of the image that now seems more important to us. Of course a few hundred such images cannot do full justice to Yellowstone, but then nothing short of coming here and experiencing it for yourself can do that anyway. These images are just another way for us to appreciate all that Yellowstone has meant to the visiting public.

Not all these images measure up to our modern computer-enhanced perceptions. Just as some have the great clarity possible with the early large-format cameras, others are hazy from the poor optics of early popular cameras, or dimmed and spotted by a century in a forgotten family scrapbook. We do not always see the past clearly. As well, not all of these images will be comfortable to us today. Some show management practices, such as the slaughter of beautiful predators or ungulates, that we now regard as regrettable at best. We do not always like what we see in our past, either.

But do not view these pictures merely as history; there is no important barrier between the people you see on these pages and us today. On their faces you can find the same joy, wonder, and even awe that we feel today. All of us, whether we arrived here by horseback, in a train, or in the family van, participate in the same adventure, the same awakening to the power of a great, wild landscape where nature still makes the important decisions.

At the same time, we sometimes forget how much Yellowstone has changed during its 125 years as a national park. One of the many values of this book is that it reminds us of where we've been. It's been a long journey from Yellowstone's early days, when the beauty of free-flowing hot springs was sacrificed to unsightly bath-houses, and the full diversity of this wild landscape was compromised by the destruction of predators and the suppression of natural fires. We like to think that we understand how to care for Yellowstone better than we once did, but the real lesson of Yellowstone's history is that every generation of its caretakers continues to learn. We have not overburdened this book with such lessons, but even the most casual reader will notice in these photographs the many signs of change, not only from the early days but even from the more recent past. Yellowstone is more than the world's first and most famous national park; it is one of America's greatest and most successful institutional experiments, one that continues to offer us important lessons today.

This book concentrates most heavily on the park's earlier days. That was just one of the many decisions made in the process of creating the book from such an overwhelming photographic resource. It made more sense to show you the Yellowstone you may be least familiar with, assuming that you have every opportunity to come here and actually visit the Yellowstone of today. But at the same time, we've included what we regard as especially important or revealing episodes from the modern Yellowstone too, in the hopes of suggesting where the park might be headed.

So settle back, get comfortable, and ride along with this vast, single-minded company of pilgrims, pioneers, sagebrushers, stagecoachers, rangers, and other adventurers as we explore the Yellowstone of our past, our present, and our dreams.

Michael V. Finley, Superintendent

But do not view these pictures merely as history; there is no important barrier between the people you see on these pages and us today.

First Glimpses

BUT RESIST THE TEMPTATION
TO THINK OF THESE PEOPLE AS QUAINT
OR REMOTE . . .
THEIR FIRST GLIMPSES OF THE NEW
NATIONAL PARK WERE VERY IMPORTANT ONES,
AND THE WORLD LISTENED CLOSELY
WHEN THEY TOOK THEIR PICTURES
AND THEIR STORIES HOME.

FIRST GLIMPSES

*It is regrettable that
we have little direct
photographic evidence
of the native people of
the park area . . .*

*T*he Yellowstone country was fruitfully inhabited and frequently visited by people for 10,000 years before it became the national park that this book celebrates. Though archaeology has only begun to uncover the world and lifeways of these native peoples, it is already clear that they found much of interest and value here, and, like people today, they were moved by the park's great "places of power," especially the fabulous collection of hydrothermal features that led to the park's creation by act of Congress in 1872.

But the photography this book celebrates only dates back to about the time of the park's establishment. The "first known photographs" were taken in 1871, and despite the great effort that has gone into tracking down images of the park's first years, we still view each newly located image as a treat—a rare glimpse of a very young, very poorly defined new type of government institution. The scenes represented in this first chapter show a place that was little more than a name and a hope, where the visitors themselves were left to decide what Yellowstone should mean to them.

It is regrettable that we have little direct photographic evidence of the native people of the park area; a few images of early Indian travelers and their effects on Yellowstone are presented under the heading of First Keepers. Then comes Jackson's Masterworks, a representative selection of the milestone photography of William Henry Jackson, whose pioneering work, starting in 1871, established a standard of excellence toward which all later photographers must strive. Some of the park's early protectors and more colorful managers are presented in Pioneer Caretakers, and such a chapter would not be complete without a few portraits of the First Tourists, hard at play in the park's immense and then unpeopled geyser basins.

When these early tourists arrived, they found a raw and difficult land. It was the sort of wilderness that everywhere else in North America we were just then busily conquering. Our great wildlife herds were being systematically slaughtered throughout the west in the 1870s, and only Yellowstone's federal protection and its slowly growing constituency of devoted friends prevented the slaughter from being as complete in the park as it was everywhere else.

More to the immediate needs of the first managers and tourists, there were few comforts and conveniences. Such roads as existed were primitive, stump-strewn ruts that made a Yellowstone visit not only an adventure but also

a slow, arduous trip of considerable length. Early park visitors were pioneering a new kind of recreation just as park managers were pioneering the management of that recreation. At the same time, the park's first concessionaires were pioneering the care and feeding of the hardy travelers who braved the Yellowstone wilderness for the sake of seeing its newly publicized wonders.

But resist the temptation to think of these people as quaint or remote. Imagine yourself in their boots, resting comfortably in camp near a geyser basin that looks strikingly similar today, or heading down to the nearest stream with a fishing rod and the identical ambition that characterizes every generation of anglers. Think of what they were pioneering, and of their opportunity: spending weeks in Yellowstone when the entire annual visitation to the place might have been measured in the hundreds rather than in the millions. Their first glimpses of the new national park were very important ones, and the world listened closely when they took their pictures and their stories home. Yellowstone would never be the same.

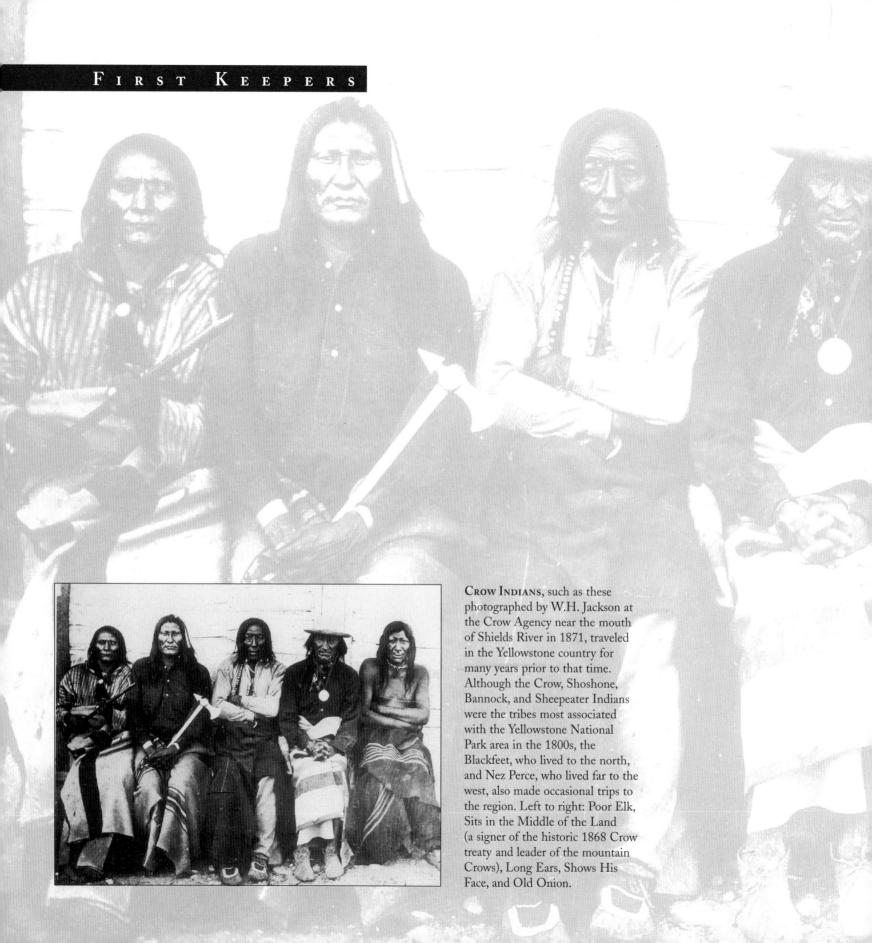

CROW INDIANS, such as these photographed by W.H. Jackson at the Crow Agency near the mouth of Shields River in 1871, traveled in the Yellowstone country for many years prior to that time. Although the Crow, Shoshone, Bannock, and Sheepeater Indians were the tribes most associated with the Yellowstone National Park area in the 1800s, the Blackfeet, who lived to the north, and Nez Perce, who lived far to the west, also made occasional trips to the region. Left to right: Poor Elk, Sits in the Middle of the Land (a signer of the historic 1868 Crow treaty and leader of the mountain Crows), Long Ears, Shows His Face, and Old Onion.

LONG-TIME YELLOWSTONE ranger Wayne Replogle spent many years tracing the remnants of Native Americans in Yellowstone. In 1955 he was photographed with a wickiup probably built some time during the 1800s. These wood structures provided acceptable temporary shelter for hunting parties traveling through Yellowstone. It is unclear which tribes built the Yellowstone wickiups.

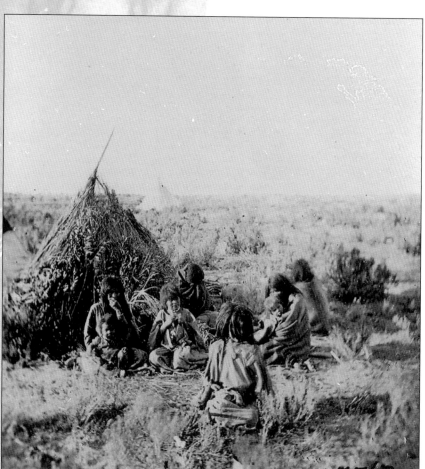

THIS 1871 JACKSON PHOTO is said to show a Sheepeater-Bannock family near Fort Hall, Idaho. These people were almost certainly familiar with the Yellowstone country, northeast of their home.

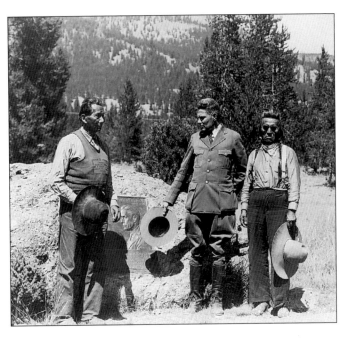

FOLLOWING THE DESTRUCTION of bison herds on the Snake River Plain southwest of the park in the early 1800s, Bannock and other tribes made more frequent trips across northern Yellowstone to hunt bison farther east. Traces of the Bannock Trail are still evident in a few places, as in this photograph of Ranger Replogle in the 1950s. The trail ruts are evident in the gap in the sagebrush between the camera and Replogle.

FAINT TRACES of the Bannock Trail can be seen zigzagging like tire tracks through the meadow in the foreground.

CHIEF MANY WOUNDS and Chief White Hawk, Nez Perce, both of whom traveled through the Park in 1877 with Chief Joseph during that tribe's famous flight from the U.S. Army, are shown here during a return visit to the park in August 1935. They were accompanied by Park Naturalist W. E. Kearns for this picture at the plaque honoring the National Park Service's first director, Stephen P. Mather, at Madison Junction.

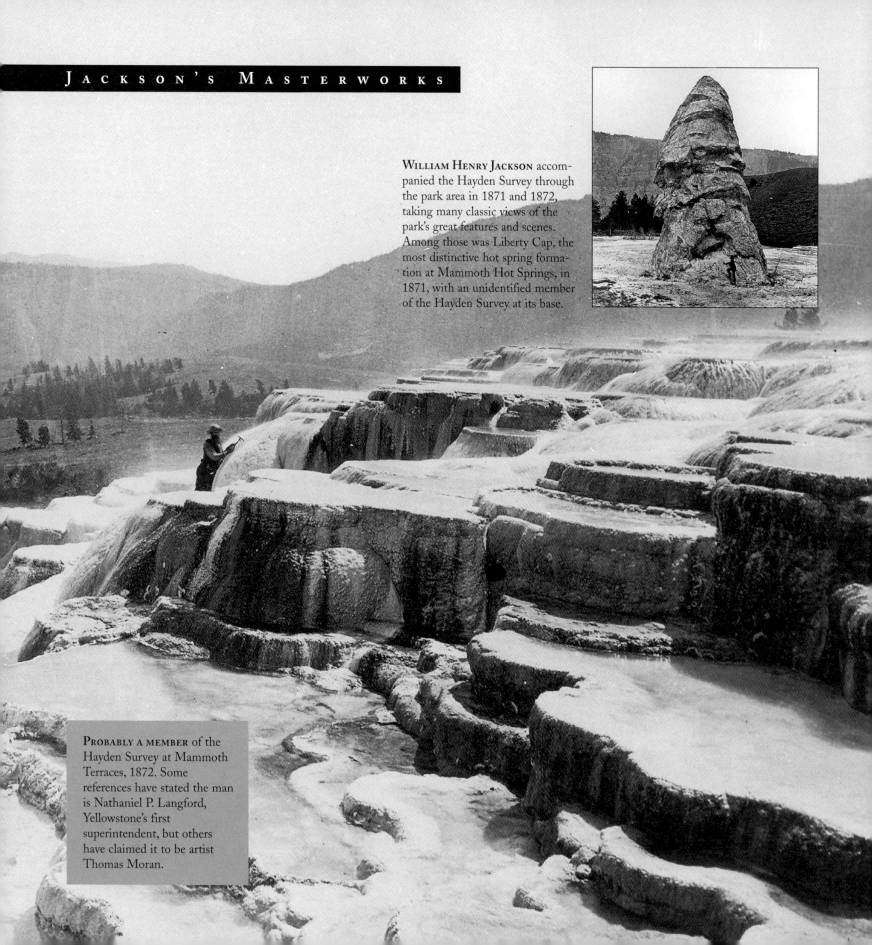

WILLIAM HENRY JACKSON accompanied the Hayden Survey through the park area in 1871 and 1872, taking many classic views of the park's great features and scenes. Among those was Liberty Cap, the most distinctive hot spring formation at Mammoth Hot Springs, in 1871, with an unidentified member of the Hayden Survey at its base.

PROBABLY A MEMBER of the Hayden Survey at Mammoth Terraces, 1872. Some references have stated the man is Nathaniel P. Langford, Yellowstone's first superintendent, but others have claimed it to be artist Thomas Moran.

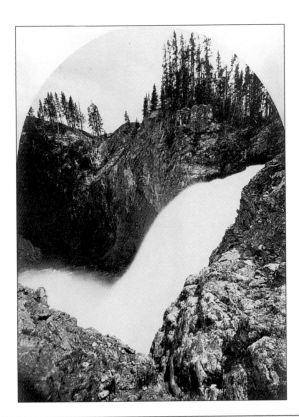

UPPER FALLS of the Yellowstone
River, 1871.

THIS 1871 JACKSON photo shows
two men fishing from a small
island at the West Thumb of
Yellowstone Lake; they probably
were among the last anglers to
have the entire lake to themselves.
The small island just offshore was
the site of a boat dock from about
1892 until the 1930s. A circular
hot spring, Winter Spring, is
visible in the lake just to the left
of the island. A potential hazard to
many early boat disembarkers,
Winter Spring finally claimed one
human life in a 1926 accident.

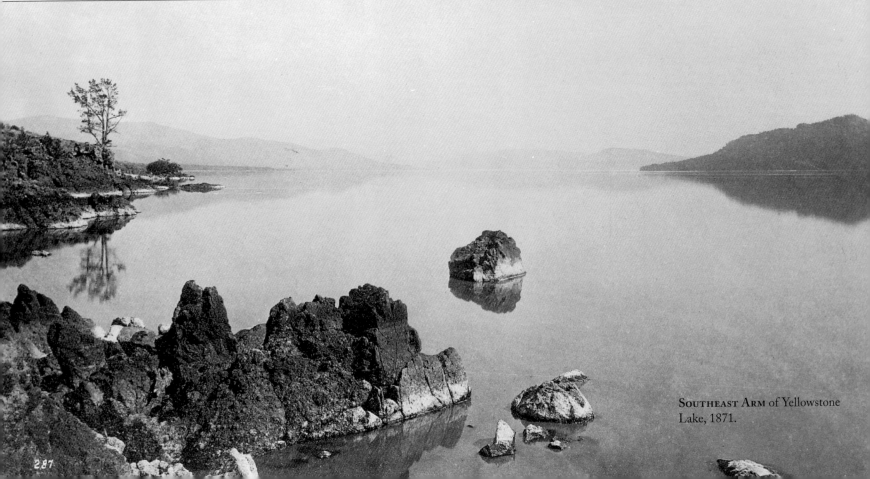

SOUTHEAST ARM of Yellowstone
Lake, 1871.

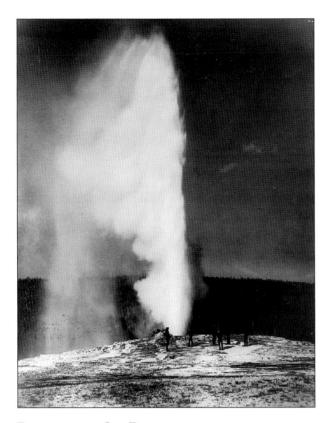

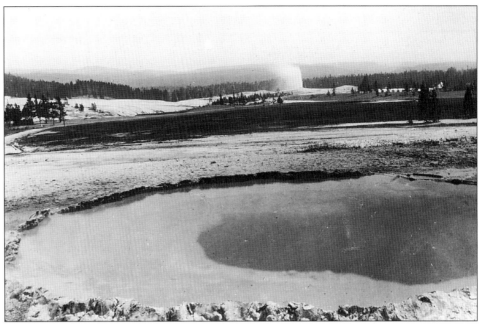

First photo of Old Faithful Geyser in eruption, 1872, with members of Hayden Survey in foreground.

Old Faithful Geyser in eruption, photographed from Crested Pool, probably in 1883. W. H. Jackson returned to the park with members of the "Hague" Surveys in 1883, and this photo was probably taken that year. Note at right the first tourist lodging facility to be established in the area, a tent camp of the Yellowstone Park Improvement Company. At left is the area's earliest building, constructed in 1879 by Superintendent Philetus W. Norris, who described it as "an earth-roofed, loop-holed log house with a good stone chimney . . . located between the Castle and the Beehive Geysers."

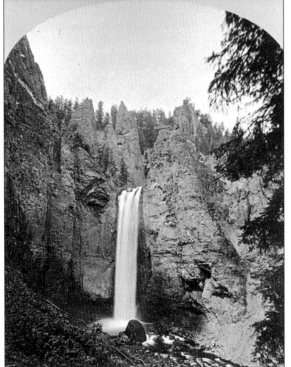

Tower Fall in 1872. The famous boulder at the brink of the falls, which some early visitors expected to fall any minute, finally did slip loose and fall in 1986.

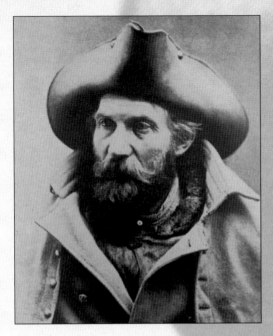

HARRY YOUNT (1837?–1924), known as Rocky Mountain Harry, has been called America's "first national park ranger." That label rests on the fact that he was the first federal employee hired in any national park below the rank of assistant superintendent. Norris hired Yount as "gamekeeper" in 1880 and he served only until 1881 (Norris's other employees, a Mr. Bush and Clarence Stephens, predated Yount, but they were assistant superintendents). Yount resigned in apparent frustration over his inability to prevent Cooke City, Montana poachers from taking animals in the park. Each year, the National Park Service now gives an outstanding ranger the Harry Yount Award to honor the memory of this pioneer park officer.

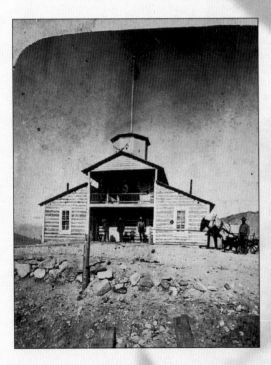

HENRY BIRD CALFEE took this photo of the park's first administration building at Mammoth Hot Springs sometime between 1879 and 1881. The building, called the Norris Blockhouse, was erected in 1879 on Capitol Hill by Superintendent P. W. Norris, who is probably the white-bearded man standing on the upper veranda. Its outbuildings included a barn, a blacksmith shop, and a bath house. The main building later served as housing for park employees until it was razed in 1909, its wood being used to construct a blacksmith shop at Lamar.

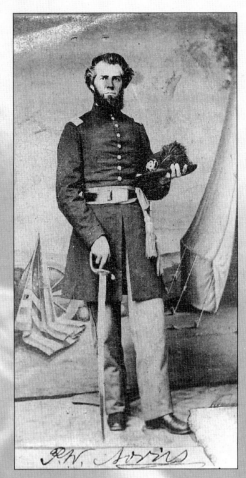

PHILETUS W. NORRIS (1821–1885), photographed during his Civil War service, was Yellowstone's second superintendent, serving from 1877 to 1882. A captain of the West Virginia scouts in the 14th Ohio Volunteer Infantry in the Civil War, Norris was one of the most colorful of Yellowstone's many superintendents, a pioneer roadbuilder and amateur archaeologist who favored buckskin outfits in keeping with his self-image as a rugged mountaineer.

NATHANIEL PITT LANGFORD (1832–1909), Yellowstone's first superintendent. This photo was used in Langford's book *Discovery of Yellowstone Park* (1905), which chronicled his adventures as a member of the Washburn-Langford-Doane expedition to the park area in 1871. Langford served as superintendent from the park's establishment in 1872 until 1877, and, though he was an outspoken advocate of the park's interests, only visited the park occasionally during his term in office.

PARK ASSISTANT Superintendent G. L. Henderson at Cleopatra's Bowl, Mammoth Hot Springs, 1882 or 1883, with Cupid's Cave at lower right. Henderson, who served as assistant superintendent from 1882 to 1885, was arguably the best of the ten assistant superintendents during the period before the arrival of the U.S. Army in 1886. After serving the government, he remained in the park until 1902 as a hotel owner and tour guide. Because of his many educational activities and conscientious work as a tour guide, he has been called the first real park interpreter in any national park.

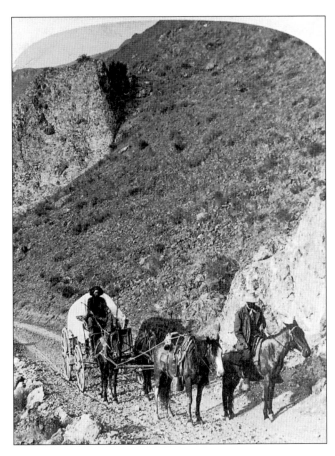

AN EARLY HAYNES view of
"Ascending the Point of Rocks," a
familiar landmark in Paradise
Valley north of the park, in 1881.
For many years, the primary access
to the park was up the Yellowstone
River Valley, a long trip by wagon.
This photo may be Haynes's
photographic outfit returning from
his very first visit to the park.

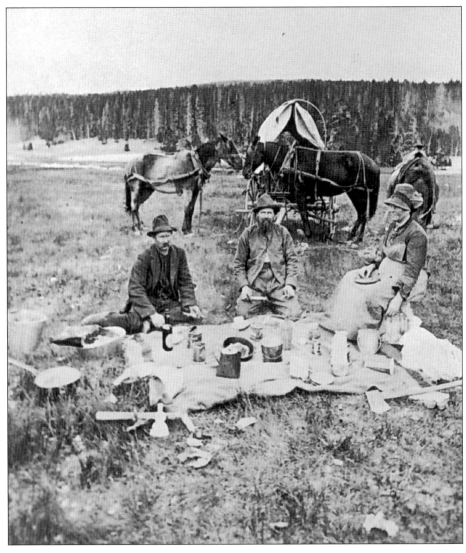

AN H. B. CALFEE view of
"A Dinner in the Park," shows
tourists in the Upper Geyser
Basin about 1880, with provisions
and tools carefully displayed for
the camera.

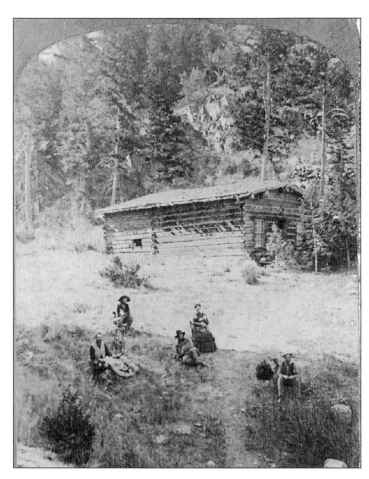

H. B. CALFEE PHOTO of early horseback tourists at Heart Lake, about 1880, with Mount Sheridan in the distance.

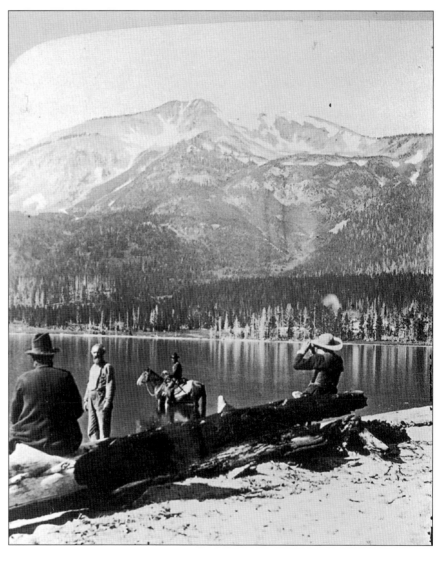

HAYNES MADE THIS photograph of "The Pioneer Hotel," actually known as McCartney's Hotel, in Mammoth about 1885, when this humble building was the only accommodation anywhere in the park. Assistant Superintendent G. L. Henderson and his family moved into a nearby building in 1883, and the search for early images of life in this neighborhood continues today. It is possible that the woman holding the baby is Henderson's daughter, Jennie, then twenty years old and married to John Dewing, who may be the man in front of her. The younger woman, lower left, may be Mary Rosetta Henderson, and the man next to her may be either Henry Klamer or Ed Wilson, later an army scout.

A HAYNES PHOTOGRAPH of "The Natural Bridge from Above," about 1881-1883. Superintendent Norris noted as early as 1877 that the bridge could accommodate a carriage-way, and in 1881 he built a bridle path with a railing (shown here) over the bridge. Many pre-1912 maps of the park show the main road from West Thumb to the outlet of the lake crossing Natural Bridge because that route avoided "the sand-spits, ponds, and gullies" along the lakeshore.

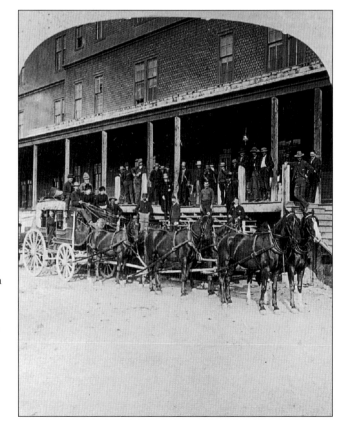

AN EXTREMELY EARLY photograph of stagecoach tourists at the Mammoth Hotel, 1883 or 1884, prior to the arrival of the standard Yellowstone wagons common in later photographs.

Wonderland Hospitality

THE TOTAL DEVELOPED ACREAGE OF THE PARK

PEAKED EARLY IN THE CENTURY AND HAS

DECLINED GREATLY SINCE THEN.

OUR VIEW OF YELLOWSTONE AS A WONDERFUL

VACATION RESORT MUST BE RECONCILED

WITH OUR UNDERSTANDING THAT

IT IS ONE OF THE LAST GREAT WILDLAND

ECOSYSTEMS IN THE COUNTRY.

WONDERLAND HOSPITALITY

*H*ere is a photographic grand tour of the park's grand loop: the road system that took visitors to all the major attractions. Starting at the park's north entrance, at Gardiner, Montana, we will follow the course of the early visitor experience south to Mammoth Hot Springs, Norris Geyser Basin, and the big geyser basins along the Firehole River, then over to the West Thumb of Yellowstone Lake, to the outlet of the lake and the developments at the lake area and Fishing Bridge, and on up the east side of the loop to the Grand Canyon of the Yellowstone and beyond, over Mount Washburn to the Tower-Roosevelt area. Along the way, side trips will explore the various entrance roads and other unexpected wonders.

At several stops, we'll take a peek or two behind the scenes, for a look at how things were run in Yellowstone once the flood of tourists was unleashed and everybody—from the hotel chambermaids to the rangers to the road maintenance crews—had their hands full with all the problems and challenges brought on by the growing number of Yellowstone enthusiasts.

One of the greatest surprises to Yellowstone visitors, especially those who have been around long enough to get to know a little about the place, is how much Yellowstone's facilities and services have changed over the years. "You mean to say that this meadow I'm standing in used to be covered by a huge lodge and a hundred cabins? And there used to be a bridge over that river? And that for every hotel now in existence in the park, there are several already gone? But it all looks so permanent, like nothing ever changes!" Well, change has been the order of the day in Yellowstone's grand tour since it began more than a century ago. For example, when our photographic tour stops at Norris, you'll learn that this particular geyser basin, which now features only a campground and a few other small facilities, has been the site of three different hotels. And of course the Upper Geyser Basin, with its most famous of all geysers, has witnessed a veritable parade of such changes, the most recent being the controversial cloverleaf bypass that now routes traffic around the basin that once got clogged with cars.

As the buildings go by, and as you watch them change over the years, take a moment to enjoy the creation of Yellowstone's modern image. Those first stores and hotels were an eclectic mixture of styles, from the crudest log cabin to very urban buildings of all sizes. Then, over time, something happened to

the design of Yellowstone buildings: an idea emerged about what a national park structure should look like, and a rustic architecture came into widespread use that we now enjoy in all parts of the park, whether the building is a store, a ranger station, or a visitor center.

Part of the growing self-recognition of Yellowstone's managers and friends was an awareness of the park as a complete experience, one in which more was being offered to tourists than a chance to see extraordinary geology and abundant wildlife. Scholars have pointed out that as Yellowstone became ensconced in the American recreational tradition, it sold much more than just the park's famous features. It sold romance: the Old West, the hearty outdoor life, and a comfortable resort atmosphere in keeping with what the well-traveled public came to expect in other parts of the world. Today's Yellowstone is a product of many expectations, including not only a worldwide conservation movement but also a lot of sophisticated marketing.

You may also notice other changes here and there, changes of attitude about Yellowstone's real role in American society. Once the grand old hotels and related developments typical of resorts of their era seemed perfectly appropriate in Yellowstone; now we are more aware of the effects of developments and large concentrations of visitors on the park's ecological processes. The needs of nature have gradually been given a higher priority in management, and a combination of facility modification or removal, along with the adjustment of opening and closing dates of facilities has mitigated many of the older natural-resource conflicts. But among the many values of Yellowstone is to preserve an important American cultural heritage as well as a natural one. The park's developments contain many historic structures that are worthy of protection, so, though developments will be rehabilitated or modified, they will generally be preserved to protect this human heritage. The total developed acreage of the park peaked early in the century and has declined greatly since then. Our view of Yellowstone as a wonderful vacation resort must be reconciled with our understanding that it is one of the last great wildland ecosystems in the country. This changing appreciation for the many values of the park makes these photographs of a younger Yellowstone all the more revealing of the changing perceptions of visitors over time.

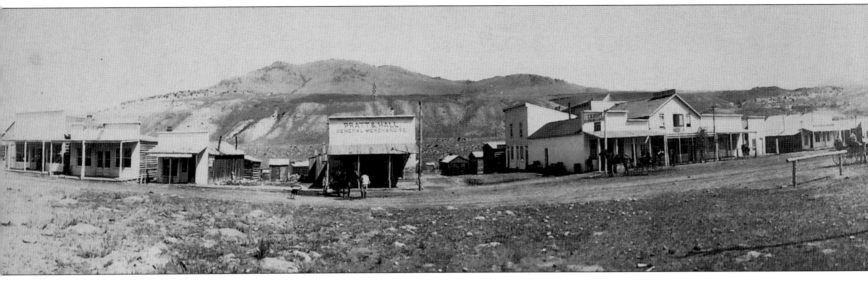

AN ADVENTURESOME suspension footbridge at Gardiner, Montana, predated the present concrete auto bridge that was constructed at this location in 1929. Prior to 1930, the auto bridge across the Yellowstone River at Gardiner was located downstream from the present bridge. The suspension bridge shown here was used by Gardiner north-side residents to reach the south side of town on foot.

GARDINER, MONTANA, about 1885. Established in 1880, Gardiner has depended upon the park for its existence from the beginning. But the park and its staff have also depended upon Gardiner—for supplies, railroad passengers, houses of worship, liquid refreshment, and (at least until the 1940s) female companionship in the local red light district.

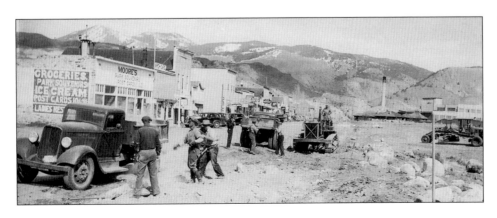

WIDENING PARK STREET in the town of Gardiner, about 1938. Among the notable commercial establishments at this time were Moore's Store and the Arch Cafe on the present site of the Bear Country Restaurant, and the Welcome Hotel owned by George Welcome's family, on the present site of Yankee Jim's Trading Post.

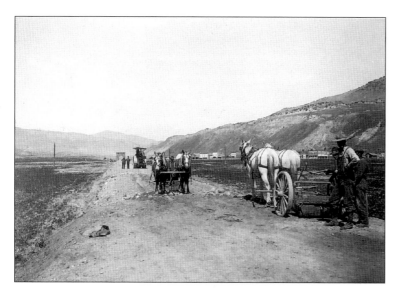

LOCAL TOWNSPEOPLE from gateway communities have formed the basis for park work forces since those towns were created. Here, a crew works on the North Entrance road in 1915. Note the Roosevelt Arch in the distance.

THE PARK opening at Gardiner, June 20, 1926. The park once held official openings every spring, usually at the Roosevelt Arch. Here park officials swing open a gate made of elk antlers. Left to right: Chief Ranger Sam Woodring, National Park Service Director Stephen Mather, and Park Superintendent Horace Albright.

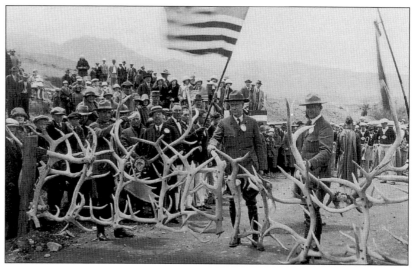

GARDINER DEPOT, 1924. The first trains bringing tourists to Yellowstone came to Cinnabar, Montana beginning in late 1883. Twenty years later, the Northern Pacific Railroad extended its tracks to Gardiner. The railroad engaged architect Robert Reamer, who also designed the Old Faithful Inn and several other area buildings, to build a log depot next to the north entrance arch, which became known as the Roosevelt Arch. Reamer envisioned a beautiful entryway into Wonderland with the depot, the arch, and a pond surrounded by willows and other vegetation dressing up the naturally arid landscape around Gardiner. The pond was built, but the rest of Reamer's fantasy was not; he had hoped to build a bridge over the pond, in the shape of the "monad" trademark of the railroad, so that half the pond could be stocked with whitefish and half with gold-fish. The depot was an attractive spot; in the background can be seen the W. A. Hall store ("sells everything"), the large Wylie Hotel, at left, and another probable Robert Reamer building (between the two of them) which became the studio of a Gardiner photographer named Schlecten. The checking station, built in 1921, can be seen just inside the arch, and the new large Yellowstone Park Transportation (YPT) buildings are in the far right background.

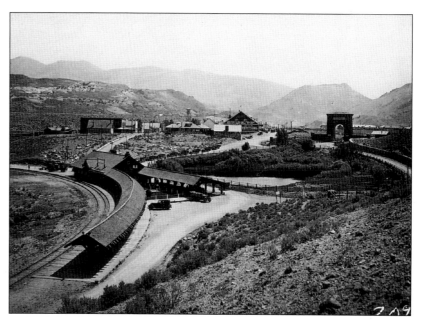

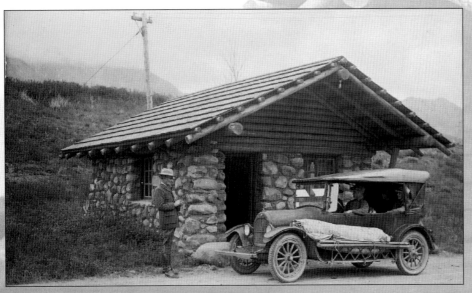

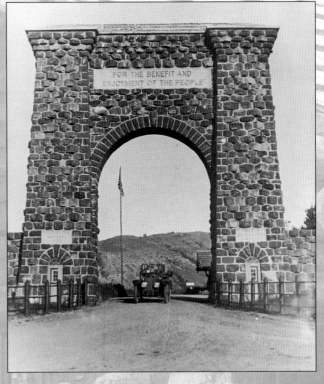

NORTH ENTRANCE checking station near Roosevelt Arch, 1923. Numerous stage and auto checking stations have existed at the north entrance. This one, located just inside the arch, was built in 1921, burned March 4, 1937, and was then rebuilt. It served until it was razed on January 14, 1966. Says Yellowstone Historian Aubrey Haines: "The trouble with it was the checker had to do business across the passenger or walk around the car to the driver's side, and then he was away from the cash box. It was a very dangerous situation because of outgoing traffic. The gate ranger's bedroom was in the back room." The present log checking station was built in November, 1991. At various times, the north entrance checking station has been located at the arch, at its present location, or at the "truck gate" just north of the present T.W. Services personnel office.

COMING OUT of the park through the arch, about 1922. The front edge of the north entrance checking station can be seen at right, across from the flagpole. The arch was designed by U.S. Army Engineer Hiram Chittenden and was dedicated by President Theodore Roosevelt during a 1903 visit. It cost $10,000.

BOTTLER RANCH HOUSE, probably in 1893, Paradise Valley, Montana. In 1868, Frederick and Philip Bottler, their half brother Hank, and their mother settled some twenty-seven miles north of present-day Gardiner, Montana, in what was probably the first permanent settlement in Paradise Valley and one of the first such in Montana. Their ranch became the most important stopping place for travelers heading to the park, and it served in that capacity until well after the turn of the century. It was the last outpost of civilization before a traveler encountered Yellowstone National Park. All early parties stopped at the Bottler's place, including the 1869 Folsom party, the 1870 Washburn expedition, and all of the Hayden surveys. This photo was probably made to celebrate the completion of the new house in 1893. The people in the photo are: (balcony left to right) Floyd Bottler, Isabelle Bottler, and Maud Bottler Donovan; (first floor, left to right) Bill Goucher of Iowa, his wife Mary, Josephine Bottler, her husband Frederick Bottler, and Philip Wills, the carpenter who built the home.

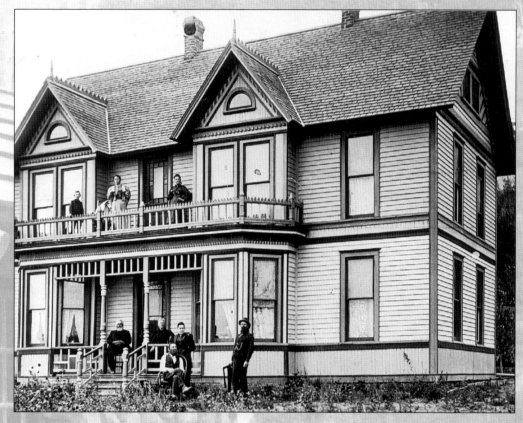

THE CRUDE WOODEN shack known as McCartney's Hotel was built at Mammoth Hot Springs in 1871, in Clematis Gulch by James McCartney. It served as Yellowstone's first and only hotel until 1880. Later it became a laundry run by a Chinese named, Sam Toy. In this photo, circa 1885, note the wooden troughs in foreground, built to convey hot water from Hymen Terrace to bathhouses that were really just crude sheds built right on the hot spring formations.

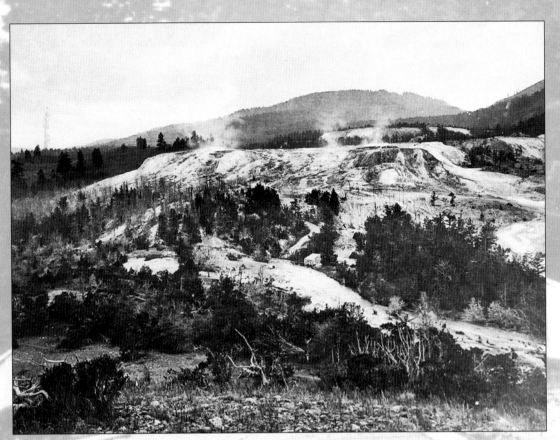

MAMMOTH HOT SPRINGS, 1872. One of the earliest photos of Mammoth Hot Springs, this W.H. Jackson photo shows the wildness of the area. One of the rough bathhouses is visible in the middle foreground. Much of the vegetation on the lower slopes of the springs has since vanished because an army outpost and several road alignments have, at times, covered much of this area. By the 1920s, the casual development philosophy that allowed unregulated construction and diverting of hot springs had changed, at least at Mammoth, when park managers discovered the damage that could be inflicted upon the springs by bathing in them, as well as the potential danger to bathers who frequently had been unable to distinguish between comfortably warm and lethally hot pools.

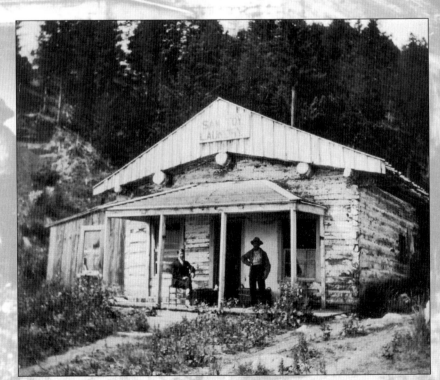

McCARTNEY'S HOTEL about 1903, after it was converted to use as the Sam Toy laundry. One of the men on the porch has been identified as Edgar Brachraw, and Sam Toy is probably the other one. The building was destroyed by fire December 4, 1913.

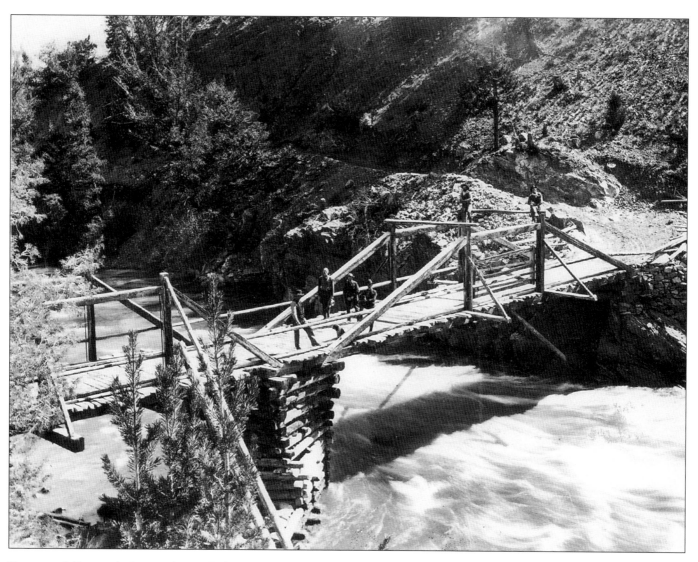

BARONETT'S BRIDGE before 1905. In 1871, a well-traveled adventurer named C. J. "Jack" Baronett built the first bridge over the Yellowstone River anywhere on its several-hundred-mile length. The bridge was not far downstream from the present high bridge across the Yellowstone River northeast of Tower Junction. From his cabin on the bank above the bridge, he managed it as a toll bridge at "two bits per animal." It and its successors served two generations of miners traipsing from Mammoth to Cooke City, as well as soldiers and Indians during the Nez Perce War of 1877, and many early park visitors. Partially burned in 1877 by the Nez Perce, it was rebuilt by Superintendent P. W. Norris in the fall of 1878. It continued to be on the main route to Cooke until after the turn of the century. The government appropriated the bridge in 1894 and paid Baronett for it in 1899. It served visitors through the spring of 1903 until it was burned in 1905. The site is readily discernible at the river's narrowest point in that area.

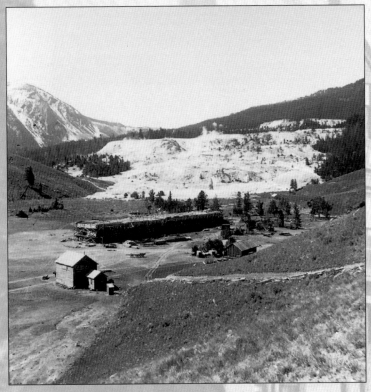

THE YELLOWSTONE PARK Improvement Company, a short-lived and notoriously greedy early park concessionaire, began construction of this, the first Mammoth Hot Springs Hotel in 1883, on the site of the present Mammoth Hotel. Note the old Gardiner road, visible at bottom center and right. Built in Queen Anne style, the National Hotel was 414 feet long and 54 feet wide with three to four stories and several wings behind it. One construction workman died after a fall from a scaffold there, and other workmen took over the hotel when they were not paid in 1884 and held it hostage for many months. They subsisted on park game until the strike was settled. During his visit in 1883, President Chester Arthur ate a meal in the new hotel, when its roof was half-finished and open to the sky.

BATHHOUSE on Hymen Terrace with the National Hotel and Assistant Superintendent G. L. Henderson's house and barn, circa 1884. The long building in the background to the right of the hotel was the headquarters of the earliest in-park stagecoach company, established by Wakefield and Hoffman in 1883. Note the horse at the hitching post and the carriage above and to the right of the bathhouse, both of which probably belonged to G. L. Henderson. Bathing in the hot springs at Mammoth was among the first uses of the waters at Mammoth and began as early as 1871, during the days when hot soaking relief for the tired and dirty was considered more important than preservation of a few hot springs. Hymen Terrace, on which the bath house stands here, was an active hot springs area until the 1930s and the site of a number of early bathhouses.

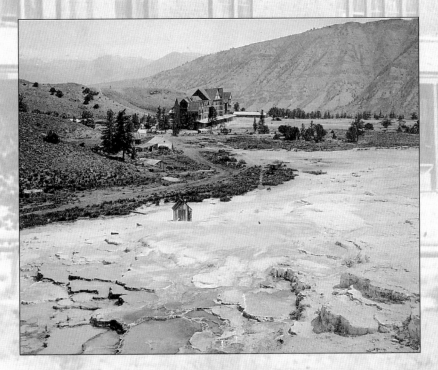

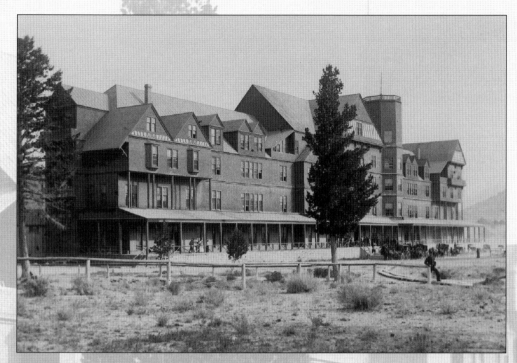

DESIGNED BY L. F. BUFFINGTON, sometimes called the father of the modern skyscraper, Yellowstone's first large hotel boasted electric lights, quite a distinction for a hostelry located so far into the wilderness. It was initially styled the National Hotel, but the name Mammoth Hot Springs Hotel was also in use by the late 1880s.

MAMMOTH HOTEL office staff, 1908.

MAMMOTH VILLAGE at dusk with electric streetlights, 1896–1903. This photo, from the family scrapbook of long-time park magistrate John W. Meldrum, captures the peace of a winter evening at Mammoth at the turn of the century.

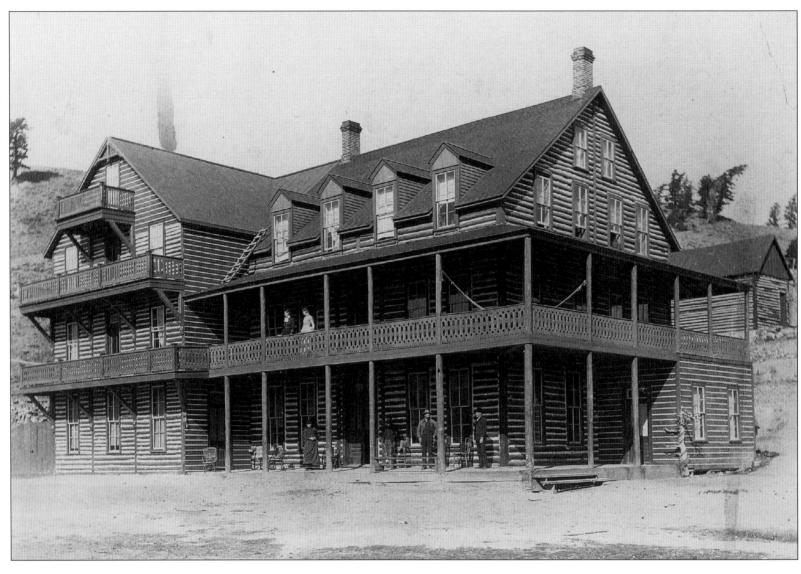

THE COTTAGE HOTEL, pictured about 1888, was built in 1885, near the site of the present Mammoth gas station. The hotel was built by G. L. Henderson, his son Walter, and his daughters Barbara, Helen, Jennie, and Mary. It was operated as a hotel until around 1910 and then as a dormitory for park employees, until it was torn down in 1964.

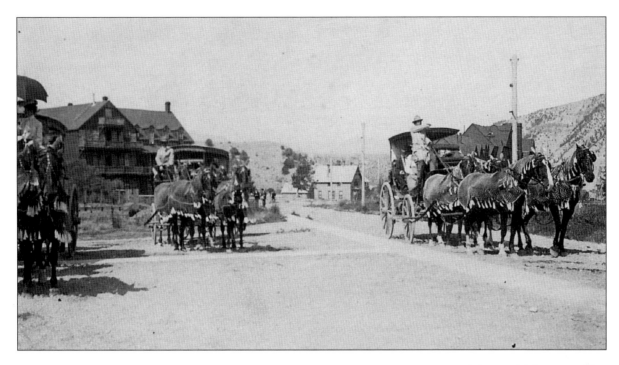

Horses and coaches with Cottage Hotel in background, about 1897. This Meldrum family photo shows mosquito-netted horses preparing to pull their coaches away from the hotel. In the center background can be seen the Lyall-Henderson store, today's Hamilton Store.

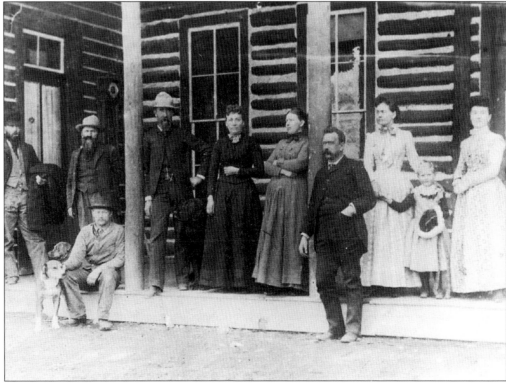

Cottage Hotel, circa 1900. The man leaning against the post is Ellery C. Culver, who served variously as a Gardiner storekeeper, a U.S. Commissioner in the park, a runner on the train between Livingston and Cinnabar, and as the winter keeper at Marshall's old hotel in the Lower Geyser Basin.

THE MAMMOTH LODGE, shown here in August 1930, was built in 1917 at a cost of $70,000 and as an extension of the park lodge system, which included other lodges at Lake, Roosevelt, Canyon, and Old Faithful. The lodge system was a continuation of the older system of permanent (tent) camps which had been run by the Wylie company and Shaw and Powell. The Mammoth Lodge was originally designed to replace a Wylie Camp at Swan Lake Flats, a few miles south of Mammoth. The lodges represented one step up from camping and one step down from hotels. A large lobby, dining room, kitchen, recreation hall, and general office were added to Mammoth Lodge in 1923, and a laundry, added in 1920, burned in 1927. The Mammoth Lodge was abandoned in 1940 and torn down in late 1949.

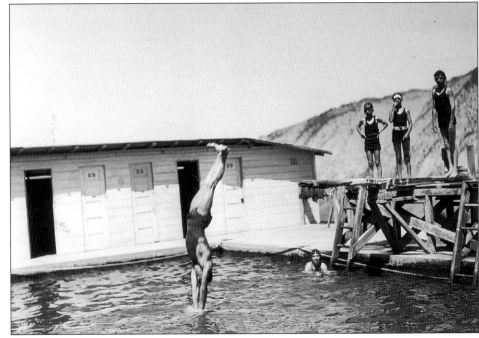

DIVING AT THE MAMMOTH plunge, 1925. The Mammoth swimming pool, or plunge, was built in 1920 to serve the nearby Mammoth Lodge. Water was taken directly from the Mammoth Terraces and from Bluff Creek, the stream that now runs through the lower Mammoth housing area. Like the Old Faithful swimming pool, the Mammoth pool sometimes had unsanitary water. The pool was dismantled in 1950.

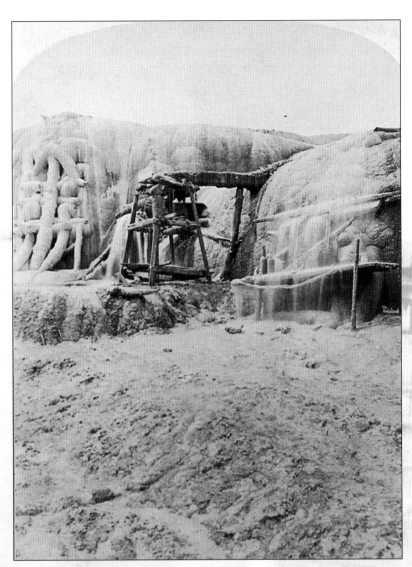

OLE ANDERSON at his coating springs, probably the 1880s. The limestone-laden waters of the springs flowed over racks, coating a variety of bottles and other souvenirs. Ole Anderson arrived in Yellowstone in 1883 and began a business of selling specimens coated with travertine from Mammoth Hot Spring waters, at first from a tent on the site and later from his Specimen House.

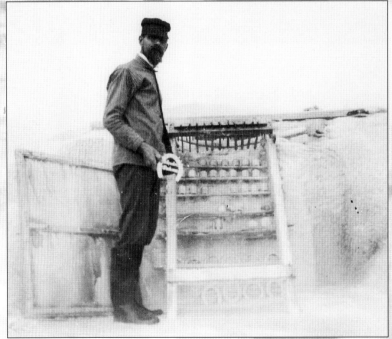

AN F. J. HAYNES photo of the coating terrace was taken between 1882 and 1884, and probably shows a portion of what is now called Minerva Terrace. Notice that, though active coating was only done on a few racks at a time, the older racks were allowed to become part of the terrace as the travertine built up and covered them.

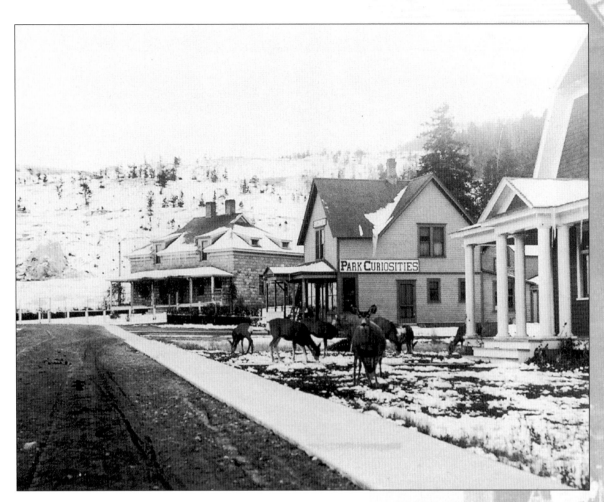

FROM THE LEFT: the judge's house, Specimen House (with Park Curiosities sign), Nichols House, with mule deer grazing on the lawns, about 1900. The Specimen House was built in 1895–1896 by Ole Anderson. Anderson sold the building to Pryor and Trischman in 1908, and they enlarged it and operated it as the Park Curio Shop. In 1925, the owners nearly doubled the building's size. Later it was operated by the Haynes Picture Shops, then Hamilton Stores, and finally torn down in the early 1980s. The Nichols house was built about 1903 for the Nichols family who was in line behind Harry Child to take over the hotel concessions. It has always been occupied by park concessionaires.

F. J. HAYNES was the park's great commercial photographer and founder of a highly respected park concession that lasted from the 1880s to the 1960s. This is the Haynes home and studio at Mammoth when it was located across the main road from the National Hotel, about 1890. Built in 1884, the Haynes house served as the center of F. J. Haynes's photo operations in the park. It was a pre-fabricated building, cut out in St. Paul and shipped to the park by rail for assembly. The Haynes house was moved in late 1902 to the north base of Capitol Hill and was razed in 1928.

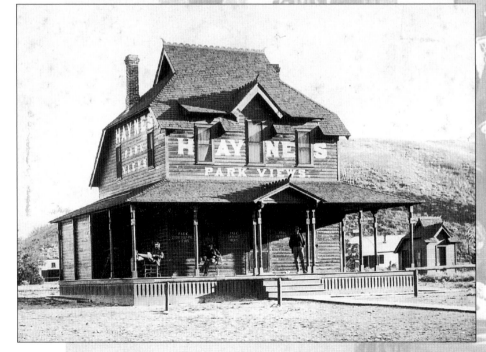

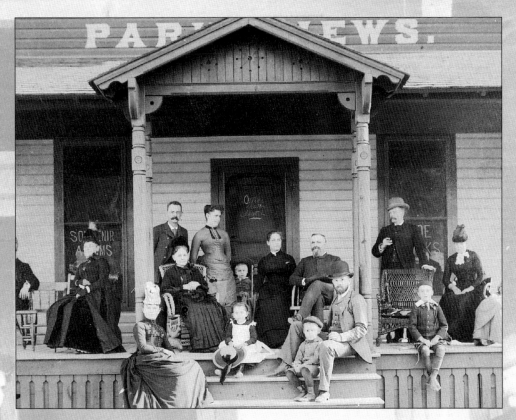

A **SINGULAR GATHERING** of important early park concession-aires, people who played important roles in Yellowstone's early history, gathered in 1886 on the front porch of the Haynes home and studio. Left to right: R.W. Minty, clerk of the National Hotel (far left, almost out of photo); Mrs. George Wakefield (wife of owner of park stagecoach company); Libby Wakefield; Frank J. Haynes; Mrs. L.H. Haynes (Frank's mother); Lily V. Snyder Haynes (Frank's wife); Anna Waters (sitting on step, daughter of park boat concessionaire E. C. Waters); Jack E. Haynes (boy, son of Frank and later long-time manager of the Haynes business); Mrs. E. C. Waters; Captain E. C. Waters; George Haynes (boy, son of Frank); William G. Johnson (Yellowstone Park Hotel Association); S. H. Emerson; George Tutherly, Jr. (boy, son of U.S. Army officer then stationed in park); Mrs. W. G. Johnson; and Mrs. George Tutherly (far right, almost out of photo).

LYALL-HENDERSON store at Mammoth, about 1897. This store was Mammoth's second store. G. L. Henderson had an earlier store at the east foot of Capitol Hill, just southeast of today's Hamilton Nature Store, and it is still evident in a large cut in the base of the hill. Today's Mammoth Hamilton Store was built in 1895–1896 as the Lyall-Henderson store and post office, owned by Henderson's family and his son-in-law Alexander Lyall.

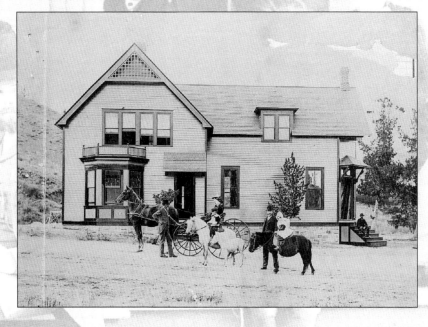

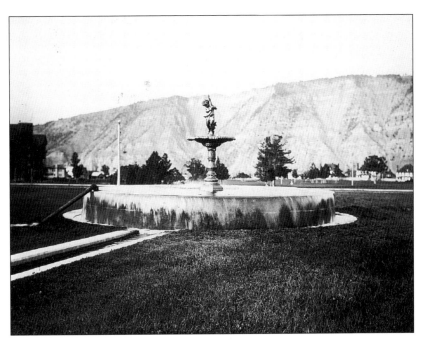

CHITTENDEN'S fountain, circa 1905. Engineer Hiram M. Chittenden built this fountain with a statue of cupid about 1901, when he was revamping the water supply system at Mammoth. The fountain, located in front of the "judge's house," was intended to distribute irrigation water to the army's parade ground (visible behind it) and other dusty Mammoth areas that had been newly covered with grass. It also watered Mrs. Meldrum's garden. President Theodore Roosevelt, who took a great interest in Yellowstone Park, complained to the park superintendent about the "ugliness" of the fountain, and it was removed a few years later. According to historian Aubrey Haines, the fountain "sat around" the park for years until it was destroyed in a World War II scrap-metal drive.

PARK CURIO SHOP, first owned by Pryor and Trischman, no date, which replaced Ole Anderson's Specimen House in or about 1908.

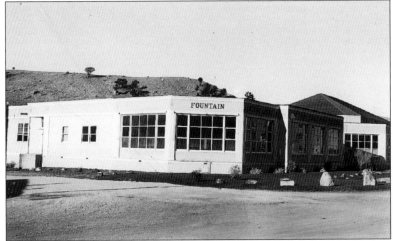

FOUNTAIN SERVICE, October 9, 1951. Built during the 1936–1938 renovations of the third Mammoth Hot Springs Hotel, the south end of today's recreation hall originally housed a fountain and café service. Today the wing is occupied by the Accounting Division of the current concessionaire, Amfac Parks and Resorts.

MAMMOTH AUTO CAMP, cafeteria, soda fountain, general store, and Haynes picture shop, looking south about 1930, with Mammoth Lodge and its cabins in the distant background. The first Mammoth Campground was located below Marble Terrace, and used the old Camp Sheridan stables; it lasted until 1916–1918. In 1919, the present Mammoth Campground was established, and it was described as being "in the timber near the power house." George Whittaker established a tent building there in 1924 to use as a store. Sisters Anna K. Pryor and Elizabeth Trischman appear to have bought him out in 1925, and they added a cafeteria in 1927. Jack Haynes established a picture shop nearby that same year. The Pryor establishment remained until at least 1939. Gradual consolidation and simplification of services resulted in the eventual centralization of all commercial services near the present hotel.

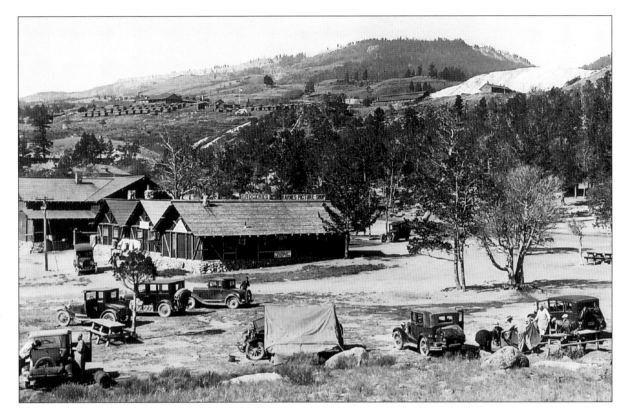

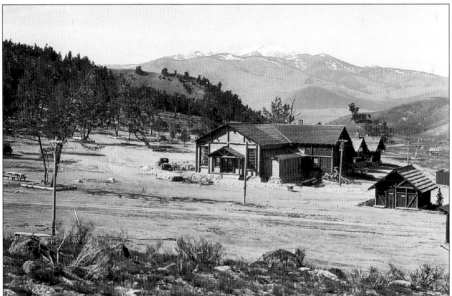

ANOTHER VIEW of the campground, looking north, 1930.

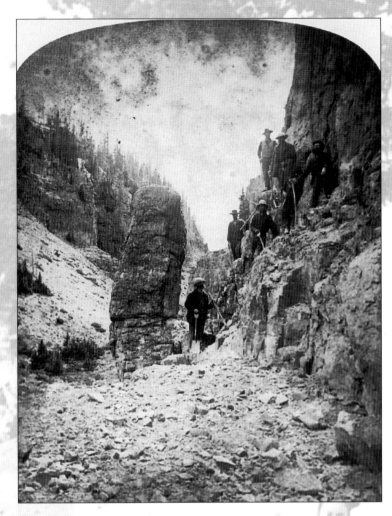

THE FIRST GOLDEN GATE BRIDGE, shown here about 1890, was a wooden scaffolding affair over which a wooden sign advised visitors to Walk your Horses. Engineer Hiram Chittenden remodeled the bridge in 1901 into a one-lane, concrete viaduct, and the bridge was remodeled again in 1933–1934 and in 1977.

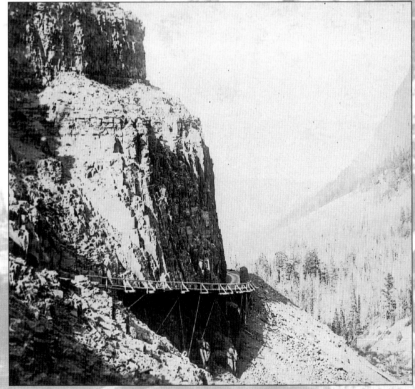

BUILDING THE FIRST road through Golden Gate Canyon, 1884. These men supervised by Lt. Dan Kingman and road foreman Oscar Swanson (who may be in the picture) built the first road through Golden Gate Canyon, named for the gold color of lichens on its rock walls, in 1884–1885. The route through Golden Gate, though requiring some exciting engineering, was a more hospitable grade than the older, steeper route through Snow Pass to the north. Note the stone Pillar of Hercules to the left of the lowest man, which has been moved and replaced to accommodate widening the road during each renovation of Golden Gate Bridge.

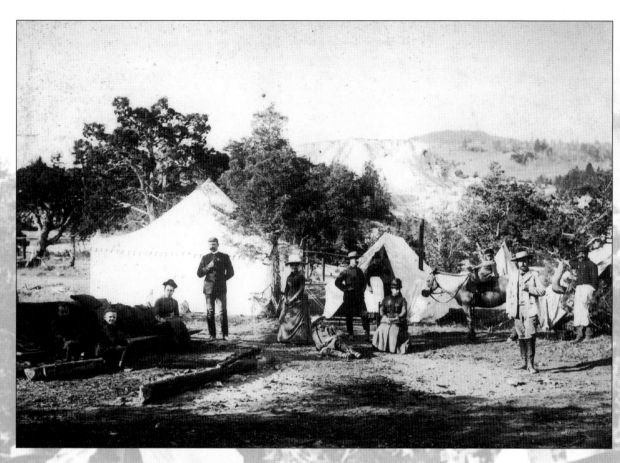

CAMP OF DAN KINGMAN, second from right in tall boots, about 1883, at Mammoth. Kingman was sent to Yellowstone in 1883 by the U.S. Army engineers to begin to establish the park's first permanent road system. His work eventually became the present Grand Loop Road system, which was finished in 1906. Kingman Pass, the gap at the upper end of the Golden Gate, was named in his honor. Others in the photo are unidentified, but the army officer fourth from left bears a striking resemblance to Gustavus C. Doane who would have been in position to accompany Kingman to the park in 1883 from Montana's Fort Maginnis. The woman to his right certainly resembles Doane's wife, Mary Hunter Doane. For his 1870 discoveries, Doane was long touted as "the man who invented Wonderland."

HIRAM M. CHITTENDEN served two tours in Yellowstone, 1891–1893 and 1899–1906, as engineer in charge of road-building. Under his leadership, the Grand Loop Road was completed over Mount Washburn, and a section of that road bears his name today. The Chittenden Bridge near Canyon is also named for him, because he completed the first such bridge there in 1903. In addition to being an engineer, he was also a historian who published *The Yellowstone National Park* in 1895, the classic early history of the park that has gone through many editions and is still in print today.

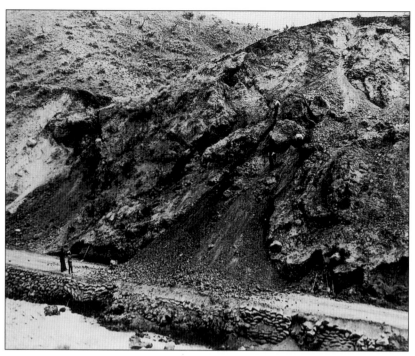

Due to the unstable character of the sandstones and mudstones of the Gardner River Canyon, the river, wind, and precipitation cause many slides like this one in 1912. The first road following the river began as a horsetrack during the 1870s. An alternative secondary road, high on the slopes to the west of the river, was known as the old Gardiner road and originated at about the same time. Two roads have led from Gardiner to Mammoth since earliest park days. At first the main road was mostly on the east side of the canyon, as it is today. In 1901 engineer Hiram Chittenden began moving much of the road to the west side. Dirt, mud, and rockslides began to occur almost immediately, and road crews labored every year to clear the route, repair it, and shore it up. In 1918, floods washed it out, and projects beginning that year moved it back to its original east-side location. East or west side, the road will always be at the mercy of the canyon's restless geology.

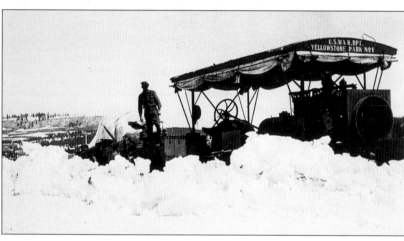

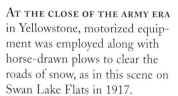

AT THE CLOSE OF THE ARMY ERA in Yellowstone, motorized equipment was employed along with horse-drawn plows to clear the roads of snow, as in this scene on Swan Lake Flats in 1917.

PARK SUPERINTENDENT Horace Albright posed in 1919 with master mechanic Bert Stennit of the maintenance division, a driver named Brownell, and what is probably the same machine as in the Swan Lake Flats photo to the left. Notice that the U.S. War Dept. Yellowstone Park No. 1 has been replaced by a National Park Service sign. Fitted with a home-made push plow designed by Albright, it became the park's first snowplow and did well in snow depths of up to five feet.

EARTHQUAKE RESULTS. An aerial photograph of damage wrought by the famous August 17, 1959 earthquake at Golden Gate Bridge. The photo was taken from a helicopter on August 28, 1959, between 9:15 A.M. and 11:30 A.M.

MRS. JOHN W. MELDRUM and her garden, with Hymen Terrace in the background, about 1900. Mrs. Meldrum was wife of Yellowstone's magistrate and lived with her husband in this stone residence. While she lived there, Mrs. Meldrum kept a vegetable garden and numerous domestic flower gardens. Her husband kept notes on the activity of nearby Hymen Terrace, then very active, now generally inactive, and other Mammoth springs.

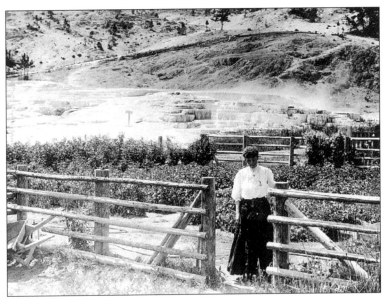

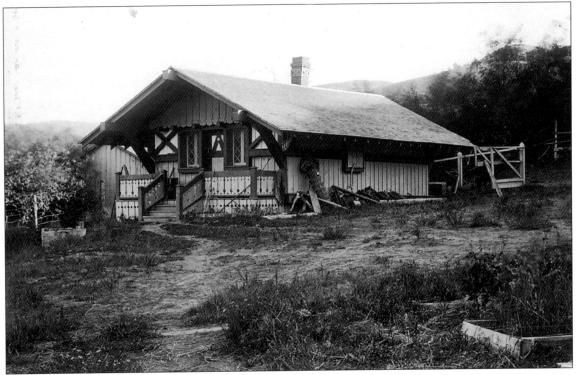

HISTORY, CONCERNED with momentous events, rarely tells us enough about how people got the everyday necessities and comforts of life in an isolated community like Mammoth. The "government garden" was started by Superintendent P. W. Norris near the present 45th Parallel Bridge along the Gardner River sometime between 1877 and 1881. When the army arrived in 1886, it took over the garden and grew vegetables for soldiers and employees at Fort Yellowstone. About 1907, the garden was turned over to the Yellowstone Park Hotel Company when it became known as the Company Garden, Truck Garden, or Chinaman's Garden. Vegetables from the garden fed hotel guests. A Chinese gardener named Sam Wo lived here and tended the garden from at least 1907 to 1917 (the year of this photograph), when the shack was remodeled into this handsome residence with the help of architect Robert Reamer. The building was apparently torn down in September of 1931.

SOME LARGE DEVELOPMENTS remained behind the scenes even though they were out in the open. Hiram Chittenden built this reservoir and dam below Marble Terrace in about 1915, and, though it still exists, it is all but invisible from all the roads and popular trails in the area. Built to furnish hydroelectric power for Fort Yellowstone, it also provided irrigation water to the Fort Yellowstone parade ground. Chittenden brought water to the reservoir via a ditch which he had dug from Glen Creek, some three miles to the south.

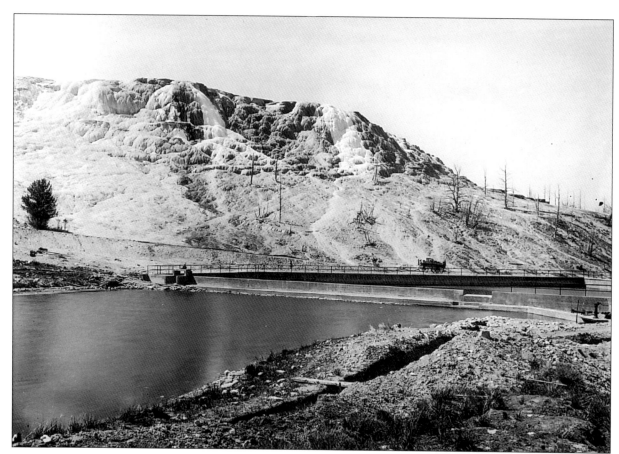

THE MAIL CARRIER'S CABIN at Mammoth was built in 1895 to house Oscar Roseborough who took over the Mammoth–Cooke City mail route that year from Augustus French. He also obtained French's buildings at Yancey's and Soda Butte. The park superintendent noted: "I have also permitted him [Roseborough] to erect a small building at the Mammoth Hot Springs to be used in connection with his mail contract, to be removed at any time when so ordered by the acting superintendent." The building, which some mistakenly assume to be the oldest at Mammoth, still houses park staff.

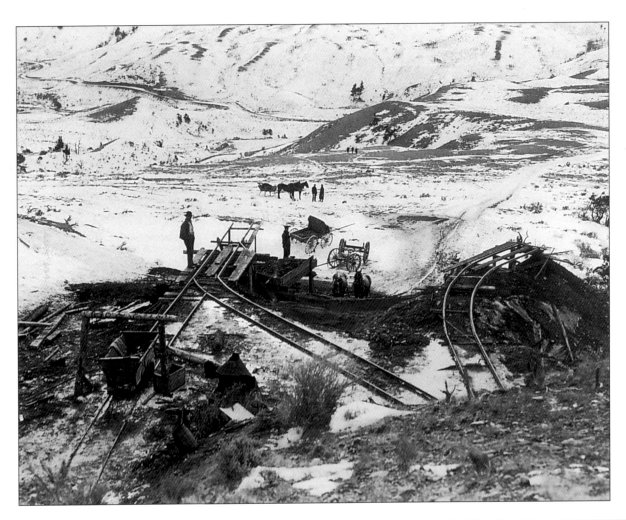

IN 1885, SILAS MCMINN began digging coal out of the north end of Mt. Everts and selling it to the hotel company at Mammoth Hot Springs. His enterprise resulted in giving the name McMinn Bench to a north prolongation of Mt. Everts. The Gardiner-to-Mammoth Road can be seen in the left background. The coal mine was never very successful, but it was reopened in 1918 during World War I and 467 tons of coal were taken out and used by government offices at Mammoth for fuel at $9.27 per ton. Apparently used again, 1919–1920, the site was restored to natural conditions by the National Park Service in 1993.

CYNTHIA SORG, motor vehicle operator foreman, 1981. By the 1960s, garbage was collected in Yellowstone in trucks of the packer type shown here.

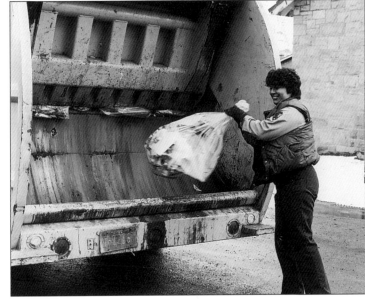

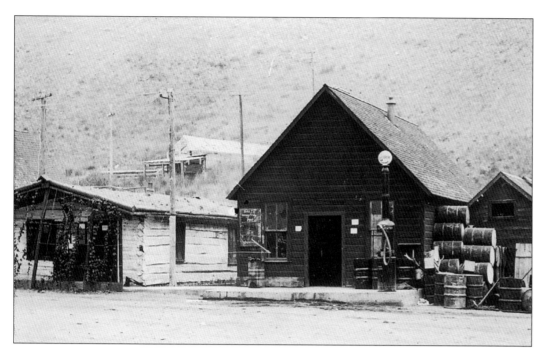

FIRST MAMMOTH GAS STATION, about 1917. Automobiles were admitted into Yellowstone in August of 1915. In 1916, both stagecoaches and autos traveled park roads. That simply did not work, so busses replaced stagecoaches in 1917. Naturally gasoline stations were needed for the season of 1916. This gas station evolved logically on the site of the Yellowstone Park Transportation Company's stage yard, which had been earlier shared with the U.S. Army Engineers. In 1997, Conoco will celebrate eighty years of continuous service to motorists in Yellowstone.

FIRE AT MAMMOTH LODGE, October 18, 1930. This fire destroyed the boiler room and laundry.

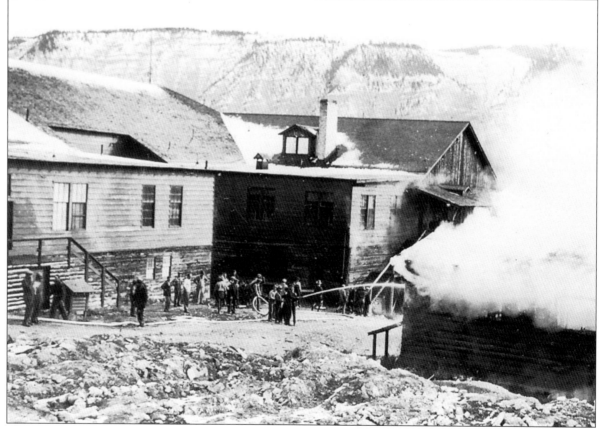

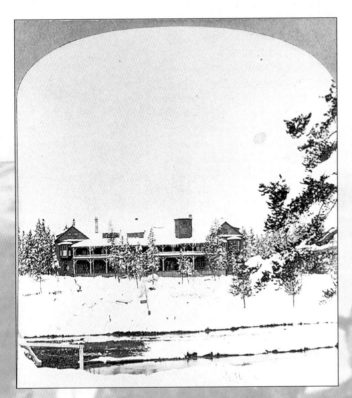

F. J. HAYNES, during his winter expedition of 1887, photographed the first Norris Hotel in January snows. Completed only the previous fall, it burned the following June when someone tried to start a fire in an unfinished chimney. Norris visitors got along in tents and shacks until 1901, when a second hotel was built.

THE GENIAL LARRY MATHEWS, who lived and worked in Yellowstone from 1887 to 1904 and became one of its first nationally-known celebrities, ran the "ramshackle" tent lunch station and hotel at Norris (shown about 1895) from 1893 through 1901.

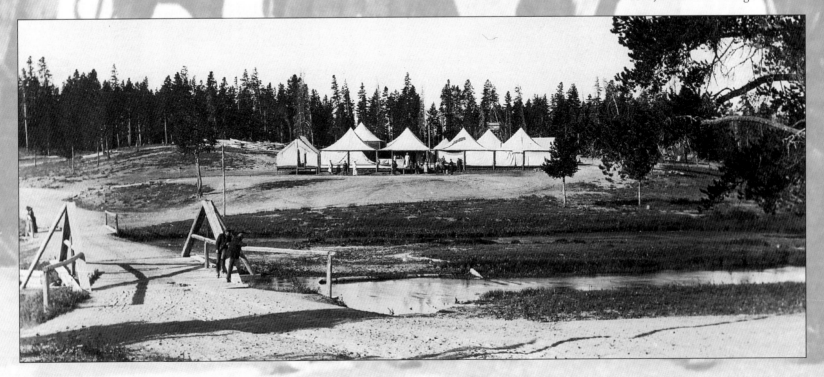

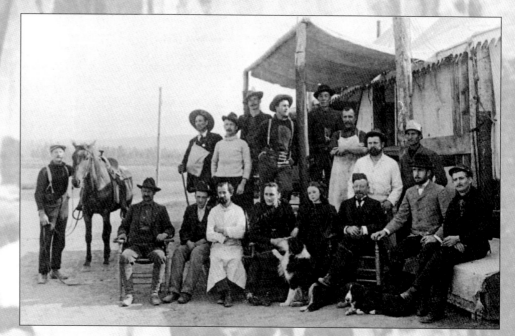

LARRY MATHEWS and his staff, about 1896. Mathews, wearing his signature skull cap, is third from the right in the front row, with his daughter Elizabeth and wife Mary on his right. He inspired great loyalty in his staff, who returned year after year.

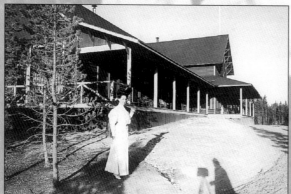

A PHOTOGRAPHER shoots a lady at the Norris Hotel, 1905. Also called the Norris Lunch Station, this hotel, the third at Norris if a cheap, tent-and-wood structure is included, was small, with only about twenty-five sleeping rooms. Most stagecoach visitors ate lunch here, wandered through the geyser basin, and boarded their stage-coaches from a covered, loading platform at Minute Geyser. Opened for the season of 1901, this Norris Hotel was located on the hill immediately north of Porcelain Basin so that visitors had a view of the geysers from the veranda. It was abandoned in 1917 and torn down in 1927.

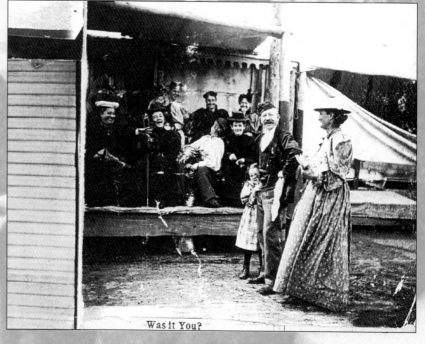

Was it You?

MATHEWS AND HIS DAUGHTER with Martha Jane Canary, popularly known as Calamity Jane, in a photo heretofore unknown to historians, provided to the park by Mathews family descendants.

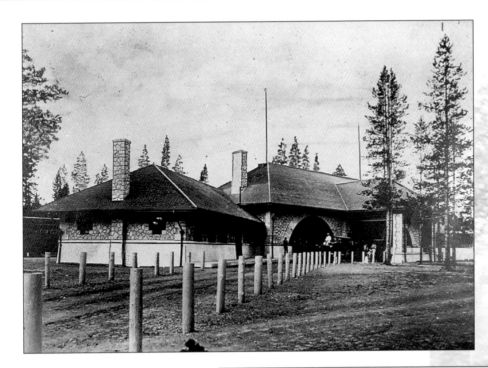

COACH WAITING to load at the Union Pacific Railroad Station, West Yellowstone, Montana, about 1915.

WHITMAN'S CONOCO, West Yellowstone, Montana, 1927. Jay Whitman opened his station in 1927 and it remains in operation today on the same site. Jay Whitman is on the left and his son John is on the right.

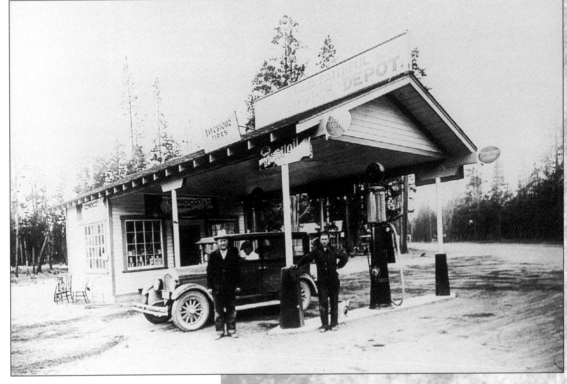

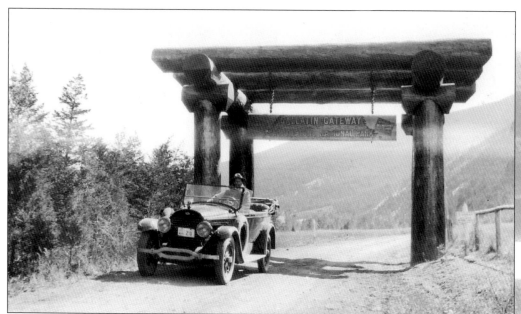

SUPERINTENDENT HORACE ALBRIGHT at the Gallatin Gateway, about 1927. Like the official openings that once occurred at the park's north entrance, the park's northwest entrance sponsored official openings in the 1920s and 1930s when the Chicago, Milwaukee, and St. Paul Railroad carried passengers to the community of Gallatin Gateway, some miles north of the actual park boundary.

OILING THE ROAD two miles from West Yellowstone, about 1910. Roads in the park were macadamized (gravelled) in the teens, oiled in the 1920s, and paved in the 1930s and 1940s.

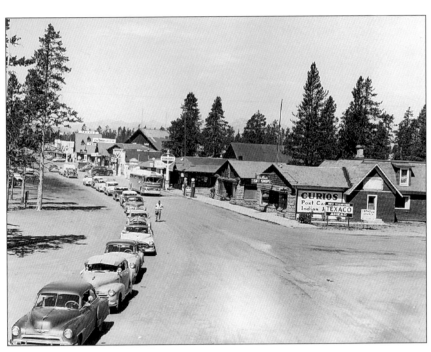

LOOKING FROM THE WEST entrance checking station toward the town of West Yellowstone, Montana, July 27, 1953.

SUPERINTENDENT HORACE ALBRIGHT speaks at the park's golden anniversary celebration, 1922, at the foot of National Park Mountain along the Madison River.

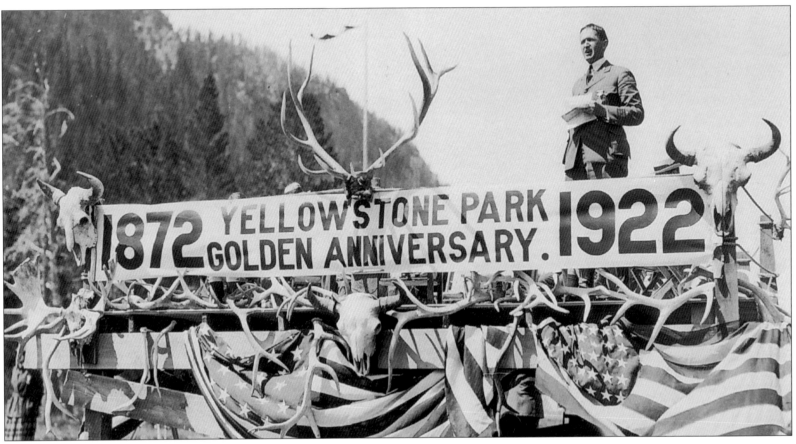

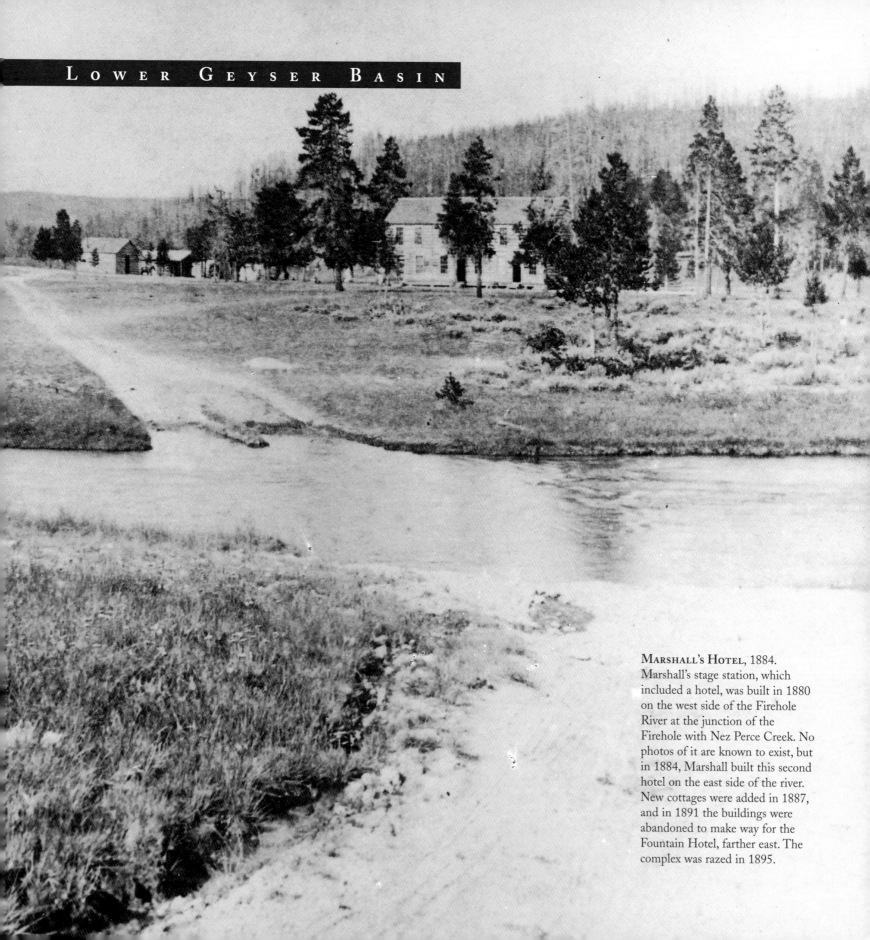

MARSHALL'S HOTEL, 1884. Marshall's stage station, which included a hotel, was built in 1880 on the west side of the Firehole River at the junction of the Firehole with Nez Perce Creek. No photos of it are known to exist, but in 1884, Marshall built this second hotel on the east side of the river. New cottages were added in 1887, and in 1891 the buildings were abandoned to make way for the Fountain Hotel, farther east. The complex was razed in 1895.

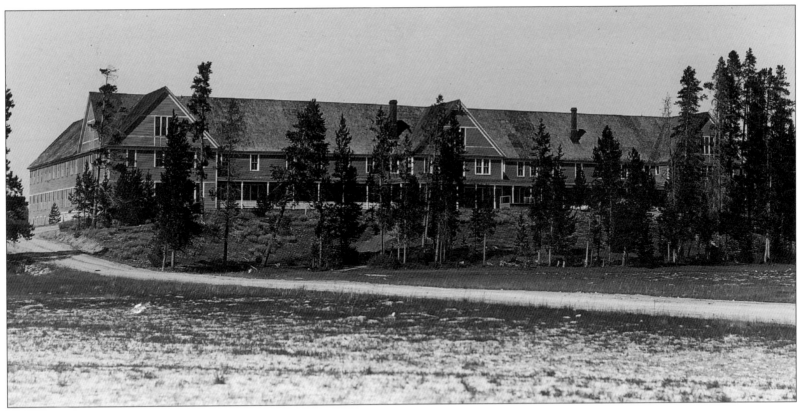

FOUNTAIN HOTEL, 1917. Construction began in 1889, and this hotel, just north of present Fountain Paint Pot, was close enough to completion to open for the season of 1891. Most stage-coach visitors before 1904 stayed here rather than at Old Faithful. They made a day-trip to Old Faithful the next day and then stayed here a second night before traveling on to Lake and Canyon. The hotel's last season was 1916. Bus motorization of the park in 1917 made the Fountain Hotel unnecessary, so it stood empty for ten years before being torn down in 1927.

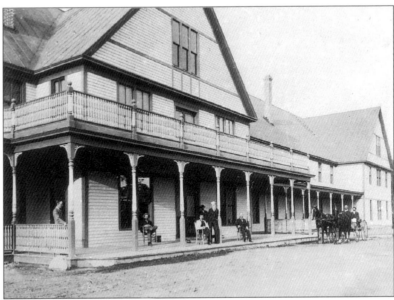

FOUNTAIN HOTEL, 1895, with visitors on porch. The hotel faced south so that visitors could have a view of the Fountain Geyser and other nearby thermal features.

OLD FAITHFUL "SHACK" HOTEL, 1890. Built in 1885 by the Yellowstone Park Improvement Company on what would be the site of Old Faithful Inn, this first permanent hotel at Old Faithful was never satisfactory. Visitors walking through its halls got splinters in their elbows from its unfinished walls, and the structure tended to shake with each step. After Superintendent Robert Carpenter was ousted in 1885, he went to Old Faithful to manage this hotel. It burned in 1894 and was replaced in 1895 by another cheap wooden structure. This is a rare, round-format photograph of the type taken by Eastman's first roll-film cameras in the 1880s.

THIS HAYNES PHOTO of the first tourist facility at Old Faithful was probably taken in 1883. It shows Beehive Geyser in the foreground, with the Yellowstone Park Improvement Company's tent camp across the Firehole River, later the site of the Old Faithful Inn. Note the narrow footbridge across the river, just to the right of the geyser cone.

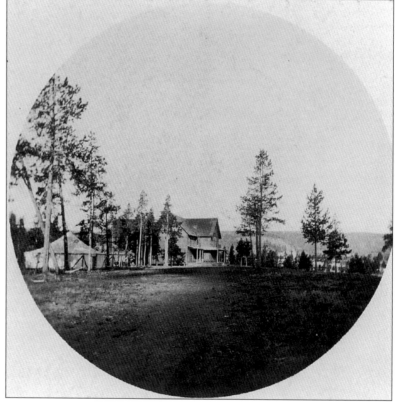

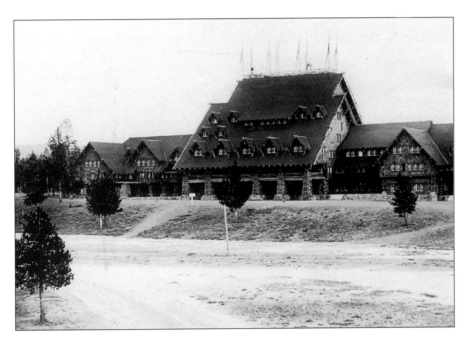

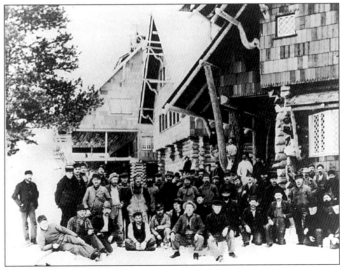

THE ONLY KNOWN PHOTO of the construction crew that built Old Faithful Inn during the winter of 1903–1904. Construction began June 12, 1903, and ended June 1, 1904.

OLD FAITHFUL INN, about 1905. This photo shows the inn when new, before wings were added in 1913 and 1927 and during the period when it flew eight flags; today there are only five. The flags seem to have been largely decorative, although at various times two are known to have read Upper Geyser Basin and Yellowstone Park Association. Note the spotlights on the roof, placed there in 1904, to illuminate night eruptions of Old Faithful Geyser, a practice which lasted into the early 1960s.

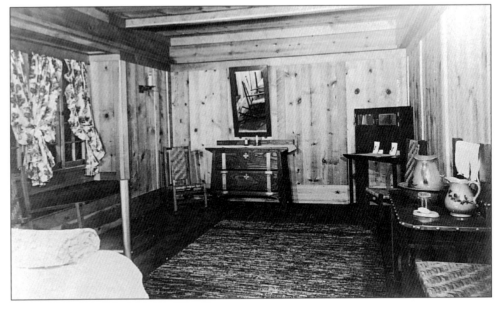

INTERIOR OF AN OLD FAITHFUL INN room, about 1904.

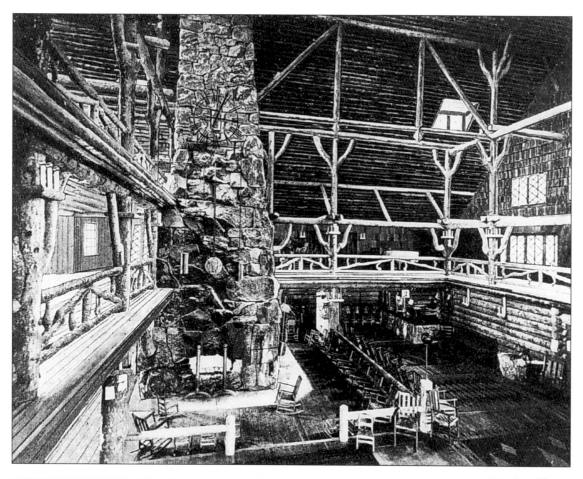

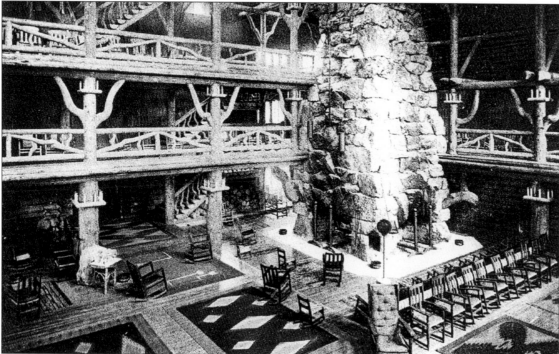

THE LOBBY OF THE OLD FAITHFUL INN in 1904 shows the studied rusticity of its architecture and the massive fireplace. Now more than ninety years old, the inn's lobby still evokes gasps from many first-time visitors who stand in awe at the huge log interior.

OLD FAITHFUL LODGE in winter
as it appears today.

KLAMER STORE, 1912. Henry Klamer built this first store in the Old Faithful area in 1897. He also fancied up the small bridge (far left) across nearby Myriad Creek, also known as Zipper Creek, by ornamenting it with burled wood. The larger stagecoach bridge, in the foreground, was also quite fancy. Klamer died in 1914, and his wife sold the store to Charles Hamilton in 1915 for $20,000.

HAMILTON STORE at Old Faithful Auto Camp, September 4, 1929. An auto camp at Old Faithful was once located where the east parking lot is now and extended east into the trees. This store served the auto camp until the present upper Hamilton Store, called the Basin Auto Camp or B.A.C. Store, was built in 1930.

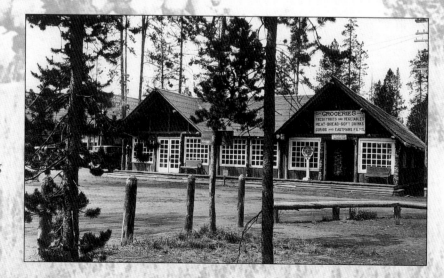

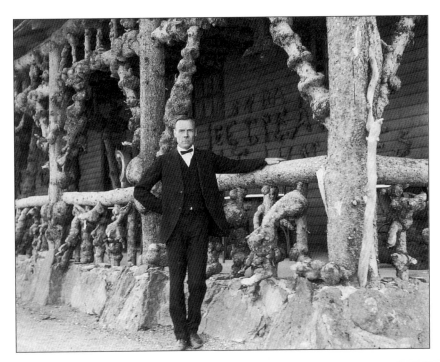

UPPER HAMILTON STORE at the close of the 1930 season. It was originally known as the B.A.C. Store because it was adjacent to the Basin Auto Camp.

CHARLES ASHWORTH HAMILTON purchased Henry Klamer's store at Old Faithful in 1915, thus beginning the Hamilton Stores in Yellowstone National Park. By the 1920s, his operation had expanded to cover the southern part of the park. Pryor and Trischman held store rights to the northern park until 1953. Here Hamilton stands in front of his Old Faithful store in about 1920.

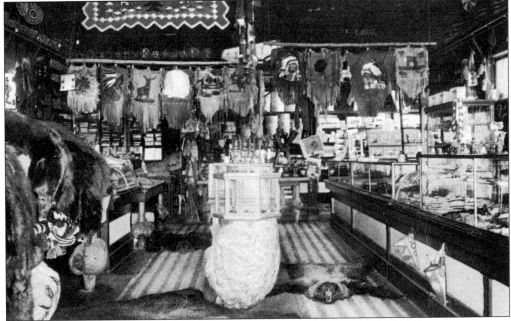

INTERIOR OF HENRY KLAMER'S store at Old Faithful, about 1908.

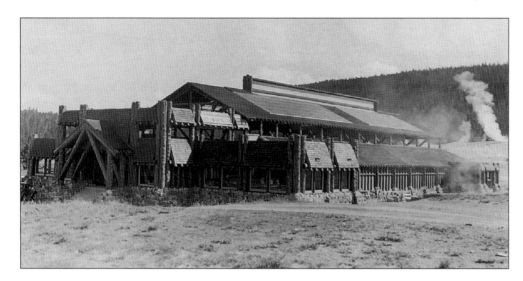

OLD FAITHFUL SWIMMING POOL, 1934, just after it was remodeled and enlarged. The operation was taken over by the Hamilton Stores in 1933, and the company added employee dormitory rooms, showers, and a public laundry. Old Faithful swimming pool was demolished in the summer of 1951, in accordance with the National Park Service's new policy to reduce recreational activities that were associated with traditional resort areas rather than a national park.

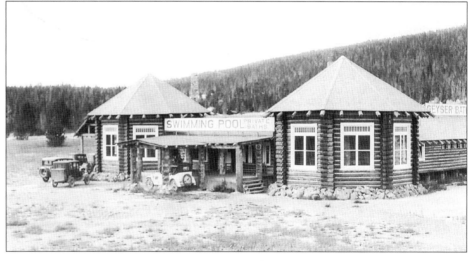

OLD FAITHFUL SWIMMING POOL, about 1925. The Old Faithful Geyser Baths establishment was the first swimming pool in the area and was built in 1914–1915 by Henry Brothers. It was a 50 by 100-foot open-air pool with five private plunges. Superintendent Lloyd Brett selected the site in May 1914 and the pool opened July 1, 1915.

THE HENRY BROTHERS GEYSER Baths pool from Beehive Geyser (1921) utilized geyser water from Solitary Spring above Geyser Hill, and it could accommodate more than one hundred swimmers. Conveying water from the hot spring down the hill and across Firehole River greatly changed the spring, which began erupting much more often as a geyser, and today is known as Solitary Geyser.

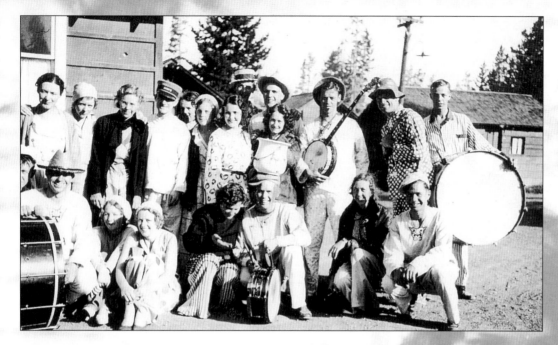

CONCESSION EMPLOYEES had a number of nicknames, the most common being "Savages." The term originally referred to park stagecoach drivers, probably because of their carefully cultivated savage nature, but which eventually came to refer to any park employee. In this 1932 photo, Old Faithful Lodge employees gathered for the Fourth of July Pajama Parade. Such parades, skits, and celebrations once were routine at Yellowstone's lodges and hotels.

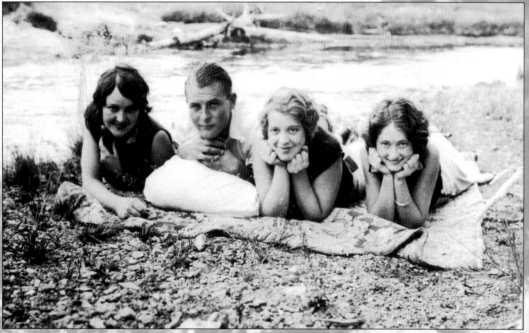

JEAN, SMITTY, LILIAN, AND TYRA, last names unknown and all 1932 Old Faithful Lodge employees, enjoy a blanket on the Firehole River during a summer long gone.

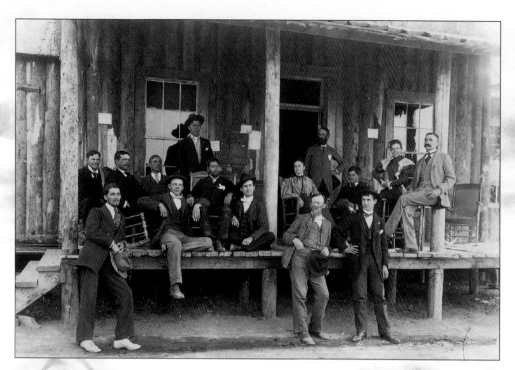

At first 1883–1884, tents served Old Faithful visitors, but in 1885 the Shack Hotel was constructed by the Yellowstone Park Improvement Company. It burned in 1894, and in 1895 this crude wooden building was erected. It was managed by W. P. Howe, shown standing in the doorway in this 1897 photo with his employees during the seasons of at least 1897 to 1900. Only one other employee, Dave Johnson, standing on porch, left center, is identified.

ARRIVING CONCESSIONS employee
sitting on luggage, about 1924.
Location unknown, but possibly
West Yellowstone train depot.

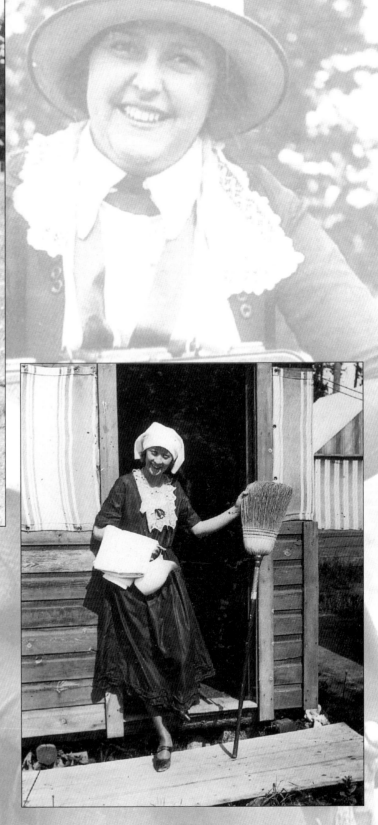

PILLOW PUNCHER a cabin maid
at cabins, unknown location,
about 1925.

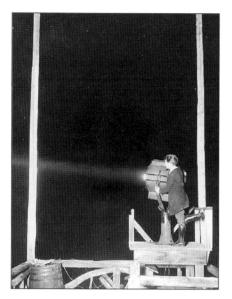

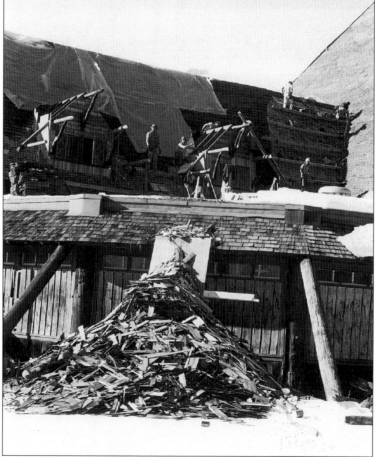

THE OLD FAITHFUL AREA hothouse, shown here in 1917, was built in 1897 by the Yellowstone Park Association, an early hotel company, in order to provide green vegetables on Old Faithful tables. It was located just south of the present lower gas station. Its initial existence predicated a magazine article that year about it in *Scientific American* entitled "Gardening Over a Geyser." The article stated that the building was heated with 195-degree geyser water, that it grew lettuce, cucumbers, and mushrooms among other vegetables, and that "the rich soil, the sun's light, and the condensation of steam from the hot water make an ideal combination for the growth of vegetation." The hothouse was still furnishing vegetables for Old Faithful winter keepers in 1930. Always intended to be a temporary building, it nevertheless was modified in appearance at least once and was still standing in 1939.

A SPOTLIGHT on the widow's walk atop the Old Faithful Inn was installed during its construction in 1903–1904. It was used, as in this 1925 photo, to light Old Faithful Geyser's nighttime eruptions until sometime in the early 1960s when the practice was abandoned as inappropriately theatrical in a national park. A 1911 railroad brochure noted: "It has long been the custom at Old Faithful Inn to flood the geyser at night with rays of a search light. Then the spectacle takes on new features—all the rainbow hues are there, and looking through the fountain along the sweep of light, one sees a bediamonded form more beautiful than any ever wrought by the hands of the Ice King."

RESHINGLING THE OLD FAITHFUL Inn, January 1981. A pile of shingles lies on old snow while carpenters painstakingly fit new ones to the roof. Unseasonably warm weather that year sped progress and made it comfortable to work shirtless in January.

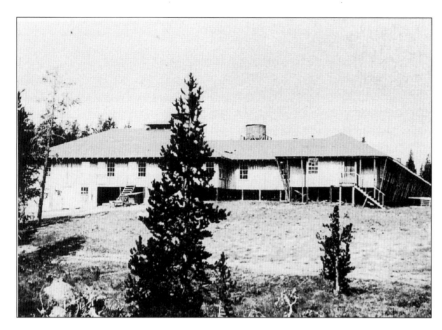

THE FIRST WEST THUMB lunch station was a tent affair which was opened for the summer of 1892 by the Yellowstone Park Association because the new road connecting Old Faithful and West Thumb was completed. The station was managed that summer by Larry Mathews. This more permanent facility replaced the tents in 1903 and operated through 1916.

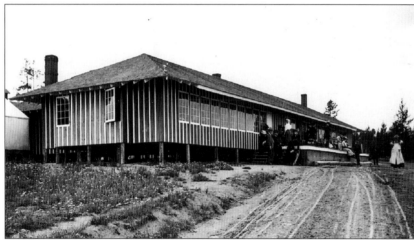

WEST THUMB LUNCH STATION with visitors, date unknown. For most stagecoach visitors it was merely a lunch-stop, but it also contained some overnight rooms for those few who wished to tarry. It was abandoned in 1917, when motor busses did away with the need for the lunch stop; it was finally torn down in 1923.

A BEAR WITH VISITORS and autos at the West Thumb store, 1929. The West Thumb was once a major facility area, with a fair-size village that included, at various times, a large Hamilton store and post office, photo shop, cafeteria, gas station, ranger station, campground, cabin rental office and about eighty cabins, a boat dock, two lunch stations, a trailer park, bunkhouses, and support buildings. These facilities were gradually removed beginning in the early 1970s, and the facilities were transferred to Grant Village, two miles south along the lake shore.

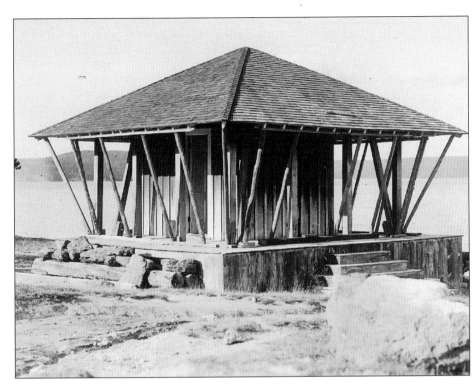

COMPANY WASHING STAND at Lakeshore Geyser, West Thumb, 1917. It is not known when the Yellowstone Park Hotel Company, formerly the Yellowstone Park Association, erected this small but fancy building near Lakeshore Geyser at West Thumb Geyser Basin. It was there by 1915, and it remained until sometime in the 1930s when it was used by fishermen to clean fish.

GRANT VILLAGE HOTEL, no date. The new hotel at Grant Village opened in 1982. The Grant Village area, first named and planned in 1945, was not a reality until the 1960s. For many years, Grant had a gas station and campground only, but in the 1980s with the phase out of the West Thumb village, it became a fully equipped visitor facility. The development of Grant Village was accompanied by more controversy and opposition than any previous park development, an indication of changing public attitudes about the way the park should be used and managed.

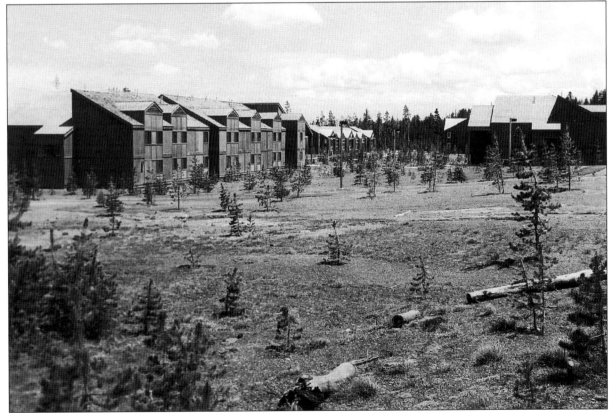

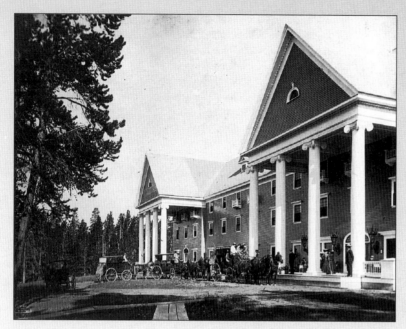

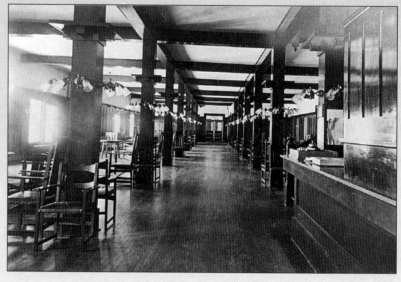

CONSTRUCTION BEGAN on the Lake Hotel, known in early days as the Lake Colonial Hotel, in 1889, and the hotel opened for the season of 1891. At first the building was a rather plain structure, very similar to the Fountain Hotel which opened at the same time. In 1903–1904, architect Robert Reamer designed a big remodeling which included the Ionic columns seen in this 1905 photo. A widow's walk on top of the hotel in early days was dismantled by the 1920s.

ONE OF VERY FEW SURVIVING pictures of the Lake Hotel lobby in the early days, this 1905 image was used in the planning for the complete renovation of the interior that was completed in 1991.

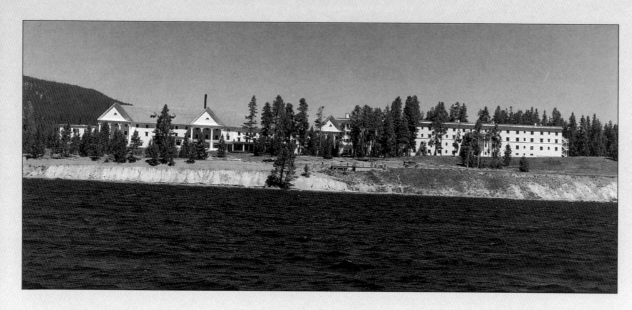

THE LAKE HOTEL, 1980s. A porte cochere was constructed in 1919, the big east wing was added in 1922–1923, and a north wing was removed in 1940. Extensive renovations in the late 1980s returned the hotel's interior to its turn-of-the-century look in time for the celebration of its centennial season in 1991. The building, which has always been painted yellow (and was featured in Sears paint commercials in the 1980s), is visible from many places along the distant lakeshore. Originally that was not the case, because trees almost obscured the building from the front.

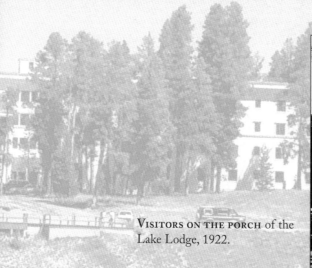

VISITORS ON THE PORCH of the Lake Lodge, 1922.

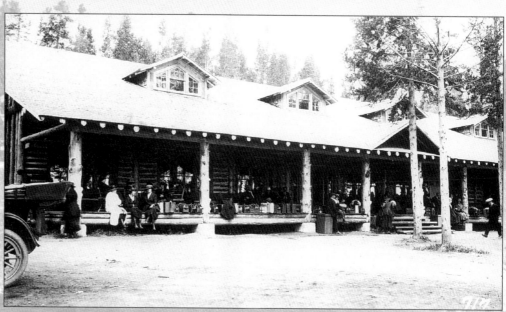

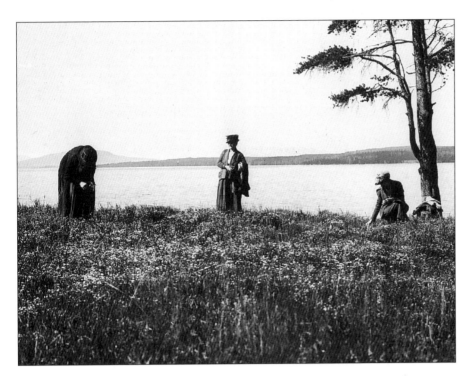

PICKING FLOWERS at Yellowstone Lake, about 1920. Another activity that seemed appropriate when visitation numbered in the thousands instead of the millions, flower picking is now prohibited so that everyone can enjoy the show.

LAKE HAMILTON STORE with its original full knotted framework, 1950. The first Lake Hamilton store was leased in 1917 from the Yellowstone Lake Boat Company and was operated in front of Lake Hotel in the old structure E. C. Waters had built. The present Lake store, built 1919–1922, had this framework on its front from around 1925 until the early 1950s when it collapsed.

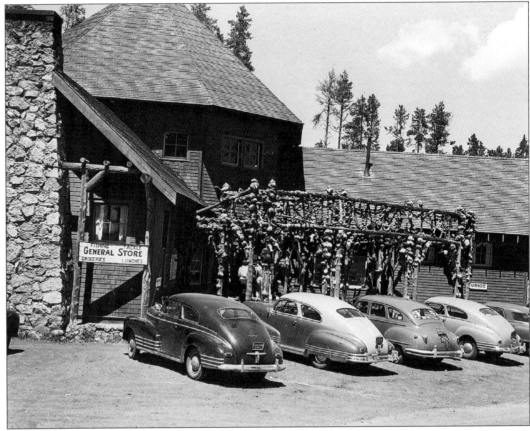

BOATING

The *Sallie,* an early boat on Yellowstone Lake, 1874, photographed by Joshua Crissman. In 1874, Eugene S. Topping and Frank Williams acquired a permit from the Department of the Interior to operate boats on Yellowstone Lake. They constructed and launched one or two boats, which took early horseback visitors on boat rides during the summers of 1874, 1875, and for a few weeks in 1876. Topping found the business unprofitable and abandoned it in 1876; no further commercial boats plied Yellowstone Lake until the summer of 1891. The *Sallie,* shown here, was either the *Topping* (another boat known to have been operated by the two men) with a temporary name painted on it, or else it was a second boat operated by E. S. Topping. The men advertised that the first woman to come to the lake would have the privilege of naming their new boat. Traveler Sarah Jane (Mrs. W. H.) Tracy, Mrs. Arch Graham, their husbands, and three other men arrived to claim the honors on July 20, 1874, probably the date of this photo. Sarah Tracy recorded that Commander Topping and his partner had completed "a good sized sail boat. The commander was waiting for the ladies to ride in his boat—the first ones to name it. As both our names was [sic] Sarah we readily agreed to christen the boat 'The Sallie.' We had a fine sail across the lake and our pictures taken on board after the name was painted on the side." The men at fore and aft of the boat are unidentified but probably are Williams and Topping.

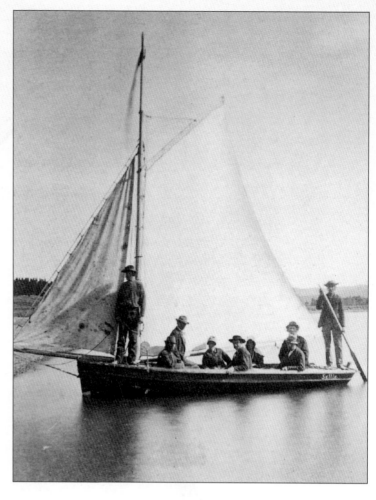

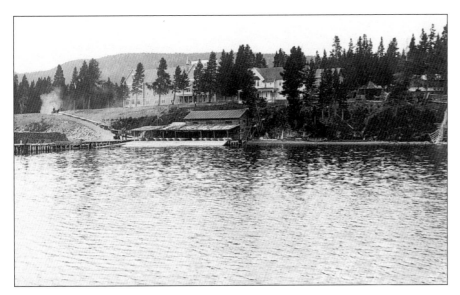

THE COMPLEX that once stood between the Lake Hotel and the lakeshore, probably 1917. This complex served as the main lake area boat dock from as early as 1891 through the 1950s. E. C. Waters, who owned the Yellowstone Lake Boat Company 1891–1907, lived in the three-story building in front of Lake Hotel. To the right of his house is the back of the Yellowstone Park Boat Company Store. In this picture, trees once hid Lake Hotel.

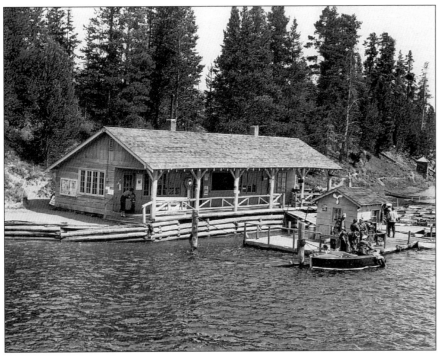

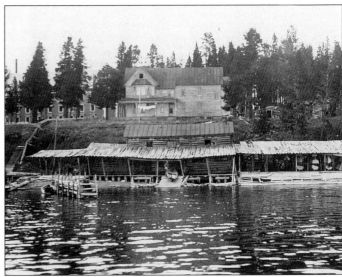

CLOSER VIEW OF E. C. WATERS'S house, which once stood in front of Lake Hotel, probably in 1917. His boat rental store was the ramshackle building at water level.

THE WEST-SIDE FISHING BRIDGE boat rental hut, August 28, 1951. The plans for this small building, erected in 1935, recently surfaced in the park archives, and they show that the building was designed by architect Robert Reamer.

THE STEAMBOAT *Zillah*, shown here about 1895, was brought to Yellowstone from the Great Lakes in 1889 and reassembled at Lake. It began trips on Yellowstone Lake in late 1891, routinely taking visitors from West Thumb to the docks at the front of Lake Hotel. Named for a female character in the Bible, the *Zillah* was owned by E. C. Waters (in the photo at far right) and later by the Yellowstone Lake Boat Company. She operated on the lake until about 1917 and then sat in drydock at Lake until 1926 when she was stripped and the hull sold for scrap.

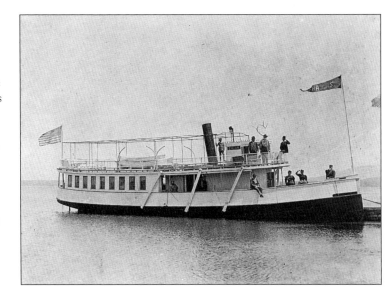

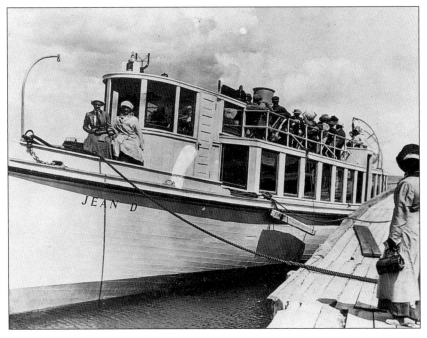

THE *Jean D.*, shown here in 1910, began operations late in the stage-coach period and was owned by the Yellowstone Lake Boat Company and its successor, the T. E. Hofer Boat Company. It was purposely destroyed in 1926.

YELLOWSTONE PARK BOAT COMPANY Store near Lake Hotel, 1917, which later that year became the first Lake Hamilton Store.

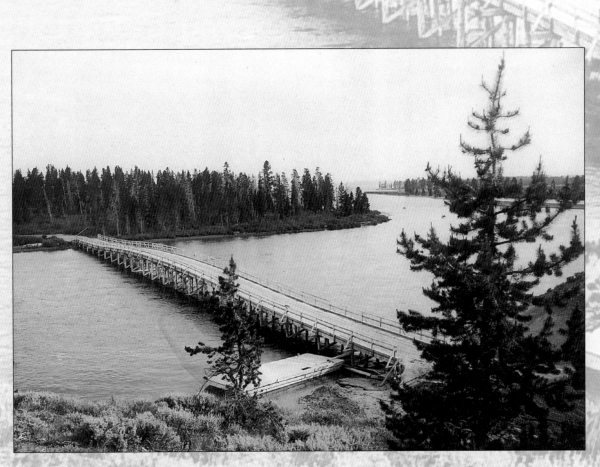

THE ORIGINAL FISHING BRIDGE was built in 1902 by engineer Hiram Chittenden during the construction of the first east entrance road. It was 360 feet long and differed from the present structure in both location and appearance, having a camel-back center with its east end farther upstream. It was named Fishing Bridge in 1914.

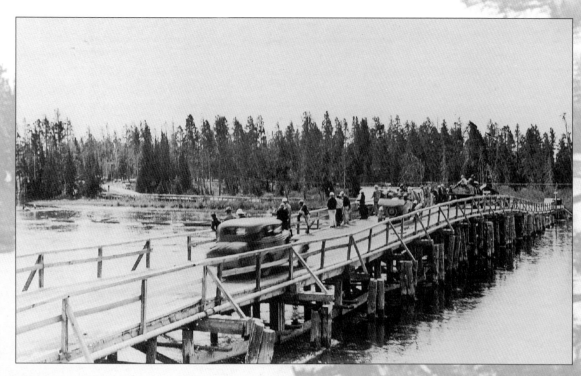

THE BRIDGE was rebuilt in 1919, and is shown here with auto traffic in 1919.

THE PRESENT BRIDGE, shown here in about 1965, was built in 1936–1937. Fishermen stood elbow to elbow fishing from the bridge until the close of the 1973 season, when fishing from the bridge was disallowed to protect important spawning areas of native cutthroat trout. Since then, the bridge has become the park's foremost fish-watching site, with thousands of visitors coming to watch the large cutthroats in the river below.

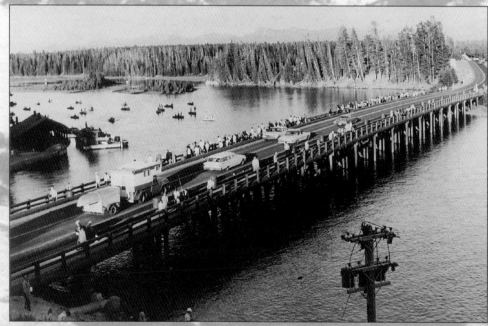

IRMA CODY GARLOW, Major Hoop, and Bill Cody's sister Louise Cody, at Pahaska Tepee, about 1900. William F. "Buffalo Bill" Cody had a hand in the founding of Cody, Wyoming in 1896 and named his hotel there for his daughter Irma. In 1903–1904, he built Pahaska Tepee, his hunting lodge, and it catered to visitors for many years. Cody Peak, on the east park boundary, is named for him.

EAST ENTRANCE checking station about 1924.

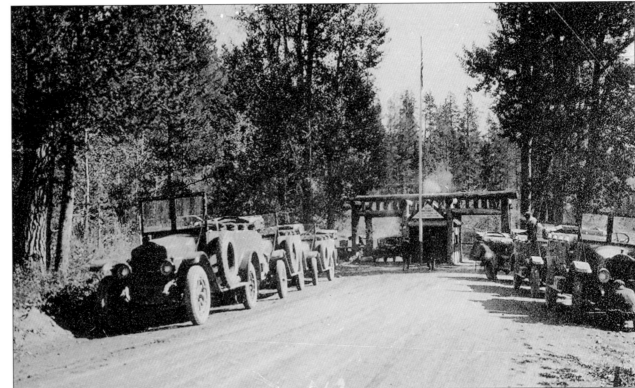

Two-horse carriage on Sylvan Pass, August, 1913. The Sylvan Pass road to the east entrance was completed in 1903 following several years work by road engineer Hiram Chittenden and his crews. Prior to that all travel from the east was by horseback. A book published in 1905, *Trial of a Trail* by Charles Heath, celebrated the road's opening, which finally connected Cody, Wyoming and its Chicago, Burlington, and Quincy Railroad terminus with the park.

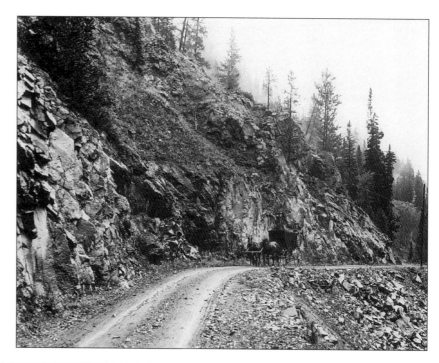

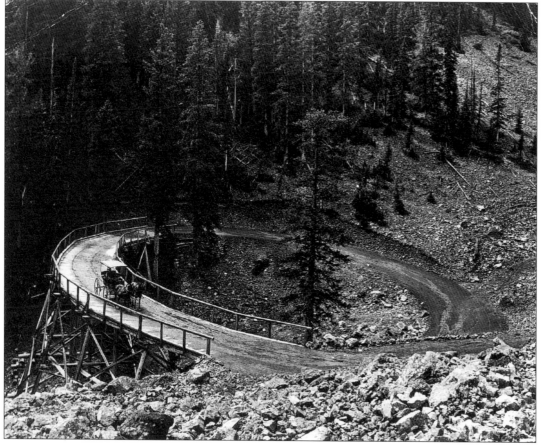

The first Corkscrew Bridge, shown here in August 1913. A wooden structure was completed near Sylvan Pass in 1905 at the time Hiram Chittenden finished the road. A second, more substantial corkscrew bridge replaced the wooden one in 1919 during the early auto era.

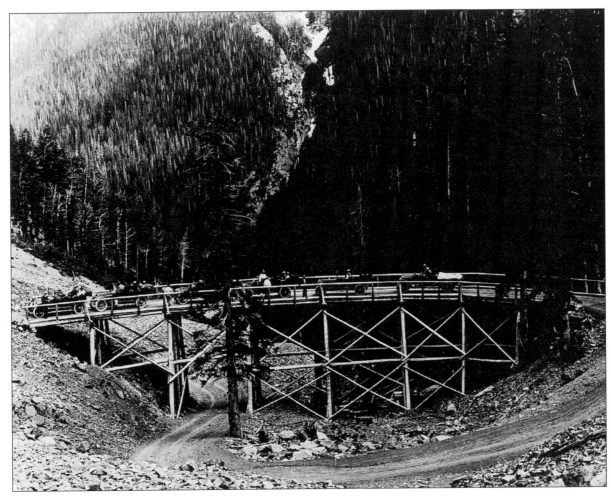

FIRST AUTOMOBILES over the Corkscrew Bridge, 1915.

LOCATED NEAR THE PARK'S EAST entrance rather than farther west on Sylvan Pass, Sylvan Pass Lodge, shown here in its first year of 1924, was active for only ten seasons. Sylvan Pass Lodge served meals to incoming and outgoing bus tourists and was managed by a Mrs. Underwood. There also were several overnight tents which could be rented by automobile travelers. The building was torn down in 1940 when the road was realigned.

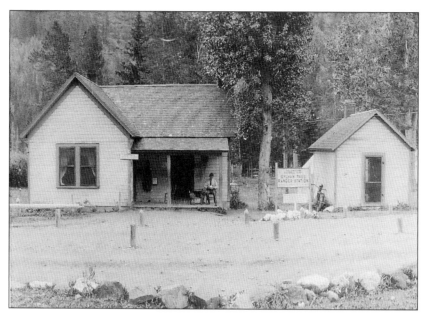

LOCATED AT THE EAST ENTRANCE rather than on Sylvan Pass proper, the Sylvan Pass Ranger Station was built as a U.S. Army soldier station in 1904. Little is known other than it was originally designed to house five men. The building was moved north to the other side of the road in the 1930s, turned 180 degrees, and placed on a concrete foundation, where it served as quarters until replaced by the present development.

SNOW REMOVAL OPERATIONS near Sylvan Pass have always been among the park's most dangerous, with gargantuan snowdrifts to be cut down and removed.

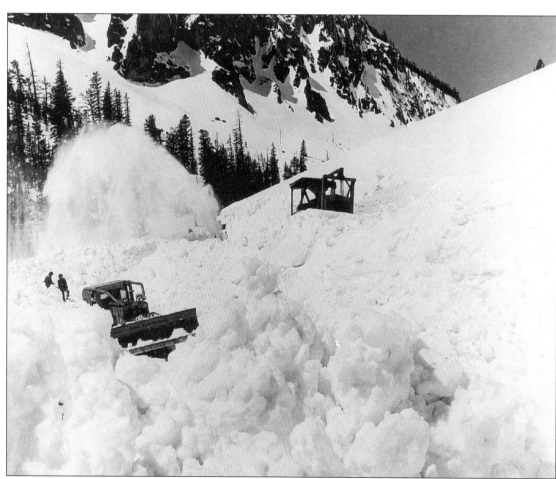

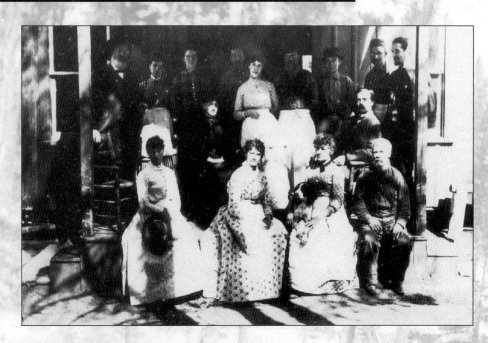

EMPLOYEES of the first Canyon Hotel, in 1886, the summer it opened. This hotel was located at the brink of Upper Falls, probably on the bench just west of the present parking lot, although some accounts place it a little farther east where the ranger station was later located. A narrow, one-story, frame structure, it replaced a tent camp that operated on the site from 1883 to 1886. The hotel was described in 1886 by visitor Catherine Bates as "a most primitive little house" where the food was "inedible." The one-story building housed an office, kitchen, and dining room; guests slept near the hotel in tents.

THE SECOND CANYON HOTEL, shown here in 1900, was first opened for the season of 1890. An unattractive, barnlike structure, it stood just above the site of the third Canyon Hotel and was incorporated into that later structure when Robert Reamer built it during the winter of 1910–1911.

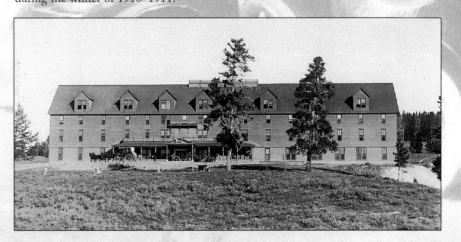

Canyon Lodge, shown about 1924, was located at the present Uncle Tom's parking area and was also known as Canyon Camp. It was a Shaw and Powell camp during the teens. New tent cabins were constructed in 1923–1924, and it got its main building in 1925. It lasted through the 1956 season; beginning in 1957, the facilities at Canyon were all at present Canyon Village.

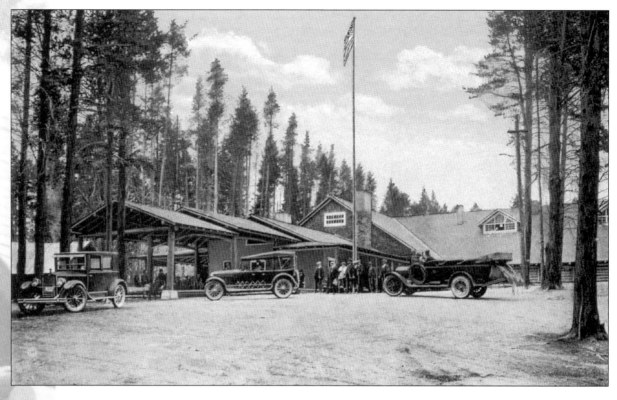

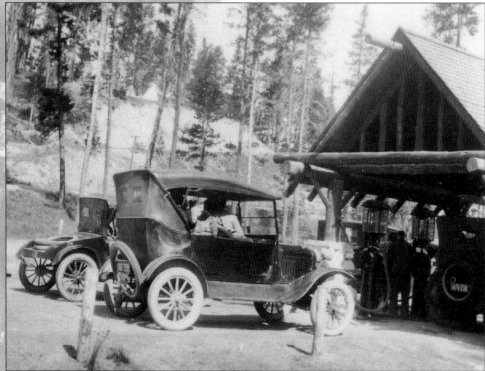

Canyon gas station 1920s, now the Brink-of-Upper-Falls Parking Area.

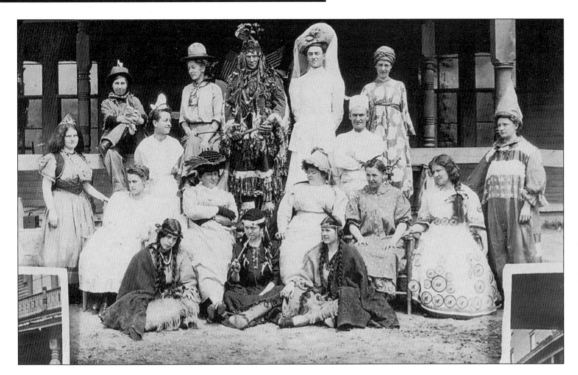

CANYON HOTEL employees during the summer of 1910, dressed to perform a costumed play for visitors.

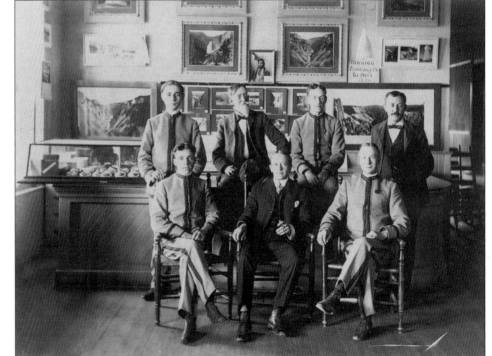

CANYON HOTEL porters and F. J. Haynes Picture Shop in the lobby of the second Canyon Hotel, in 1902. Note sign on wall reading Monida Passengers Report here. F. J. Haynes owned that transportation company as well.

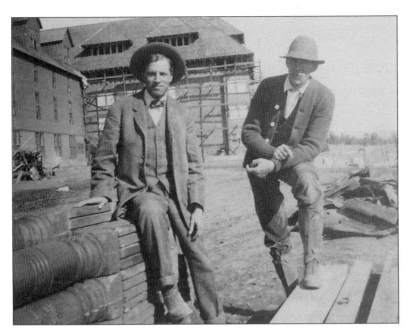

ROBERT REAMER (left) and his foreman, Mr. George, during the building of the Canyon Hotel, October 1910. The building of the third Canyon Hotel occurred during the winter of 1910–1911, and its builders simply incorporated the second Canyon Hotel into the third one. Robert Reamer was the architect of numerous buildings in Yellowstone, including the Old Faithful Inn, the Lake Hotel renovation, Lake Lodge, the Mammoth Hotel renovation, the Canyon Hotel, the North Entrance Arch, Gardiner's railroad depot, and Gardiner's W. A. Hall store, now Cecil's Restaurant.

THE THIRD CANYON HOTEL, completed in 1911, opened with a gala ball, was a mile in circumference and could house up to 900 guests. It took its water supply from a spring in the hills behind it, and it was the subject of a 1912 pamphlet by John Raftery entitled "A Miracle in Hotel Building." It served Yellowstone visitors through the summer of 1958. In 1959, it was sold to a wrecking company. The company was in the process of tearing the building down when it mysteriously caught fire and burned in August 1960.

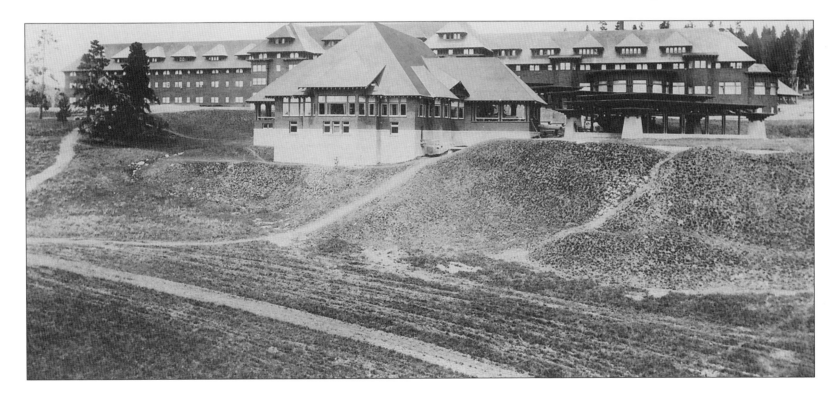

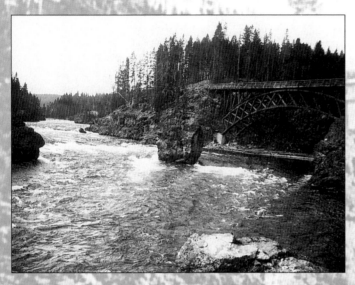

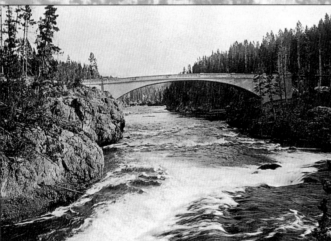

In 1903, THE RECENTLY completed bridge over the Yellowstone River just upstream from the Upper Falls was known as the Melan Arch, but later was named to honor Hiram Chittenden.

THE ORIGINAL BRIDGE over Jay Creek in the Canyon area, shown before 1914, was built between 1893 and 1895. This bridge was an unfortunate affair. The overseer in charge managed to spend more than half the park's annual appropriation on an over designed structure. In 1894, Acting Superintendent Anderson managed to get park road construction operation away from the overseer and completed the bridge by the end of the 1895 season. This bridge was replaced in 1914–1915 with a 210-foot long structure with a 145–foot arch. Originally a stagecoach and auto bridge, today it is for foot and bicycle traffic only.

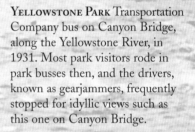

YELLOWSTONE PARK Transportation Company bus on Canyon Bridge, along the Yellowstone River, in 1931. Most park visitors rode in park busses then, and the drivers, known as gearjammers, frequently stopped for idyllic views such as this one on Canyon Bridge.

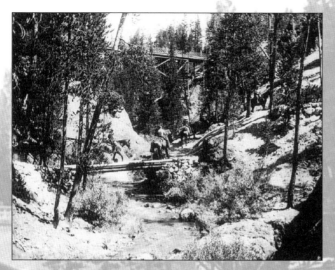

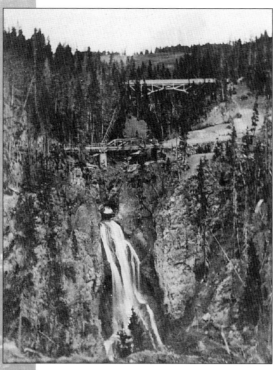

A RARE VIEW of the two bridges above Crystal Falls over Cascade Creek, 1910. The lower road and bridge were built by superintendent P. W. Norris in 1880, while the upper road and steel bridge were not built until 1903–1904. The upper bridge was 80 feet above the creek and was 223 feet long.

HORSE PARTY above Crystal Falls with Cascade Creek bridge above them, 1936.

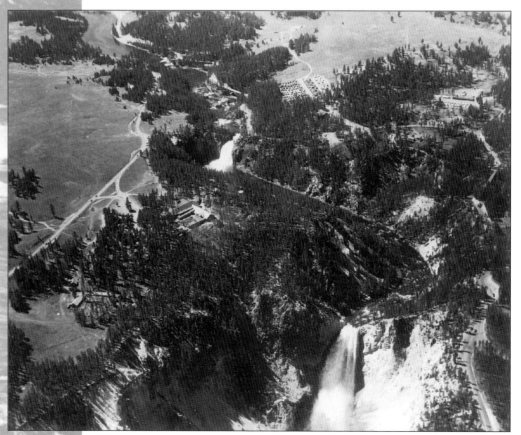

THIS 1942 AERIAL PHOTO of the Canyon area shows the development around the canyon prior to the present Canyon Village, which opened in 1959. The long buildings at the lower left are the Yellowstone Park Company horse barns; the large complex of buildings just below the Upper Falls is the Canyon Lodge and cabins; the Canyon Bridge is visible just above the Upper Falls; to the right of the Canyon Bridge is the tent-top cabin area, with various other visitor facilities to its right.

CANYON VILLAGE cabin maids, 1958.

CANYON VILLAGE employees in the cafeteria, 1958.

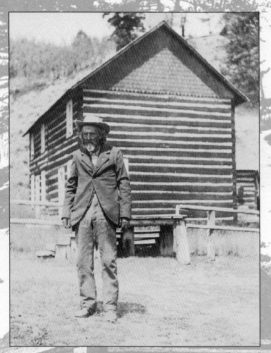

UNCLE JOHN YANCEY established a mail station in Pleasant Valley in 1882, and built his rustic hotel in 1884. His operation, shown here about 1900, included a saloon, barn, and stock shed. He shared the area with a stage station on the other side of the road. He catered to visitors traveling to and from Cooke City, and to a devoted cadre of fishermen who found his home-grown hospitality suitable to their needs. Yancey, described as a "goat-bearded, shrewd-eyed, lank, Uncle Sam type," lived in the establishment year-round until his death in 1903. His hotel was devised to his nephew who did not wish to run it. The establishment burned April 16, 1906, but remnants of it were in place until the 1960s.

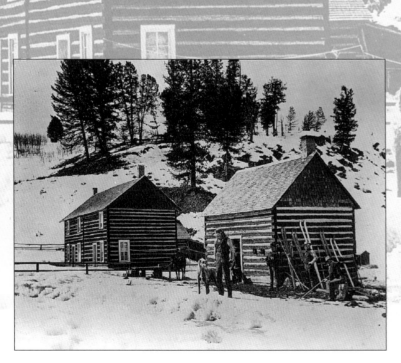

YANCEY AND HIS DOG stand in front of his saloon building some time before 1904. Note local men and their very long skis at right.

THE MONIDA AND YELLOWSTONE STAGE COMPANY erected this building in 1912 as a stage station, and photographer Jack Haynes took it over in 1917 to use as a picture shop. This was Haynes's first store at Tower, and a few years later, National Park Service Director Stephen Mather asked him to run a store "with brake bands and tires," in order to deal with the many auto maintenance problems cropping up from nearby Dunraven Pass. The store was remodeled and greatly enlarged in 1927–1928.

ROOSEVELT CAMP BATHHOUSE, 1917, near present Roosevelt Lodge. Park visitors bathed in Nymph Spring, the only real hot spring in the present Roosevelt Lodge area, from the earliest days of the park. This one-story log building was located near the main road at Roosevelt Lodge, probably near Nymph Spring. It, or a forerunner, was, built in 1906 by the Wylie Camping Company the first year they ran the Roosevelt Camp. A 1907 Wylie brochure advertised "hot sulphur baths" at Roosevelt Camp. In 1926, a second log building was built nearby. It is not known when the buildings were removed, but it probably occurred in the 1930s.

THE NATIONAL PARK SERVICE'S first director, Stephen P. Mather, at Camp Roosevelt in 1923, three years after the building that is now known as Roosevelt Lodge was built. Though local folklore long presumed that Theodore Roosevelt camped on this spot, his nearest camp during his famous 1903 visit was closer to Tower Fall, about two miles southeast of here.

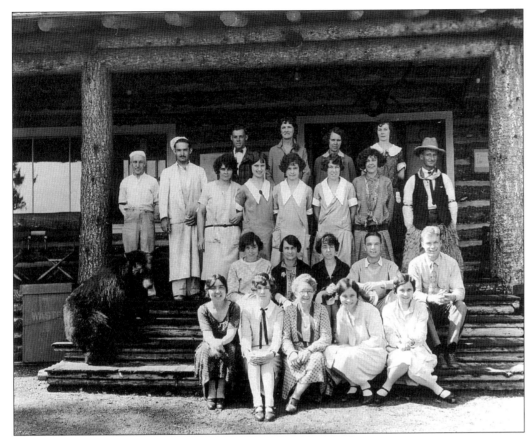

ROOSEVELT LODGE STAFF, 1927, with black bear. The only person identified is the manager of the Lodge that year; she is Isabel Nauerth, second from left in the second row from the bottom. She married Jack Haynes in 1931, and became a historic figure in Yellowstone circles over the next half century.

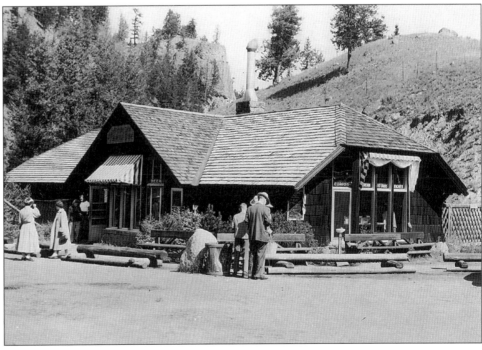

VISITORS AT JACK HAYNES'S picture shop at Tower Fall, 1920s.

Z. R. "RED" SIWASH's Round Prairie Saloon, shown here in 1884, was located near the Cooke City road in the meadow known as Round Prairie. This saloon served miners traveling back and forth from Cooke City to Mammoth Hot Springs. Siwash claimed it was outside of park boundaries, but in 1886, the army discovered otherwise, and in 1887 the building was removed. Siwash, who appears as "Sowash" in army documents, applied for a lease in the park but was turned down by Acting Superintendent Moses Harris, who noted, "he does not keep such a public house as would be creditable to the National Park . . . Mr. Sowash's place is nothing more than a liquor saloon."

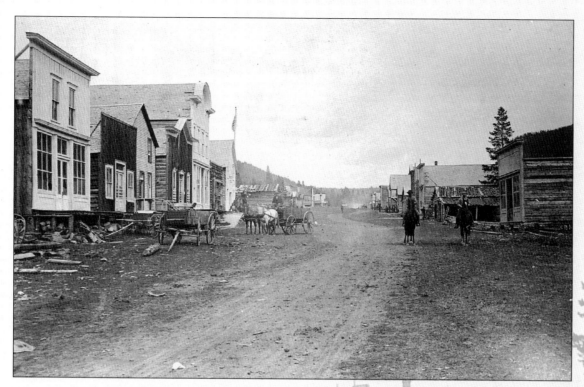

EARLY FREIGHTER and his wagon on Cooke City's main street sometime before 1900.

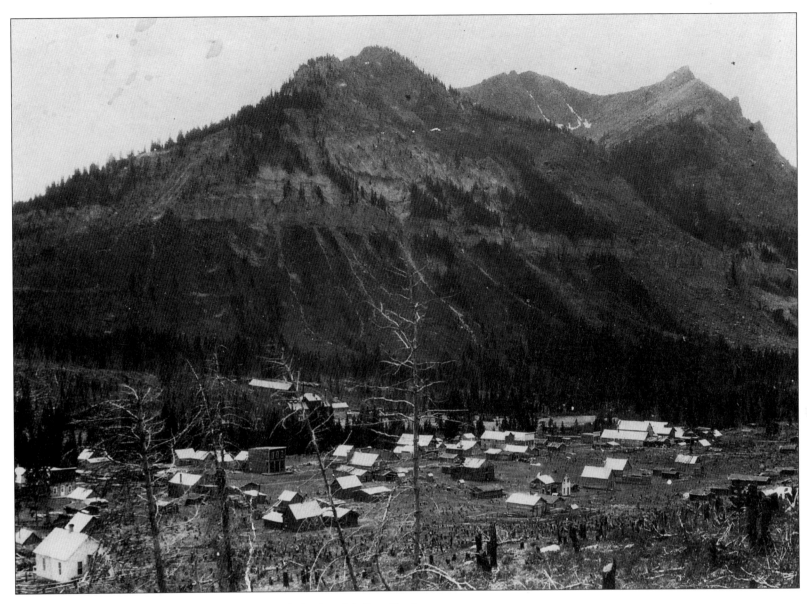

COOKE CITY, Montana before 1900. Cooke City is the only community in the Yellowstone National Park area that is older than the park—that is, if one considers four men with picks and shovels to be a "town." Cooke City began in 1870 when Adam Horn Miller, James Gourley, Ed Hibbard, and A. Bart Henderson made the first gold strike there. The mountain shown in this photo was later named Republic Mountain, probably for the Republic Mining Company. Notice in the foreground how early town residents cleared the forest for building materials and firewood.

America at Play

WHETHER IN CAMP, IN A RUSTIC HOTEL LOBBY,

ALONG THE BOARDWALKS OF A GEYSER BASIN,

RIDING DOWN A BRIDLE PATH,

KNEE-DEEP IN A TROUT STREAM,

OR HIKING DEEP INTO THE PARK'S WILDEST CORNERS,

YELLOWSTONE HAS RARELY FAILED TO

LIVE UP TO ITS REPUTATION.

America at Play

Year after year, visitors have come in growing numbers to enjoy the wonders of Yellowstone. The first adventurous souls devoted half a summer to the long wagon trip from some distant western town, around the park, and then home. The arrival of the railroad with its organized tour groups in the 1880s made the park a popular and convenient destination; long lines of stagecoaches met the trains and hurried the visitors off to the park's growing number of comfortable hotels. And the admission of automobiles in 1915 made Yellowstone travelers as independent as cars had made Americans everywhere, signalling a major change in visitor travel patterns.

Yellowstone's transportation companies raised the stagecoach trip nearly to an art form, taking what had for many years been a basic and mundane means of conveyance and transforming it into an important and unforgettable part of the park experience. Just as the stagecoach was becoming unnecessary and anachronistic on many of the nation's roads, it found a new home in Yellowstone, where people could relive an earlier West courtesy of the park tour. The stagecoach drivers themselves became celebrated Yellowstone attractions, wrestling the reins of their big teams while spinning tales of the park's old days; before the arrival of rangers, the drivers may have been the most romantic characters in the public image of Yellowstone.

And in the first few years after 1915, when technology finally caught up with Yellowstone and the automobile was finally admitted after years of resistance by park managers who wanted no part of the twentieth century's internal combustion obsessions, the stagecoaches were replaced by tall, open busses that seem to us today only slightly less colorful and historic than the stagecoaches. And again, the drivers and commentators on the busses became an essential element of a park visit for all who rode with them. As famous as Yellowstone's rangers are, it is probably true that concessionaire employees, including bus drivers, tour guides, and many others, have provided advice and assistance to more visitors over the years, and have done so with an unsurpassed style and devotion to the park.

But eventually, of course, it was the car that dominated Yellowstone's roads. Generation after generation of Americans have conducted their exploration of the park in the family automobile, from the first Model T allowed to enter the park in 1915 to the most sophisticated modern recreational vehicle bristling with a satellite dish, lawn furniture, and trail bikes.

What a time we've had when we stepped from those cars. Whether in camp, in a rustic hotel lobby, along the boardwalks of a geyser basin, riding down a bridle path, knee-deep in a trout stream, or hiking deep into the park's wildest corners, Yellowstone has rarely failed to live up to its reputation. Everyone, from the anonymous traveler to the world's great notables trailing an entourage of assistants and media, seems to take the place personally, abandoning their social or political status for a moment to reach into Yellowstone's heart for something of meaning to them.

And it is here, in the personal experience of the park, that the changes in Yellowstone are most felt. Where once roadside bears were nearly pets, gobbling junk food and posing for millions of pictures, they are now only occasionally glimpsed wonders of the Yellowstone wilderness; the bears are still there, and quite numerous, but you earn your sighting, as you must earn anything worth having. Where once winter was a time of forbidding harshness, and when the public was actively advised against getting anywhere near the park, it is now recognized for its breathtaking beauty and is attracting more people each year. The park in winter, once the realm only of a few sturdy locals and the occasional ranger patrol, is now another destination for Americans. The Yellowstone experience has come a long way.

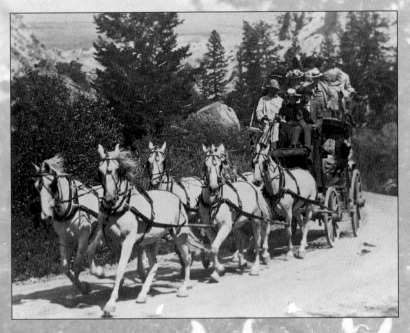

STAGECOACH DRIVER JOHNNY McPHERSON drives a six-horse stage above Eagle Nest Rock, in the Gardner Canyon. The original caption for this photo stated that the stage was a Shaw and Powell rig. If that is so, the date of the photo has to be between 1898 and 1916, the dates that company existed.

WYLIE TENT CAMP, Swan Lake Flats, a few miles south of Mammoth Hot Springs, and early camping party sometime between 1906 and 1916. The Wylie Camp at Swan Lake Flats was opened in 1906, having been moved north from a mosquito-ridden location at Apollinaris Spring. It closed in 1917 when the park bus fleet was acquired and horse-drawn coaches were no longer used. There appears to be an independent camping party passing in front of the Wylie camp.

PRIOR TO 1938, the main road between Old Faithful and West Thumb ran through Spring Creek Canyon. This 1912 photograph shows that the road was narrow and curvy as it followed Spring Creek at creek level. In 1908, a road bandit robbed seventeen successive stagecoaches and 174 passengers of about $2,000 at Turtle Rock in the canyon.

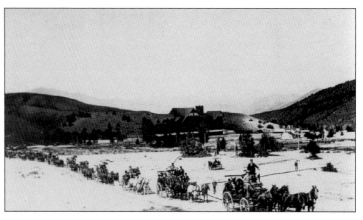

STAGECOACHES LEAVING National Hotel, 1896. Parades of stagecoach visitors began touring from this hotel in 1883, even though it was only partly finished. Coaches usually traveled at least two hundred feet apart in order to allow dust to settle, and many passengers wore linen dusters to protect their clothing. The number of stage drivers employed by the companies ranged from 150 to 250 depending on the year. The stage drivers were the highest paid and most elite of park employees until the park fleet was motorized in 1917 and rangers arrived.

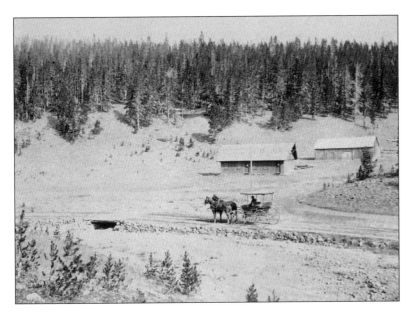

TWO-HORSE CARRIAGE and U.S. Engineer buildings at Dry Creek road camp, between Old Faithful and West Thumb, September 1912. Road camps such as this housed park workers and supplies at locations all over the park; the arrival of cars and trucks allowed these work forces to be centralized.

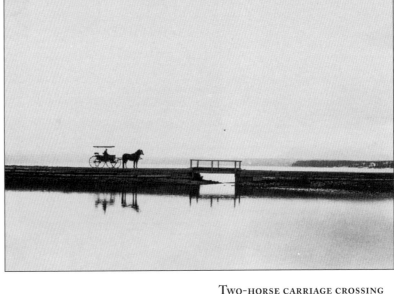

TWO-HORSE CARRIAGE CROSSING the natural, wave-formed sandbar at Arnica Creek, about 1903. For a brief time between 1897 and 1904 the main road used this sandbar as its roadbed, which was corduroyed by laying logs or planks down to make travel easier. It was probably this early use that was responsible for the name given by later rangers to the area: "hard road to travel." That old plank-road on the sandbar remained in use by fishermen until World War II. Historian Aubrey Haines remembers pulling cars from the sand in the 1940s.

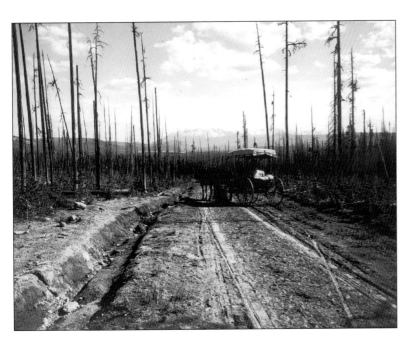

AS THIS 1905 PHOTOGRAPH along the south entrance road shows, forest fires are nothing new to Yellowstone. Lightning-caused fires, considered natural in the park, have burned in Yellowstone for thousands of years. Dozens of diaries of early park visitors mention many old forest-fire burns.

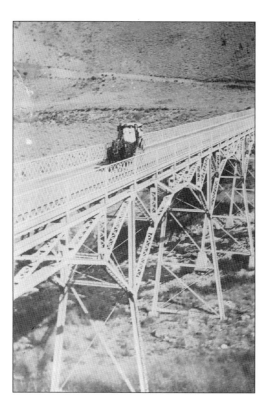

SHEEPEATER CANYON BRIDGE,
1909. The North Entrance–Cooke
City road is the park's earliest road,
and the first bridge utilized long,
dangerous switchbacks. The pic-
ture shows the renovated bridge a
few years after Hiram Chittenden
built it in 1903–1904, a renovation
that eliminated the switchbacks.

SHEEPEATER CANYON BRIDGE,
shown here during the 1920s, was
replaced in 1939 by the present
higher bridge at a location down-
stream and using a more easterly
road alignment.

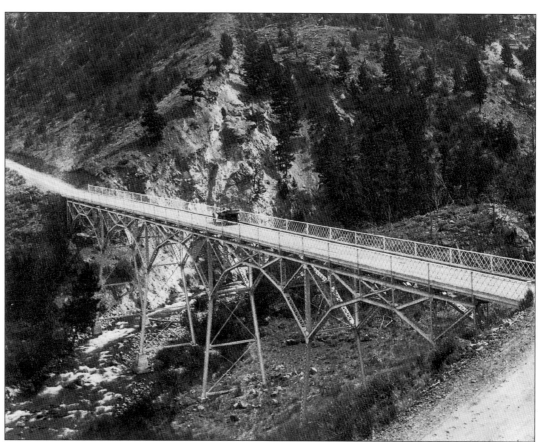

YELLOWSTONE'S MOST ROMANTIC characters: Tallyho stagedrivers from Yellowstone, 1909. These men drove the large, six-horse, thirty-two-passenger, Tallyho stagecoaches that transported park visitors from the railhead at Cinnabar or Gardiner to the National Hotel at Mammoth. Early concessionaire Jack Haynes wrote that the first two Tallyhoes arrived in 1897, but an 1891 Haynes book shows one in service that year. Photographed at a building near the Gardiner depot, drivers are (left to right): Jack "Johnny" McPherson, John "Daddy" Rash, Al McLaughlin, Harry Lloyd, and Wallie Walker. At least seven other men of this elite cadre are known to have driven the Tallyhoes and, with these five, spent most of their lives in Yellowstone. Several are buried in the Gardiner cemetery.

YELLOWSTONE-WESTERN STAGE Company drivers, 1914. Park photographer Frank J. Haynes established the Monida and Yellowstone Stage Company in 1898. In 1913, its name was changed to the Yellowstone-Western Stage Company, and it continued to run in the park through 1916. The only identified drivers are: J. C. Skidmore (bottom row center, with mustache); Hurless (at right of whip tree, wearing a transportation agent's uniform); Walt Wolf (at Hurless's left and below him, sitting); Ira Keims (third row from bottom, at far right with white mustache); Hughie Shears (top row, second from right); Frank Crookston (top row, fourth from right).

IN 1883 when the first train passengers came to Yellowstone via Cinnabar, James A. Clark was permitted to build a small cottage at Mammoth, and he drifted into the business of transporting and guiding tourists through the park. In 1885, he received a lease for a "hotel and outbuildings," and that is probably when he built this building, shown here 1885–1888, later the site of Jack Haynes's house. Clark built no separate hotel but probably lodged visitors in tents nearby. An 1885 article in the *Livingston Enterprise* stated: "Clark's Town is at the foot of Capitol Hill, and contains five houses and a number of tents." Clark sold out in 1888 to the Yellowstone Park Association, that used his barn for their horses.

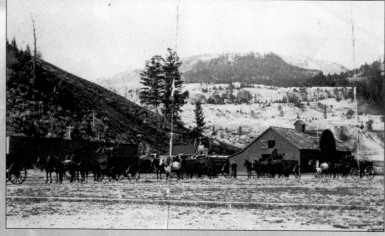

STAGEDRIVERS from Yellowstone, 1907. These drivers posed for a photo together not wearing their uniforms. They are: (front row) Tim Conners, Tim Connel, Frank Davis; (second row) Sid Schultz, Bill Phillips, Al Milliam; (Top row) Harry Lloyd, "Red" Mike, Walter Hicks, H. McInnary, Ab Decker (or Deckard).

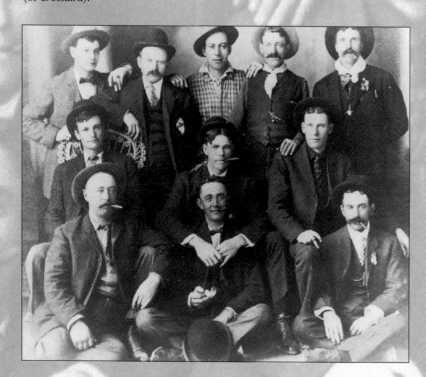

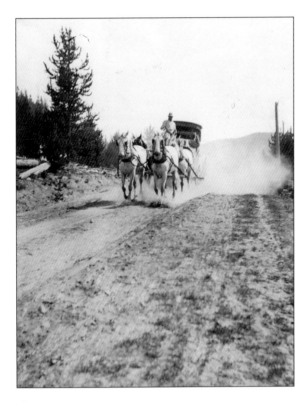

As this 1907 photo shows, even after regular sprinkling of park roads began in 1901, dust on park roads was frightful. Dust was ankle-deep in places and was the subject of countless complaints. Said park tour guide G. L. Henderson in 1890: "When… all the freight wagons and heavy Concord coaches are constantly passing over the roads, deep ruts are made by numberless wheels, and vast clouds of dust rise and hang suspended in the air when there are no breezes; and when the wind blows you either ride in your own dust and in that of the carriages ahead, or if a head wind, the dust is driven into your face with a force that blinds and maddens you."

STAGECOACH WASHING FACILITY at Mammoth, date unknown. The drivers had to take care of their rigs when away from Mammoth. Mammoth also had a vehicle paint shop, repair shop, and blacksmith shop.

REFILLING A SPRINKLING WAGON during the stagecoach days. A large fleet of tank wagons was kept busy wetting down park roads.

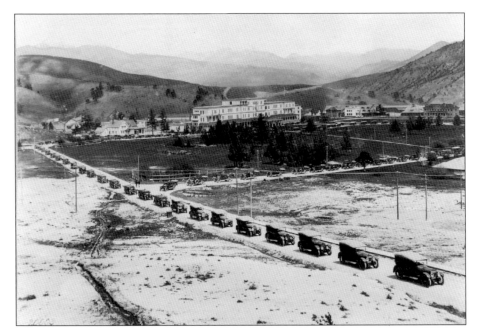

THE ARRIVAL OF THE BUS FLEET in 1917 was a milestone in Yellowstone history, signalling a whole new park experience and the abandonment of one of the most distinctive Old West elements of the Yellowstone tour. The YPT Company's fleet of 1917-model White buses, then numbering 116 or 117 vehicles, was lined up in the fall of 1920 for this picture by Jack Haynes. The seven-passenger busses can be seen at the front of the line, while the other one-hundred busses were eleven-passenger vehicles.

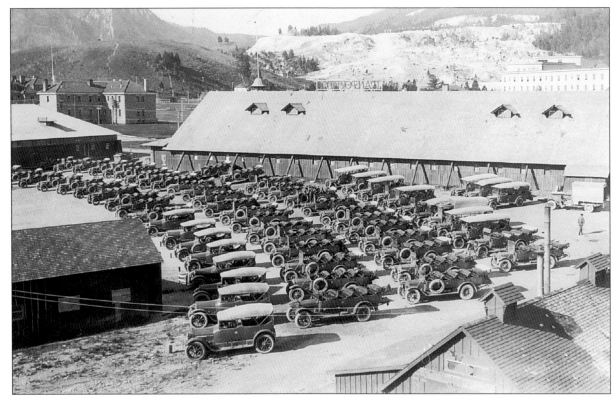

THE YPT BUS FLEET, 1920. New busses arrived in the park in 1924, and in early 1925, the company's fleet also included several fancy Lincoln touring cars.

GROUP OF NEW BUSSES, just purchased in 1924, is looked over by YPT Company officials F. E. Kammermeyer (director of transportation) and W. N. Nichols (company president).

UNION PACIFIC RAILROAD "official car" (YPT bus number 316) at Mammoth Hotel, probably in 1925. Bus 316 was one of the White Motor Company series B-5 ten-passenger vehicles, purchased in 1925 by the YPT Company.

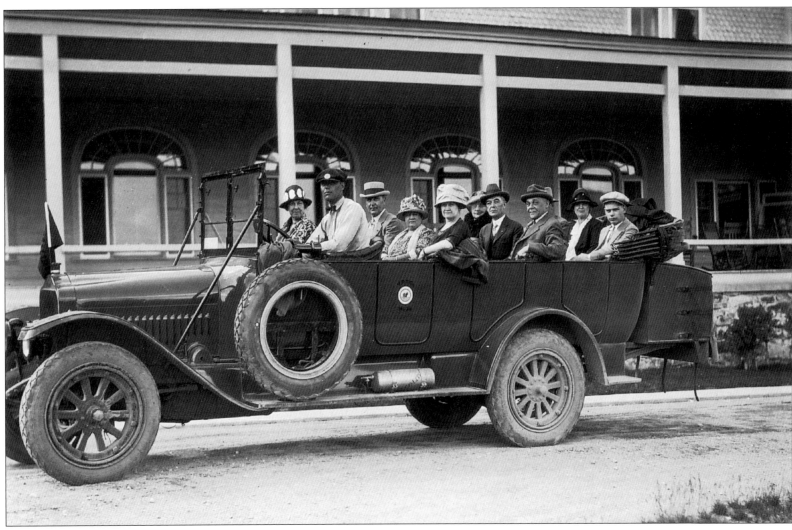

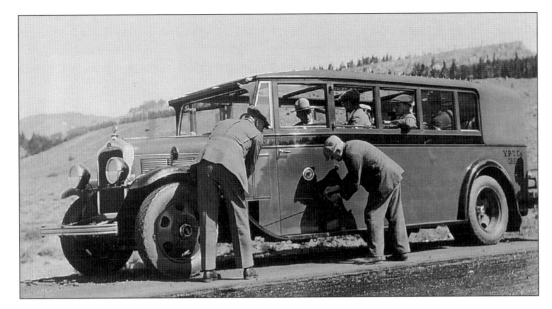

NEW YPT COMPANY BUS, 1930, on a demo run. Former driver L. Merlin Norris remembers that two of these busses, larger than the 1917 and 1924 models, came to the park in 1930 to test whether or not they could serve on Yellowstone's unusual road system.

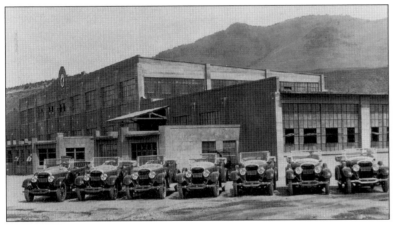

YELLOWSTONE PARK Transportation Company garage and the fleet's seven Lincoln touring cars in 1926. After the disastrous Mammoth fire in March 1925 that destroyed seventy-five busses and eighteen other cars, the YPT Company moved to these buildings at Gardiner. The Lincolns were used for VIP groups, in the same way that a limousine was used in the 1960s and early 1970s.

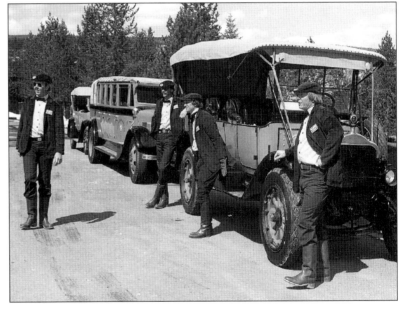

T.W. RECREATIONAL SERVICES, the current hotel and transportation concession, outfitted several of its most experienced drivers in period bus-driver costumes so that they could drive the company's historic vehicles during special events, like this 1981 occasion. Left to right: Leslie J. Quinn, Steve Blakeley, Herb Vaughan, and Larry Crowe.

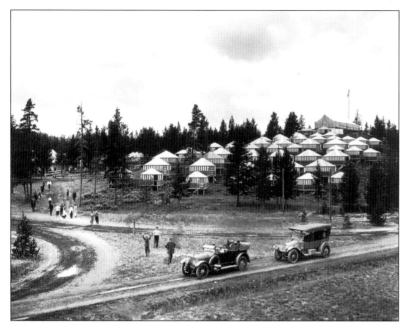

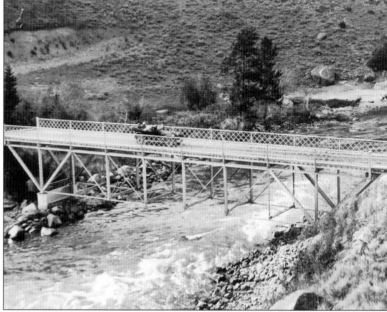

A GREAT DAY FOR AMERICAN motorists: the arrival of the first automobile at Old Faithful on August 15, 1915. The photo was taken at the Old Faithful Wylie Camp on Wylie Hill, just west of present Grotto Geyser.

TOURING CAR CROSSING the bridge over Yellowstone River near Tower Junction, 1917. The present bridge was built in the early 1960s and is slightly south of this one.

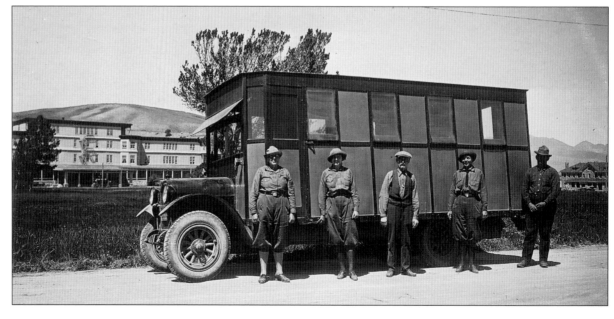

VISITORS IN FRONT OF MAMMOTH Hot Springs Hotel with an early recreational vehicle, 1924.

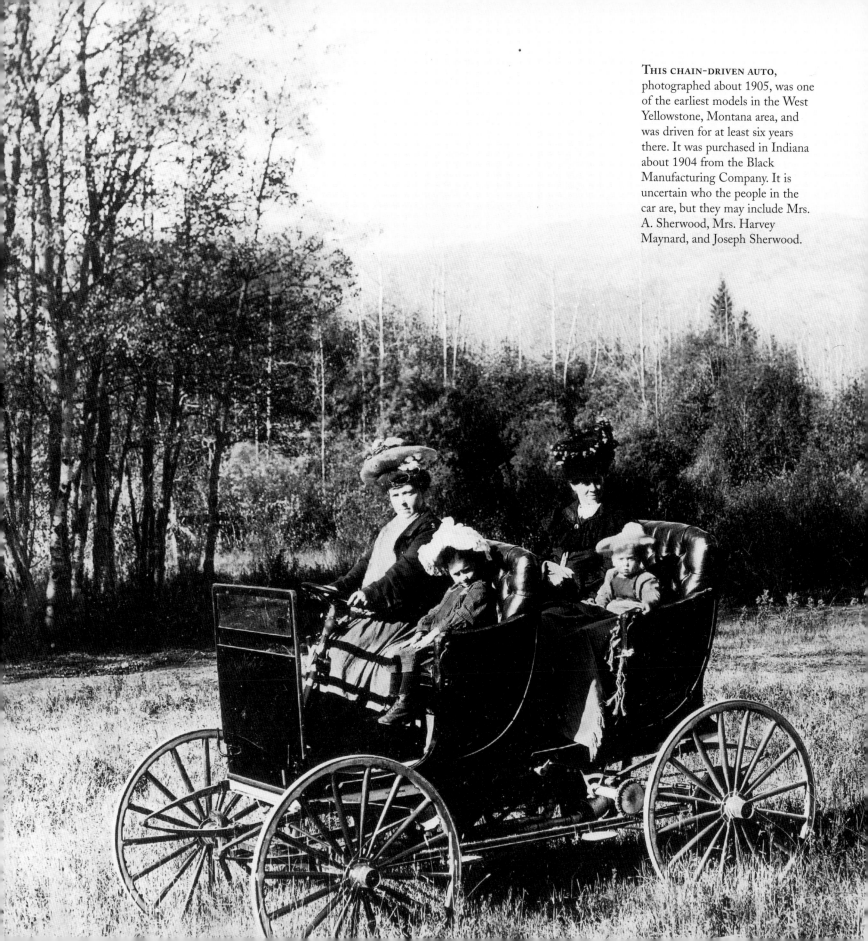

THIS CHAIN-DRIVEN AUTO, photographed about 1905, was one of the earliest models in the West Yellowstone, Montana area, and was driven for at least six years there. It was purchased in Indiana about 1904 from the Black Manufacturing Company. It is uncertain who the people in the car are, but they may include Mrs. A. Sherwood, Mrs. Harvey Maynard, and Joseph Sherwood.

VISITORS VIEWING buffalo, probably in the 1920s, near Mammoth Hot Springs. By the 1890s, Yellowstone's bison herd had been reduced to fewer than fifty animals. In 1902, C. J. "Buffalo" Jones was hired to manage the herd. Bison were brought in from Texas and Montana and bred with park bison in a fenced pasture at Mammoth. A house and corral were built at this location south of Mammoth for Mr. Jones in 1902. After Jones left the park in 1905, the managed herd remained at Mammoth for two years. The entire herd was moved to Lamar in 1907, but in 1909 fourteen animals were moved back to Mammoth to become the Show Herd. Thereafter for many years, a group of buffalo was brought to the Mammoth pens in summer in order that park visitors could view them. A small museum about bison was established in Jones's old house in 1925 but lasted only until 1929. Buffalo in Yellowstone were referred to as the Wild Herd, ones that were truly wild, the Tame Herd or Fenced Herd, the managed ones at Lamar, and the Show Herd, the ones brought to Mammoth each summer.

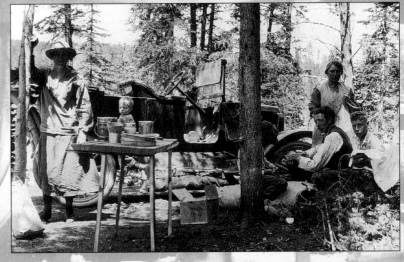

AUTO CAMPERS IN THE PARK, 1921, location unknown.

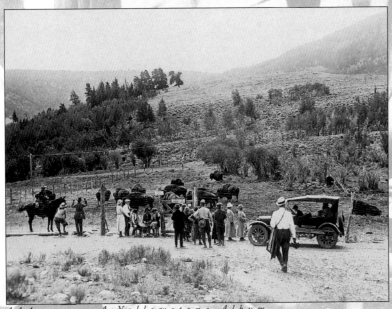

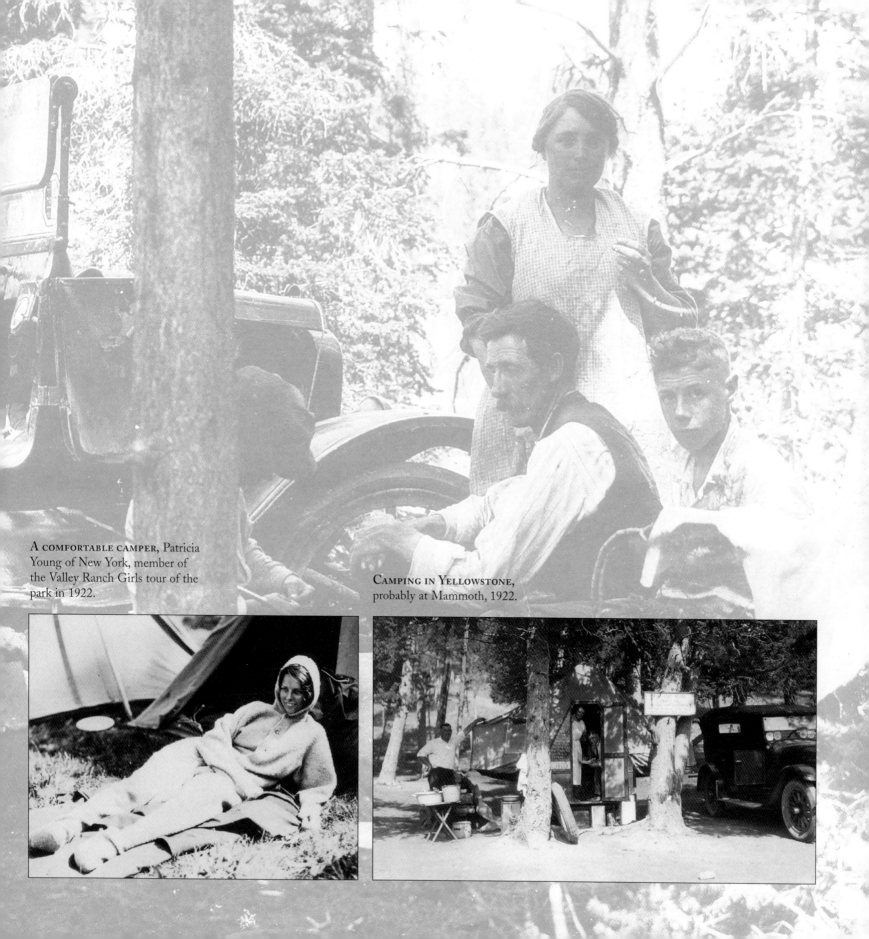

A COMFORTABLE CAMPER, Patricia
Young of New York, member of
the Valley Ranch Girls tour of the
park in 1922.

CAMPING IN YELLOWSTONE,
probably at Mammoth, 1922.

FIRST AUTO IN THE PARK, 1902. Pictured here is Henry G. Merry, superintendent of the Montana Coal and Coke Company, in the 1897 Winton that he illegally drove to Mammoth Hot Springs in June of 1902. The army escorted Mr. Merry out of the park and admonished him not to do it again, but first Merry had to take Acting Superintendent John Pitcher for a ride in the backfiring, newfangled contraption.

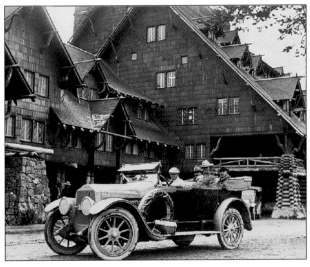

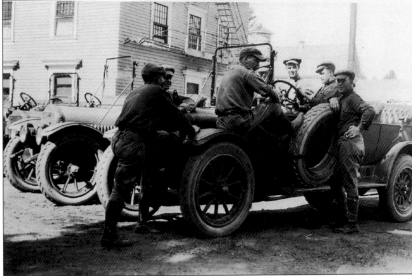

YPT COMPANY BUSDRIVERS, called gearjammers, at the transportation facilities behind Lake Hotel, about 1920. The tall "boots" they wore were not really boots but rather leather coverings called "puttees."

IN 1915, the National Park Service, under pressure from various auto clubs, made a feasibility study of cars traveling in the park. This car, at the Old Faithful Inn, was used in that study. Among others it carried Acting Superintendent Lloyd Brett (tallest man, in white campaign hat). Others involved in the study were Amos G. Batchelder of the American Automobile Association and Robert Marshall of the U.S. Geological Survey. To no one's surprise, the National Park Service and the AAA reported in favor of the automobile. The first auto was allowed into the park July 31, 1915, and the last horse-drawn vehicles were used in 1917.

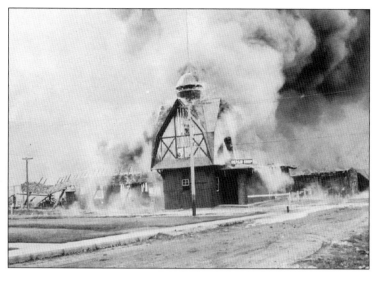

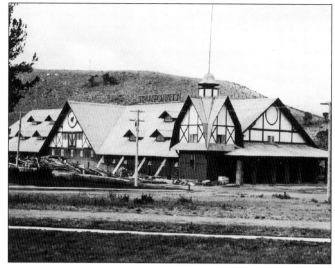

THE YPT COMPANY transportation building during a catastrophic fire on March 30, 1925. The fire began at about 2:15 P.M. and was caused by a defective oil burner spurting oil that was ignited by a nearby forge. The fire destroyed the building and ninety-three vehicles.

YPT COMPANY BUILDING at Mammoth, 1917. Architect Robert Reamer designed this building to hold the company's offices, horses, and stagecoaches and it was erected in 1903–1904. Visitor Alfred Richardson said of it in 1904: "[There is] a new barn of the Transportation Company, at the Springs, a building whose architect seems to have been inspired by recollections of the Grand Canyon in his ideas of dimension and coloring. It is quite a large barn, painted exteriorly with a number of substantial colors, among which yellow, blue, green, white and black perhaps predominate."

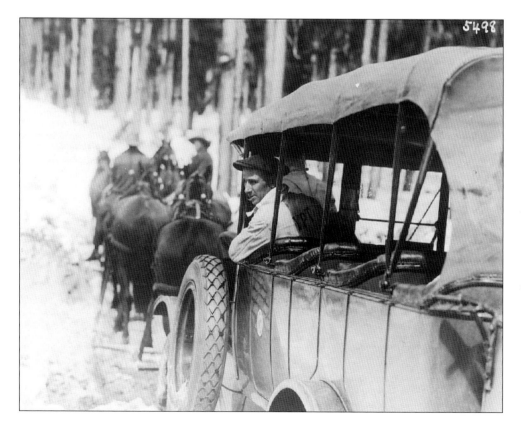

PULLING A YELLOWSTONE PARK Transportation Company bus through snow with horses, near the south entrance, 1927. Although the park was motorized between 1915 and 1917, horses continued to be used to do heavy work into the 1920s.

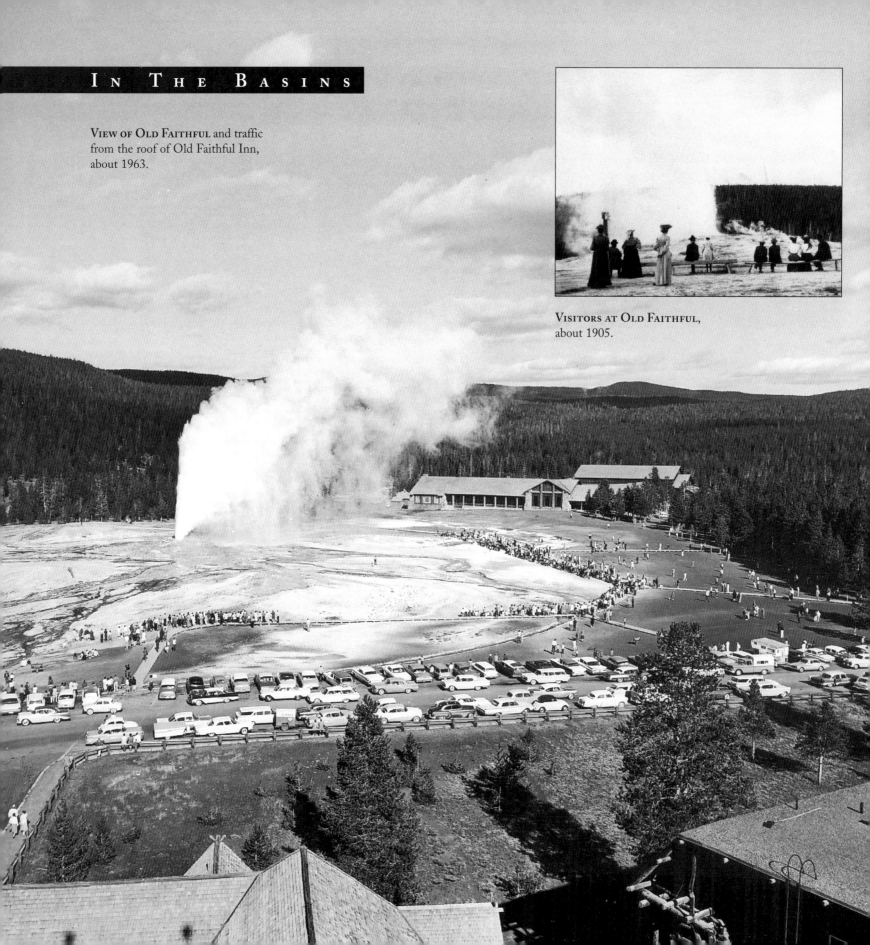

VIEW OF OLD FAITHFUL and traffic from the roof of Old Faithful Inn, about 1963.

VISITORS AT OLD FAITHFUL, about 1905.

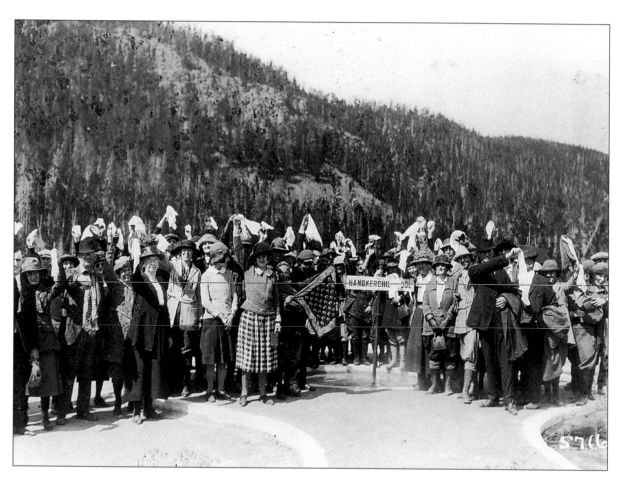

CROWD AT HANDKERCHIEF POOL, 1922. After Old Faithful Geyser, Morning Glory Pool, and Emerald Pool, Handkerchief Pool was arguably the fourth most famous hot spring in Yellowstone Park from 1888 to 1926. Handkerchief Pool was known for being the spot where one could watch one's handkerchief be sucked down and then spit back up. The subject of a 1913 study in *Science* magazine, Handkerchief Pool is no longer accessible to visitors, because such abuse of springs usually destroys them.

VISITORS AT CLIFF GEYSER, Black Sand Basin, 1895. A foot-bridge that once connected Ragged Spring with Cliff Geyser allowed visitors access to Cliff Geyser during the 1890s. Although "Haynes Guides" of the era claimed 100-foot-high eruptions for Cliff Geyser, other evidence makes it likely that Cliff seldom had eruptions that large and that the 100 feet referred to nearby Rainbow Pool.

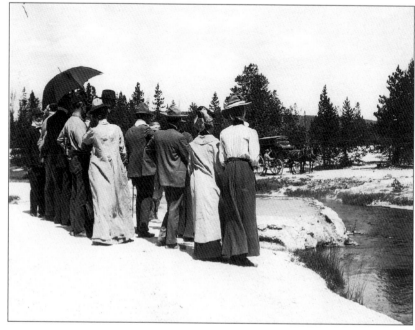

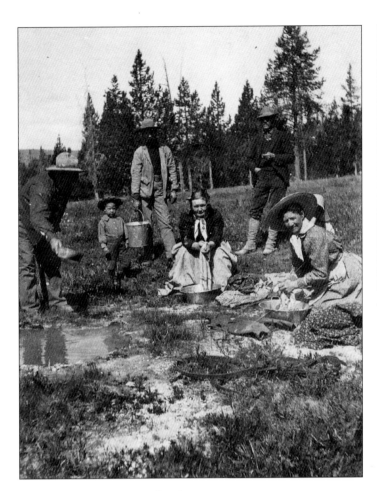

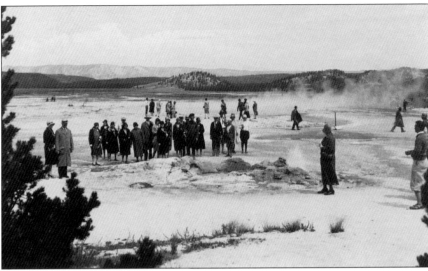

TOURIST PARTY watching Jet Geyser, 1930.

"THE LAUNDRY AT NORRIS" is the caption of this photo in the park collection. It depicts what appears to be a family of campers, called sagebrushers during stagecoach days, doing their laundry in a hot spring around 1905. Use of thermal springs to do laundry and to cook was widespread before World War I.

VISITORS SUSAN (left) and B. J. Earle drink from Apollinaris Spring, 1966. In the early 1980s, the National Park Service decided the spring did not comply with drinking-water standards and removed the pipes.

THREE 1912 VISITORS to Mammoth stand in front of a very active Hymen Terrace that is much taller than today's nearly-dormant formation.

APOLLINARIS SPRING, late 1920s. In 1925, Apollinaris Spring was built in with travertine blocks for flagstones. This photo shows visitors there about 1927.

CAMP EMPLOYEES rehearse for a play, 1926. Sometime in the 1890s, the Wylie Camping Company began the tradition of having their employees perform songs, dances, skits, and readings for park visitors. When the several camping companies were merged in 1917, the new concessionaire, Yellowstone Park Camps/Camping Company continued the custom of having employees put on entertainment for guests, a tradition that continued until World War II. Some vestiges of the practice remained into the 1950s, but died in the 1960s. Here "camps" employees rehearse for a 1926 play at Apollinaris Spring. In the 1920s, nature pageants portraying woodland nymphs and spirits were popular in national parks, and that is probably what is happening here.

TOURISTS ENTER DEVIL'S KITCHEN cave, about 1897. Tours of this cave were conducted from 1884 until 1939, when the cave was closed due to lethal gas concentrations in it.

IN 1924, store owners Anna Pryor and Elizabeth Trischman erected a snack shop on the upper Terraces near the cave known as the Devil's Kitchen. They styled their new enterprise, shown here in 1929, the Devil's Kitchenette. It was a short-lived business that lasted only through the mid-1930s.

A WINTER VISITOR to Devil's Kitchen, February, 1933. Judging from the presence of both skis and snowshoes, at least one other visitor has already climbed down the ladder into the cave.

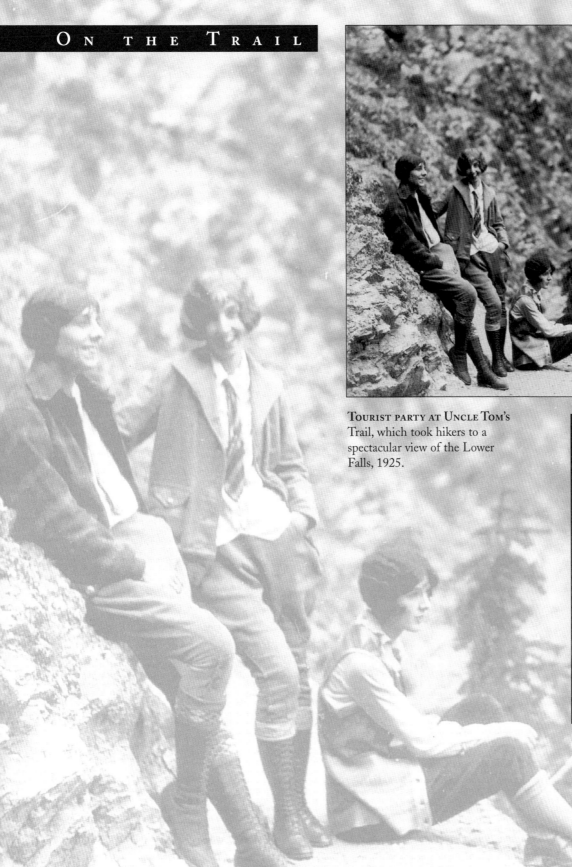

Tourist party at Uncle Tom's Trail, which took hikers to a spectacular view of the Lower Falls, 1925.

Tourists at North Entrance Arch entering park on horseback, about 1919.

THREE TOURISTS on horseback, 1910.

HOWARD EATON, shown here about 1900, was a celebrated horse guide and outfitter in Yellowstone and Glacier National Parks for nearly forty years, from the mid-1880s until his death in 1922.

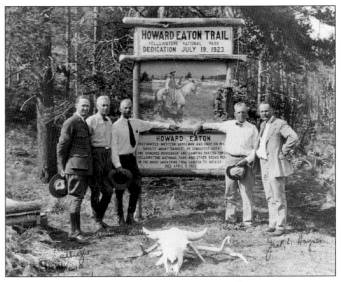

OUTFITTER HOWARD EATON and his tough riders, August, 1899.

DEDICATION of Howard Eaton Trail at Sheepeater Cliff, July 19, 1923. After Eaton's death in 1922, the park's loop-trail system was christened the Howard Eaton Trail and dedicated to him in special ceremonies attended by several hundred people. Sheepeater Cliff was selected because it had been Eaton's first campsite each year. Left to right are: Horace Albright (park superintendent); Stephen Mather (director, National Park Service); the two brothers of Howard Eaton; and Jack E. Haynes (park photographer).

THREE TOURISTS at Lake Hotel exhibit a catch of trout, about 1900.

LAKE HOTEL EMPLOYEES, 1901, exhibit a typical day's catch of fish when the fish populations seemed unlimited. By the 1920s, such excessive kills were affecting the quality of the fishing, and by the 1960s the cutthroat trout population of Yellowstone collapsed under the fishing pressure, only to be restored by restrictive regulations in the 1960s and 1970s.

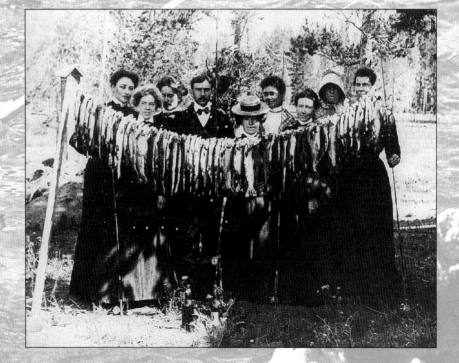

AN MODERN ANGLER lands a trout on Firehole River, one of the world's most famous trout streams.

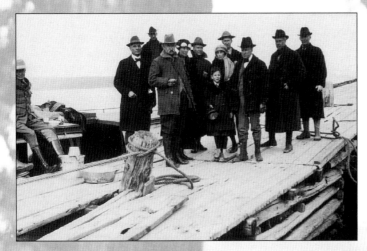

SECRETARY OF THE INTERIOR Albert Fall's party at West Thumb boat dock with Horace Albright (back center, in ranger hat) and Stephen Mather (second from right). Legendary ranger Harry Trischman is at far left. Fall (fourth from left), later convicted in the Teapot Dome Scandal, visited the park in 1921. As secretary, Fall was in a position to aid or harm the new National Park Service and the whole national park movement, and he nearly did do permanent harm to Yellowstone by advocating the Walsh Bill of 1922, which would have allowed the damming of Yellowstone Lake. He called park defenders "meddlers interfering with the sworn duty of the Secretary of the Interior." Albright had a difficult job in protecting Yellowstone while not offending his boss.

DAN BEARD and Secretary of Interior Albert Fall at Buffalo Ranch, 1923. Beard is best known as a founder of the Boy Scouts of America in 1910.

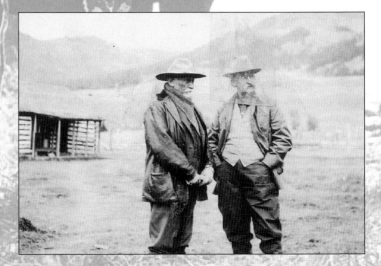

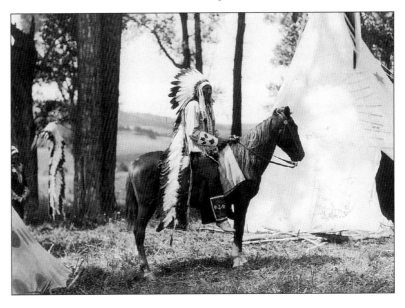

CROW CHIEF PACKS the Hat, 1925, at Lamar Valley. Packs the Hat was a friend of Superintendent Horace Albright's during the 1920s and was sometimes asked to appear at park functions. Born in the late 1850s, he lived and died near Lodgegrass, Montana until his death in 1928, where his descendants still reside. A brother of the more famous White Man Runs Him, Packs's Crow name was E-Cupe-Pa-Cheesh, which means packs the hat.

GOVERNOR NELLIE TAYLOE ROSS of Wyoming, Ranger Freida Nelson, and Superintendent Horace Albright at the west entrance, 1925. The park entertained a conference of state governors in 1925, including Ross, the first elected woman governor in the nation. Ranger naturalist Freida Nelson worked for the park in 1925 and 1926, one of ten women rangers who served Yellowstone between 1919 and 1929.

TOM MIX was a star of many silent Hollywood Westerns by the time this photo was taken in 1926. He was basking in the fame of his role in Lewis Seiler's *The Great K&A Train Robbery*, and he laughs it up on a trip to Yellowstone with the Shriners' imperial potentate.

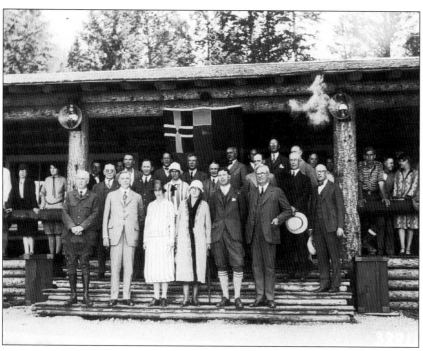

ROYAL PARTY at Camp Roosevelt, 1926. Crown Prince Gustavus Adolphus of Sweden visited Yellowstone in 1926 in company with numerous dignitaries. His presence may have resulted in the naming of King Geyser at West Thumb Geyser Basin. The photo includes National Park Service Director Stephen Mather (front left), Superintendent Horace Albright (second row, second from left), and the prince (first row, second from right in tall socks).

WILLIAM ADAMS, a well-known conservationist, and family at Horn House, Mammoth Hot Springs, about 1930.

PRESIDENT THEODORE ROOSEVELT and Acting Superintendent John Pitcher at Mammoth Hot Springs, 1903.

CHESTER A. ARTHUR, shown here in camp at Old Faithful, visited Yellowstone in 1883, becoming the first U.S. president to do so. Arthur and his large entourage entered the park from the south traveling by horse from the Union Pacific Railroad in southern Wyoming. These VIPs are (seated first row): Montana Governor Schuyler Crosby, appointed by Arthur; General Phil Sheridan; President Arthur; Robert T. Lincoln, Secretary of War and son of President Abraham Lincoln; Senator George Graham Vest of Missouri, a constant watchdog of Yellowstone National Park; (second row): Colonel Michael Sheridan, military secretary to the President and brother of Phil Sheridan; Brig. Gen. Anson Stager; Capt. Philo P. Clark, U.S. Second Cavalry; Judge Daniel G. Rollins, Surrogate of New York; and Lt. Col. James F. Gregory, the President's aide-de-camp.

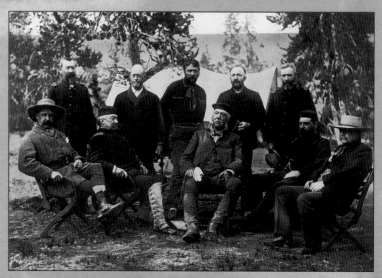

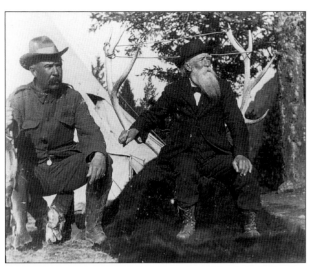

ACTING SUPERINTENDENT John Pitcher and naturalist John Burroughs, in camp on the Yellowstone River, 1903. Burroughs accompanied President Theodore Roosevelt to the park in April, when the president laid the cornerstone for the new North Entrance Arch at Gardiner. One of the nation's best-loved nature writers, Burroughs chronicled the trip in his 1907 book *Camping and Tramping With Roosevelt*.

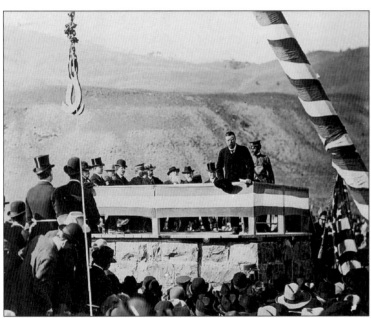

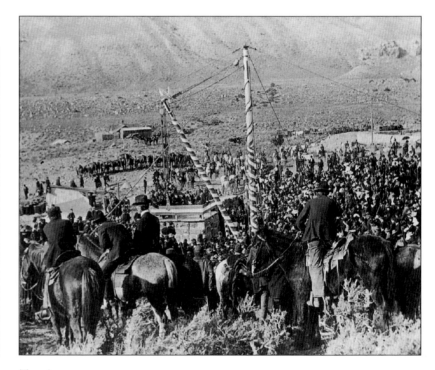

PRESIDENT THEODORE ROOSEVELT oversees the laying of the cornerstone of the North Entrance Arch at Gardiner, Montana, in April 1903. The arch was completed later that year. Today it is sometimes known as the Roosevelt Arch.

THE ARCH DEDICATION ceremony, 1903. In the distance, President Theodore Roosevelt can be seen on the platform with Hiram Chittenden, who later oversaw construction of the arch. John Burroughs is also there with his long, white beard.

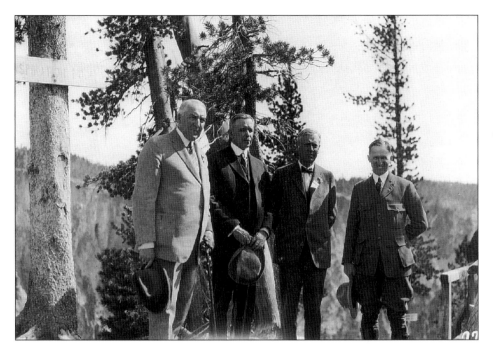

PRESIDENT WARREN G. HARDING, Secretary of Interior Hubert Work, National Park Service Director Stephen Mather, and Superintendent Horace Albright at Inspiration Point, July 1, 1923. Harding visited Yellowstone Park June 30-July 1, 1923, and declared that "I know of nothing to compare with it anywhere in the world." He died just a month after his visit and, in deference to him, all Yellowstone Park traffic and services came to a complete stop for a five-minute period on August 10, 1923. A geyser that broke out that year at Norris Basin was named for the president.

PRESIDENT HARDING feeding a bear cub at the Continental Divide, 1923.

PRESIDENT HARDING and his wife at Old Faithful, 1923.

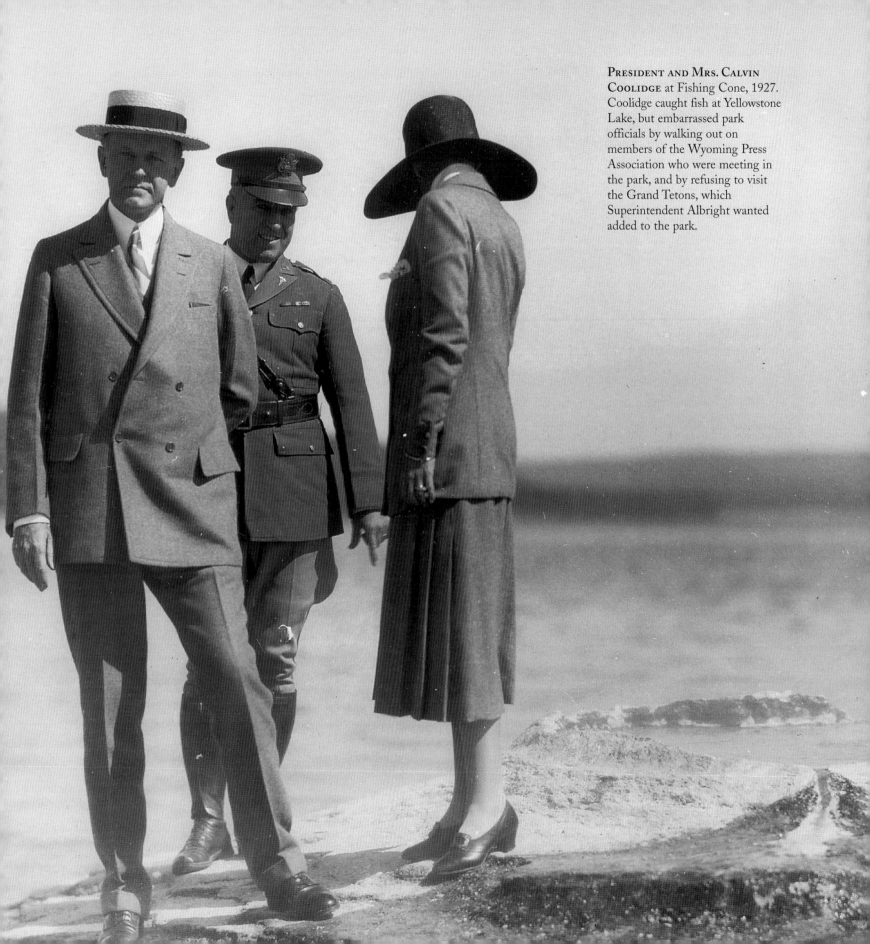

PRESIDENT AND MRS. CALVIN COOLIDGE at Fishing Cone, 1927. Coolidge caught fish at Yellowstone Lake, but embarrassed park officials by walking out on members of the Wyoming Press Association who were meeting in the park, and by refusing to visit the Grand Tetons, which Superintendent Albright wanted added to the park.

A YOUNG GERALD FORD as a
Yellowstone ranger, summer, 1936.
Ford is third from left in this photo
and Ranger Wayne Replogle is to
his left.

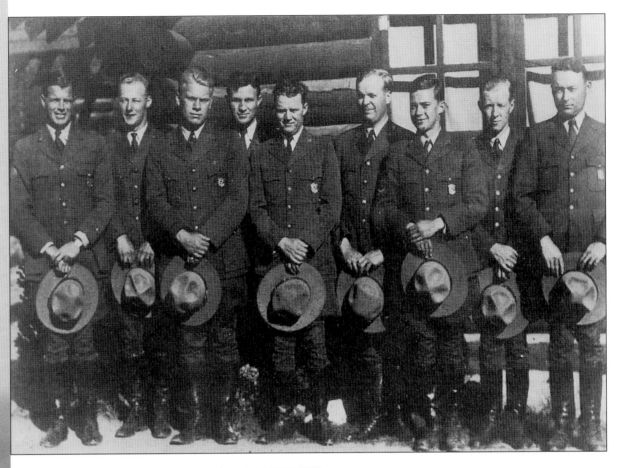

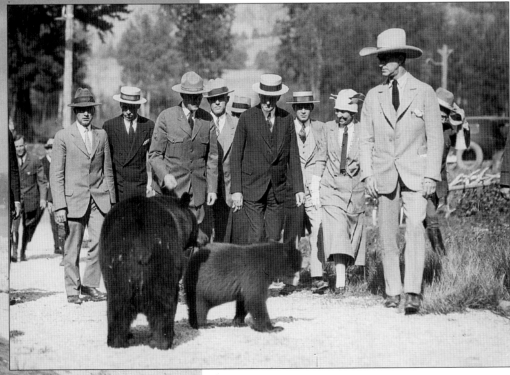

PRESIDENT COOLIDGE at
Roosevelt Lodge with bears, 1927.
Superintendent Horace Albright is
at the president's right and Mrs.
Coolidge is at the president's left
in the distinctive hat. Note the
stern expressions on the faces of
the president's bodyguards, who
clearly did not like to see a large
carnivorous wild animal so close to
the president. The tall man at right
wearing the cowboy hat is identified
as a Colonel Starling.

RANGER-NATURALIST Wayne Replogle and President Gerald Ford share a light moment at Artist Point forty years after their summer as Yellowstone rangers. Replogle, known as Ranger Rep, was a summer seasonal for more than forty years in Yellowstone.

PRESIDENT GERALD FORD returns to the park after forty years, August 29, 1976, to speak at Old Faithful during his presidential campaign.

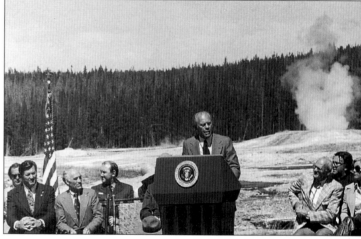

PRESIDENT FORD speaking with Old Faithful Geyser in the background. As hoped by the president and event planners, the geyser erupted during the president's speech.

Dignitaries welcome first lady Pat Nixon to Old Faithful, September 19, 1972, as part of the celebration of the Yellowstone Centennial and the First World Conference on National Parks. Left to right: Idaho Governor Cecil D. Andrus; Secretary of Interior Rogers Morton (at microphone); Past President of the International Commission on National Parks, Jean Paul Harroy; Mrs. Richard Nixon.

President Franklin Delano Roosevelt, Superintendent Edmund Rogers, and First Lady Eleanor Roosevelt in Yellowstone, 1937. On this visit, Mrs. Roosevelt made the first national radio broadcast from the park. The president spent September 25 and 26 in Yellowstone, which was closed on September 25 that year because of funding shortages, and resulted in protests from newspapers, civic organizations, and Congress.

Lady Bird Johnson during a 1977 visit to the Grand Canyon of the Yellowstone. Mrs. Johnson, then a member of the Secretary of the Interior's National Parks Advisory Board, is still an active conservationist.

PRESIDENT JAMES EARL CARTER visits the Old Faithful area, 1978. President Carter, an avid fisherman, has returned to the park area several times since his presidency.

PRESIDENT GEORGE BUSH and Superintendent Bob Barbee disembark from a marine helicopter June 12, 1989, to view the effects of the 1988 fires.

PRESIDENT GEORGE BUSH
inspects a burned area at Fountain
Flats accompanied by Yellowstone
Chief of Research John Varley.

PRESIDENT BILL CLINTON and
Hillary Rodham Clinton enjoy
an eruption of Old Faithful,
August 25, 1995.

PRESIDENT CLINTON and party
watch Anemone Geyser, 1995.
Left to right, Ranger Ann
Deutsch, President Clinton,
Superintendent Michael V. Finley,
Hillary Clinton, Chelsea Clinton
(far right), and Chelsea's friend
Rebecca Kolsky watch Anemone
Geyser erupt. President Bill
Clinton visited Yellowstone again
on August 12, 1996.

ACTING SUPERINTENDENT
Captain George S. Anderson, U. S.
Cavalry, with captive bear cub at
Fort Yellowstone, Mammoth Hot
Springs, in the 1890s. From this
time on for several decades, there
often was at least one captive black
bear on display somewhere in
the park.

VISITORS WATCH BEARS foraging
in a park garbage dump, date
unknown. This photograph was
probably taken at the bear-feeding
area near the Fountain Hotel,
sometime between 1891 and 1916,
but bears were fed at several
locations, and the activity became
a popular visitor diversion in
the evenings.

FEEDING A BLACK BEAR at
Roosevelt Lodge, 1920s.

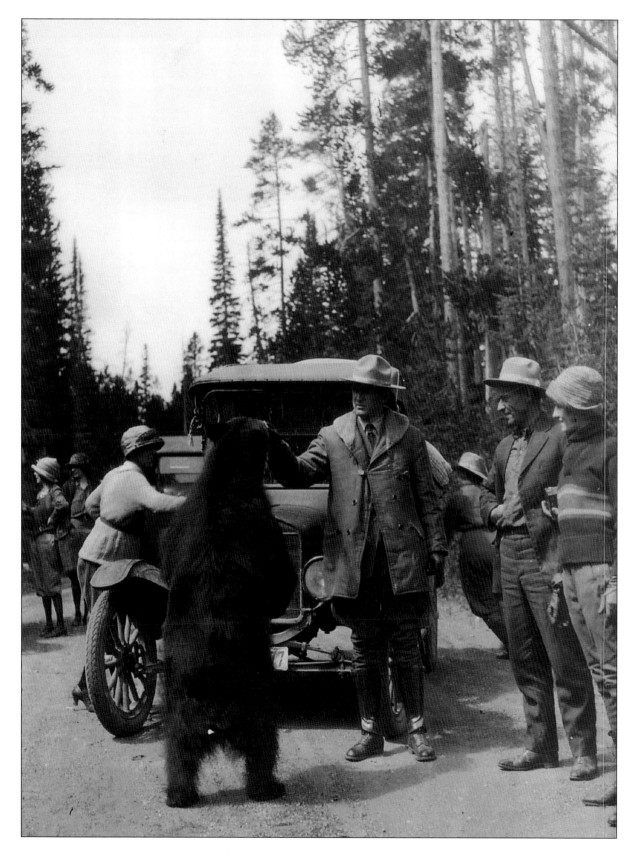

SUPERINTENDENT Horace Albright feeds a bear at Continental Divide, 1923. Feeding park animals has been illegal for most of this century, but was such a popular visitor activity that soldiers and rangers turned their heads and tolerated a certain level of it. Albright, who recognized the great popularity of bears, was always seeking ways to increase public support for the parks, and bear feeding was a way to make the park more friends. This unhealthy and unsafe situation resulted in the deaths of an average of two dozen bears each year from 1930 to 1970. The practice was finally changed in the early 1970s, when bear feeding was firmly prohibited, the garbage dumps closed, and the park's hundreds of garbage cans bear-proofed.

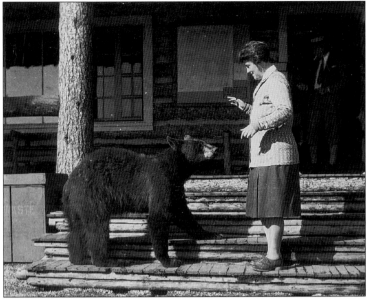

WOMAN WITH BEAR at Roosevelt Lodge, 1920s.

BEAR MOOCHERS signs were in use by 1960, an early attempt to stop people from feeding bears.

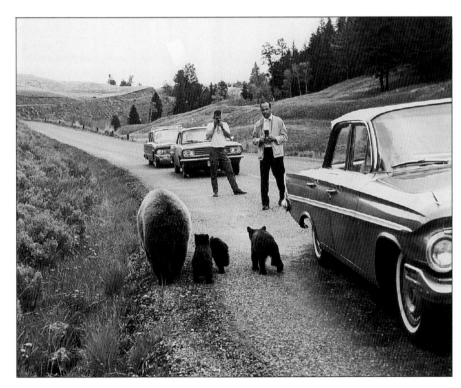

BEARS ON THE ROADSIDES, a common sight during the "bear jams" of the 1960s, when drivers would back up for a mile or more to wait their turn to see and feed the bears.

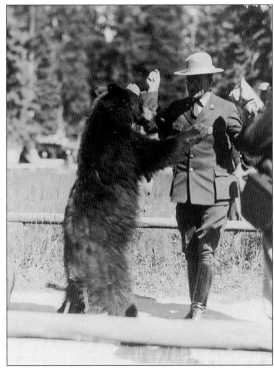

WHEN IT CAME to bear feeding, everyone got into the act: Chief Ranger Sam Woodring feeding a bear, 1922.

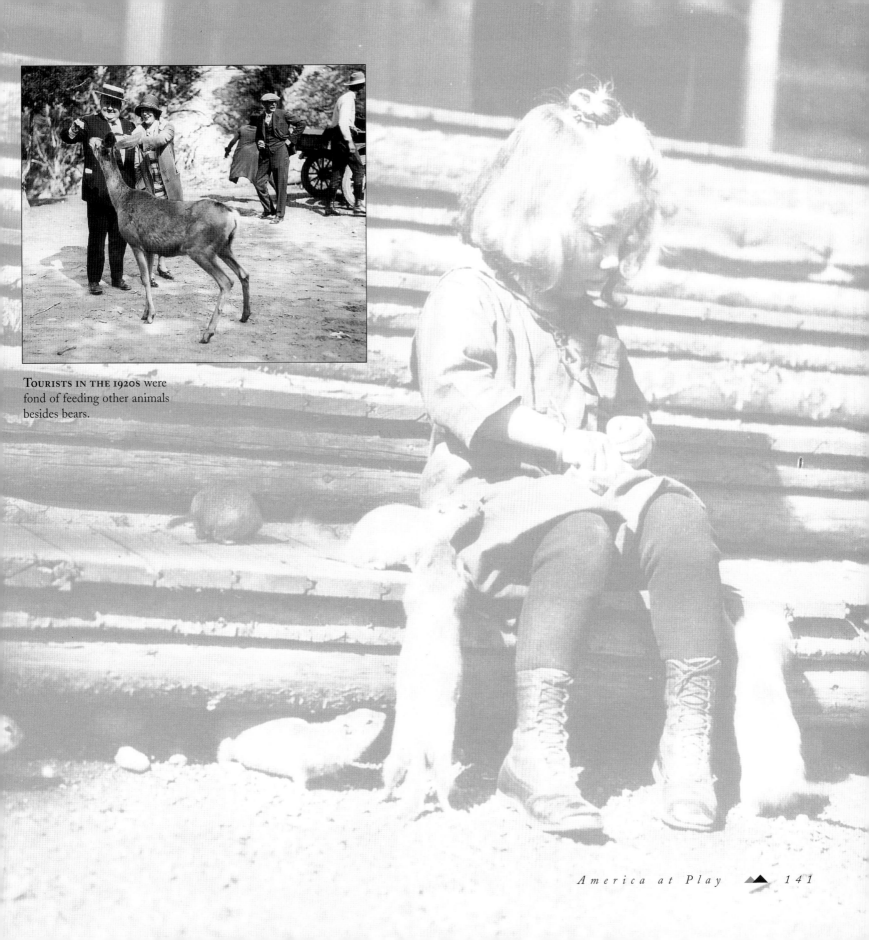

TOURISTS IN THE 1920s were fond of feeding other animals besides bears.

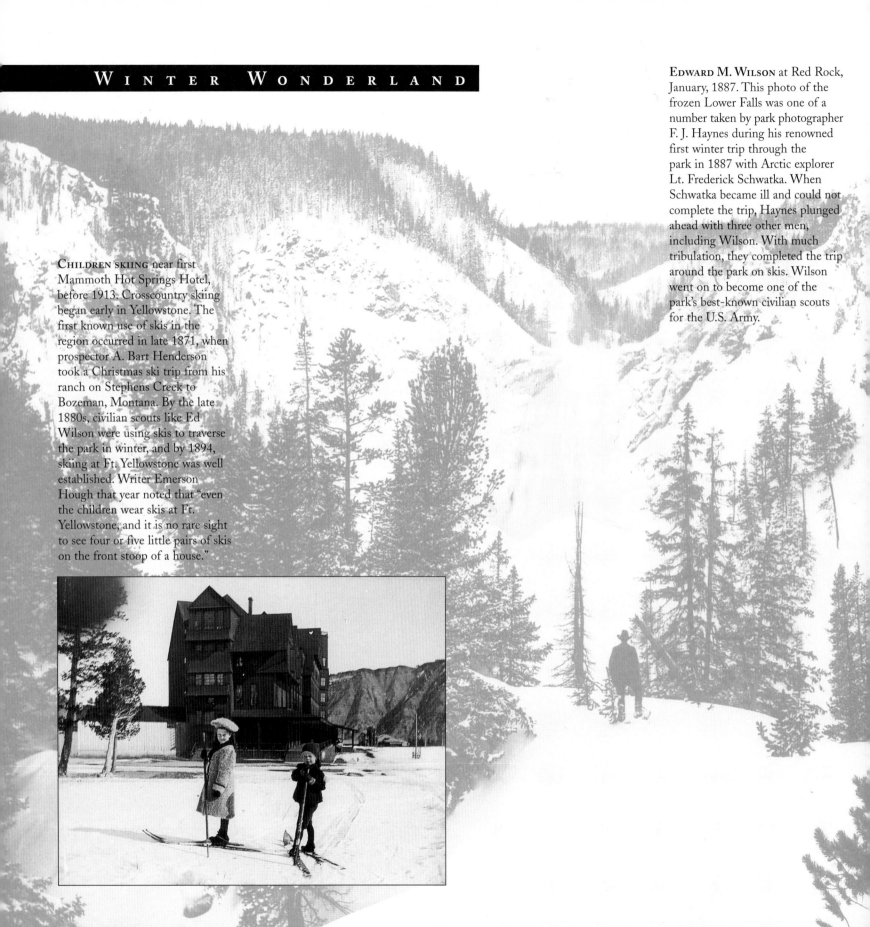

EDWARD M. WILSON at Red Rock, January, 1887. This photo of the frozen Lower Falls was one of a number taken by park photographer F. J. Haynes during his renowned first winter trip through the park in 1887 with Arctic explorer Lt. Frederick Schwatka. When Schwatka became ill and could not complete the trip, Haynes plunged ahead with three other men, including Wilson. With much tribulation, they completed the trip around the park on skis. Wilson went on to become one of the park's best-known civilian scouts for the U.S. Army.

CHILDREN SKIING near first Mammoth Hot Springs Hotel, before 1913. Crosscountry skiing began early in Yellowstone. The first known use of skis in the region occurred in late 1871, when prospector A. Bart Henderson took a Christmas ski trip from his ranch on Stephens Creek to Bozeman, Montana. By the late 1880s, civilian scouts like Ed Wilson were using skis to traverse the park in winter, and by 1894, skiing at Ft. Yellowstone was well established. Writer Emerson Hough that year noted that "even the children wear skis at Ft. Yellowstone, and it is no rare sight to see four or five little pairs of skis on the front stoop of a house."

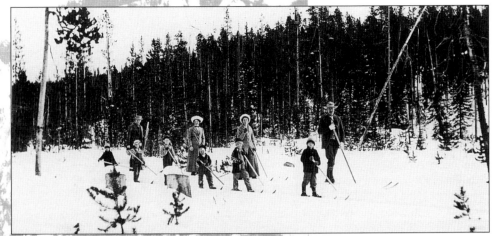

The A. L. George family skiing in the park, 1910.

WOMAN WITH CALENDAR, bouquet of flowers, and snowbank on Dunraven Pass, July 4, 1921. Park visitors have thought it novel and interesting from the earliest days of Yellowstone Park that snow can fall or be present on Independence Day, often in the presence of growing wildflowers.

MAN WITH DOGSLED and dog team at Upper Geyser Basin, about 1960. Dog teams were occasionally seen in winter at West Yellowstone, but only rarely did they go into the park. This photo probably represents a trial of the dog team.

ORIGINS OF THE SNOWCOACH operations (above). In 1955, Harold Young and Bill Nicholls, shown here January 3, 1958, of West Yellowstone, Montana, purchased several Bombardier snowcoaches and obtained a permit to run winter tours into Old Faithful. Young and Nicholls sold out to the Yellowstone Park Company in 1967, and those same Bombardier snowcoaches, with most of their parts replaced many times, are operated by AmFac Parks and Resorts today.

THE YELLOWSTONE SNOWCOACH fleet, March 1991, at West Yellowstone, Montana. The Yellowstone Park Company acquired the Bombardier snow-coaches in 1967–1968 from Harold Young and Bill Nicholls, and that concessionaire or its successors have operated them in the park ever since. Until this photo was taken no photo existed of the entire fleet of nineteen passenger coaches. These vintage machines have taken on almost as much personality and romance among park staff as did the stage-coach drivers years before. The snowcoaches, lined up here in exact order, are numbered 702 through 721, except that there is no 717. Some of the coaches had names: Boop Coupe (705), Baby (706), Convenience Store (711), Screaming Night Hog (714), Caroline (715), Yankee Clipper (718), Studmobile (719), and Itinerant Drifter (721). Coach 717 was destroyed in a collision some years earlier. Freight coach 722 was in Gardiner and thus not in the photo, and number 723 is a recent addition, a red coach used by mechanics for repair calls.

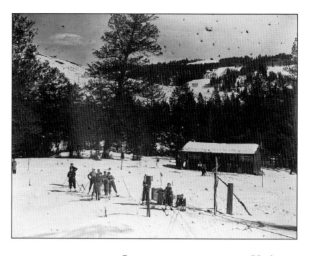

SKI HOUSE AND SKIERS at Undine ski hill, February 1942, the year the park's small downhill ski area was established near Undine Falls. It replaced a primitive ski slope with no mechanical equipment along the Mt. Washburn road. The Undine ski hill was open to the public, but was used primarily to teach Mammoth school children how to ski. It was dismantled in 1993–1994.

SNOWMOBILERS at the Hoodoos, south of Mammoth, 1970. Private snowmobiles were first allowed into Yellowstone for the winter of 1963–1964, and park roads were first groomed for such use during the winter of 1970–1971. While the Mammoth Hotel was kept open in winter in the late 1960s in a short-lived and unsuccessful experiment, the first park hotel to be continuously open in winter was the Old Faithful Snow Lodge beginning in the winter of 1971–1972. Today Yellowstone receives some 140,000 winter visitors, and increasing winter use is a major issue for park planners and interest groups.

The Spirit of the Ranger

THE RANGER WAS MORE THAN A POLICEMAN.

HE, AND SOMETIMES SHE, EVEN IN THE EARLY DAYS, WAS A WOODSMAN,

A TEACHER, A CONSERVATIONIST, A MEDIC, A FIREFIGHTER,

A RESCUER, A WILDLIFE MANAGER,

AND A ROLE MODEL FOR GENERATIONS OF YOUNGSTERS.

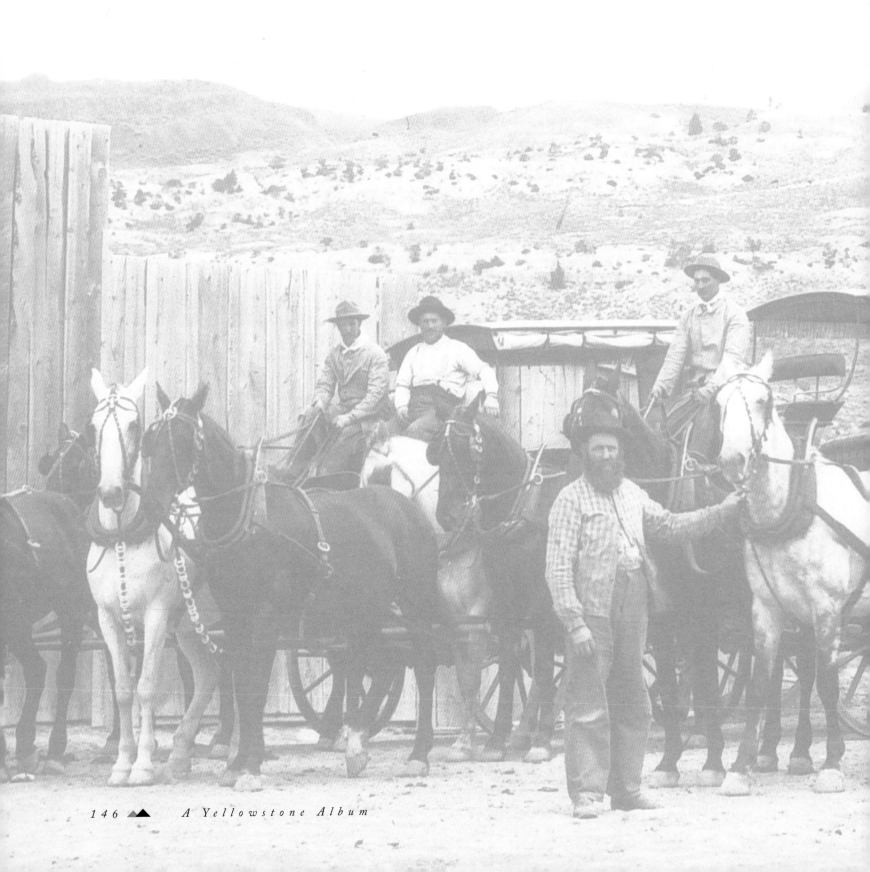

THE SPIRIT *of* THE RANGER

*T*he spirit of the ranger is alive in the hearts and minds of many of the men and women who have cared for Yellowstone. Long before there was a National Park Service, there were people doing ranger's work. Some were called scouts, some were superintendents and their assistants, but all were working toward the same goals as modern rangers.

The most historically remarkable of these may have been the soldiers and civilian scouts who patrolled the park from 1886 to 1918 in what was certainly one of the U.S. Army's most unusual assignments ever. From their main headquarters, Fort Yellowstone at Mammoth Hot Springs, troops spread out across Yellowstone, establishing a system of soldier stations at key park locations, and a separate system of tiny snowshoe cabins in the backcountry, all to enable more effective management and protection of the park. The almost routine heroism of their duties, and the great good that came from their work, has placed the American conservation movement in the permanent debt of these largely forgotten men.

But their legacy was also extraordinary—from their example emerged the national park ranger. When the National Park Service was created, in 1916, some of Yellowstone's first rangers were recruited from the ranks of the soldiers and scouts, giving the new agency continuity and hard-earned experience on park trails. The new ranger was something different, though. No longer was it enough for Yellowstone's protectors merely to patrol and protect. Now they became the face and voice of an agency with an entirely different mission, one determined to cultivate public affection for the national parks. The ranger, it has been said, is the closest we have come in the United States to duplicating the breadth of skills and romantic image attributed to the Mounties of the Royal Canadian Mounted Police. The ranger was more than a policeman. He, and sometimes she, even in the early days, was a woodsman, a teacher, a conservationist, a medic, a firefighter, a rescuer, a wildlife manager, and a role model for generations of youngsters.

The spirit of the ranger lives in many jobs in today's Yellowstone and speaks with many voices; every employee, whether a flagman on a road crew, a waitress at a hotel, or a tour guide on a bus tour, spreads the message of Yellowstone's wonder. A variety of civilian work groups, beginning with the Civilian Conservation Corps and proceeding to modern youth groups, carry on the work today, supporting the park's large maintenance program as they introduce young people to the possibilities and responsibilities of conservation.

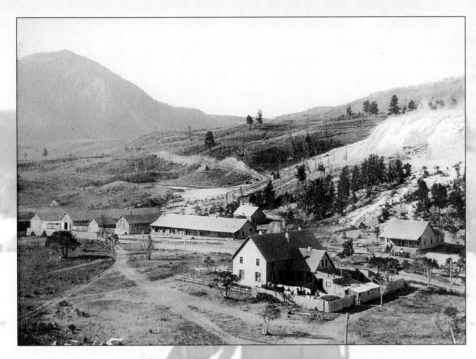

BEEHIVE BUILDING and Camp Sheridan buildings at Mammoth, about 1895. The Beehive Building (center) was constructed in 1887 as quarters for the park wheelright and plumber; it was razed in 1924. During the 1890s, it was the home of the park superintendent, Captain George S. Anderson, and was called the Beehive, because of its crowded tenancy. The name was a sly reference to the house of the same name in Salt Lake City that served as housing for Brigham Young's wives. The "road to the geysers" ran south from there then, as it does today, but it followed the base of the Mammoth terraces instead of being farther east. The Camp Sheridan buildings were razed in 1915.

CONSTRUCTION OF FORT YELLOWSTONE began in 1891, with the buildings shown in this photo. Later waves of building, in 1897 and around 1909, resulted in a four-troop post that was regarded as a showpiece of the period. Because Fort Yellowstone received more foreign visitors than any other American army post, except perhaps West Point, it was given special attention. In the distance on the left are early YPT Company barns and residences.

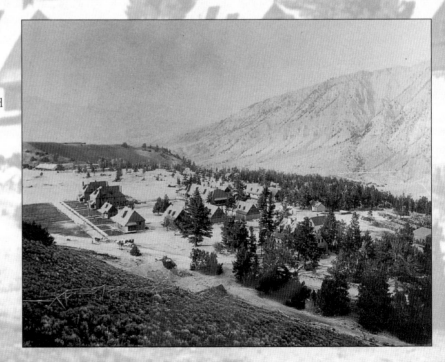

The Norris Soldier Station, the third administration structure at Norris, was built in 1908. It now houses the Museum of the National Park Ranger and sits near the entrance to the Norris Campground. Shown here in about 1911–1913, its stonework sign suggests that members of F Troop, First Cavalry were in residence.

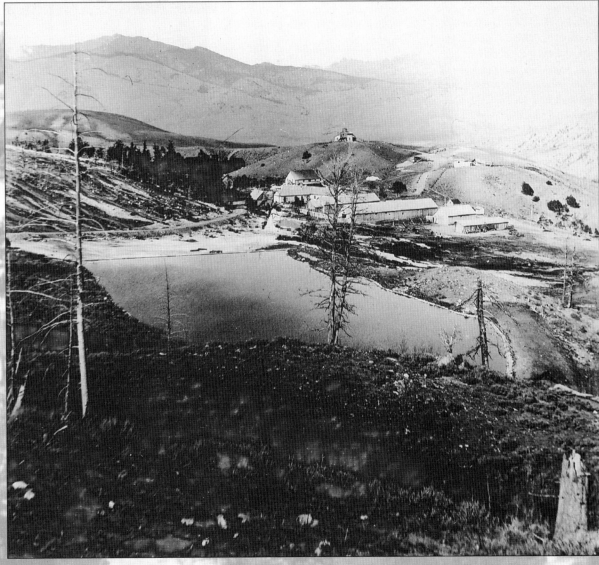

Chittenden's reservoir and Camp Sheridan buildings about 1901–1909. The Camp Sheridan buildings, constructed 1886–1887, can also be seen in the photo to the right of the reservoir. On top of Capitol Hill is the first park administration building (1879) which was razed in 1909.

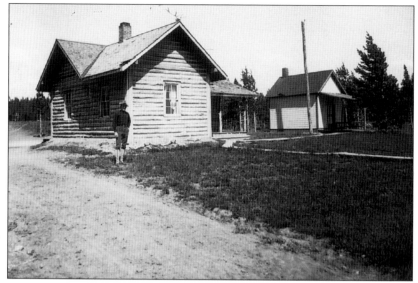

RIVERSIDE SOLDIER STATION, about 1905. The original Riverside station was a mail station built in 1880 by O. J. Salisbury near the junction of the west entrance road with the old Madison Plateau road, some five miles east of the west boundary. The army occupied that station from 1887 through 1910. In 1900, this building was erected at the newer Riverside location about one mile inside the west entrance and north of the main road on the Madison River.

FOUNTAIN SOLDIER STATION, about 1905. This station, built in 1887 to accommodate five men, stood until sometime in the 1920s. Stagecoach visitors from the west entrance were required to sign the station's large logbook and declare their guns. The station was located in the trees just northeast of the point where the Fountain Flats Drive begins.

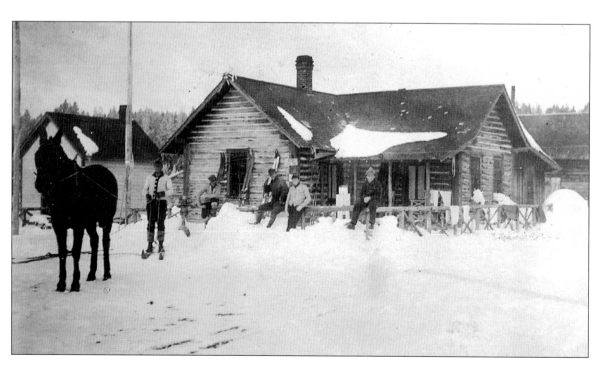

OLD FAITHFUL SOLDIER STATION in winter, 1913. The first building at Old Faithful was built by Superintendent P. W. Norris in 1879 and described as "an earth-roofed, loop-holed log house with a good stone chimney and located between the Castle and the Beehive Geysers." Norris's building on the Firehole River was probably the base building for this first soldier station, erected in the same spot by the U.S. Army along with several other buildings and tents. It is not known when the army built these structures, but a map shows them in place by 1904. This same complex was also used as the first Old Faithful ranger station until 1921, when a new ranger station was built southwest of Old Faithful Lodge.

SNAKE ENTRANCE SOLDIER STATION (south entrance), 1905. The first soldier station for the south entrance was established in 1892 below the mouth of Polecat Creek, at the old Marysville Road ford across the Snake River. Intended to protect the newly created Yellowstone Park and Timberland Reserve area to the south and east of the park as well as the southern park area, that station was unsuccessful because it was too far from headquarters, and soldiers were required to cover too much territory. It was torn down in 1902, and the logs were moved to the place "where the road crossed the boundary line of the park." This station burned August 7, 1914.

WEST THUMB SOLDIER STATION, 1905. The first army outpost at West Thumb was established in 1892 at the time the new Old Faithful–West Thumb road was opened, and the buildings shown here were erected in 1904.

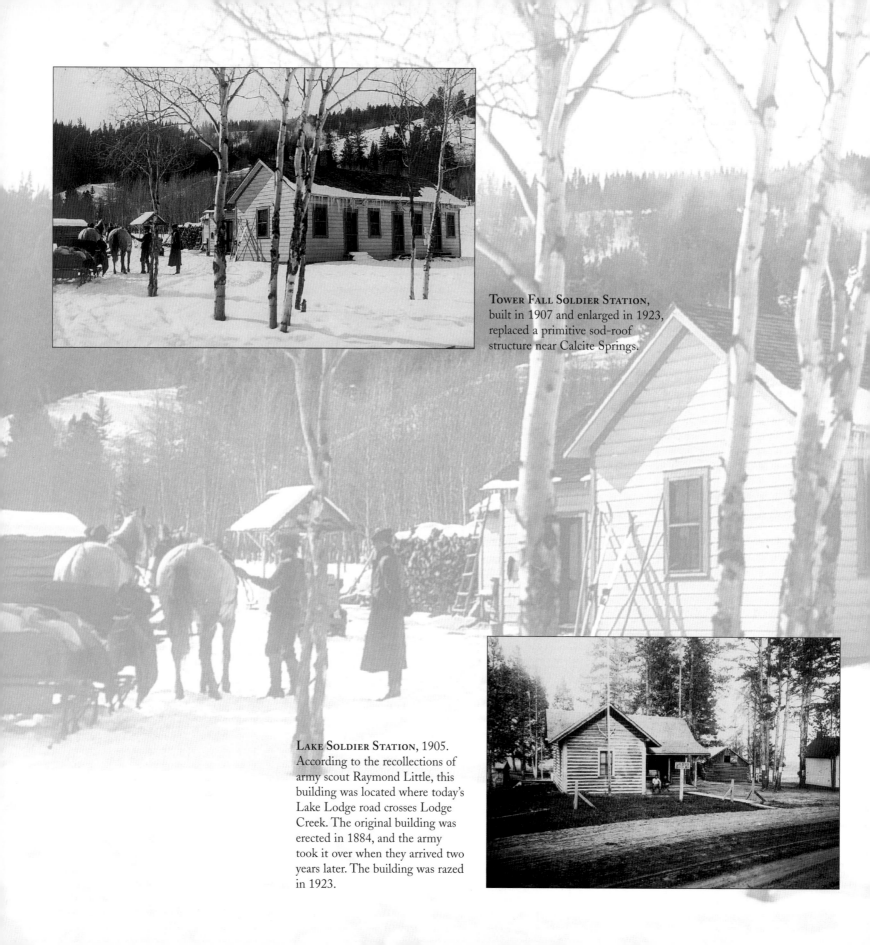

Tower Fall Soldier Station, built in 1907 and enlarged in 1923, replaced a primitive sod-roof structure near Calcite Springs.

Lake Soldier Station, 1905. According to the recollections of army scout Raymond Little, this building was located where today's Lake Lodge road crosses Lodge Creek. The original building was erected in 1884, and the army took it over when they arrived two years later. The building was razed in 1923.

TROOP F, FIRST U.S. Cavalry in front of enlisted men's barracks, Ft. Yellowstone, 1913.

SOLDIER AND HORSE JUMPING fence during cavalry drill at Mammoth, 1911. Notice that several of the men watching are "helping" the horse clear the barrier by kicking their own legs high.

A soldier with a visitor near the cone of Old Faithful Geyser, 1889. The photo is a rare round-format one taken with an early Eastman Kodak camera.

A group of soldiers on ski patrol at the Grand Canyon of the Yellowstone, 1910 or 1911.

A SOLDIER WHO DIED of exposure during a winter patrol, probably John W.H. Davis in December of 1897, being taken back to Fort Yellowstone on his skis. (From an article entitled "Ski-Runners of the Yellowstone," *National Magazine*, February 1904)

ONE CAPTION gives this as "Mud Volcano cabin in winter, 1894." If so, this is the only known photo of the Mud Volcano Soldier Station, once located near the present Cascade Picnic Area. Another possibility is that this is the soldier cabin on upper Alum Creek south of Glen Africa Basin on the north side of Hayden Valley.

BISON HEADS CONFISCATED from poacher Edgar Howell, who, in 1894, was close to wiping out the last wild bison in the park. His capture led to a public outcry that resulted in stronger legislation to protect park wildlife. The soldiers are (left to right) doctor Charles Gandy, Lt. John T. Nancy, Capt. George Scott, and Lt. W. W. Forsyth. The original handwritten caption says "Poachers Waiting to be shot. Sic Semper [thus ever]."

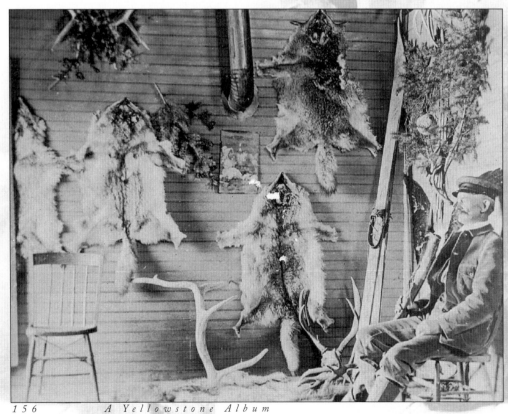

CUSH JONES, brother of Buffalo Jones; then the park's buffalo keeper, in Mammoth buffalo corral cabin with pelts of predators killed in the park, about 1902. Informal natural history displays appeared here and there in Yellowstone from its early days.

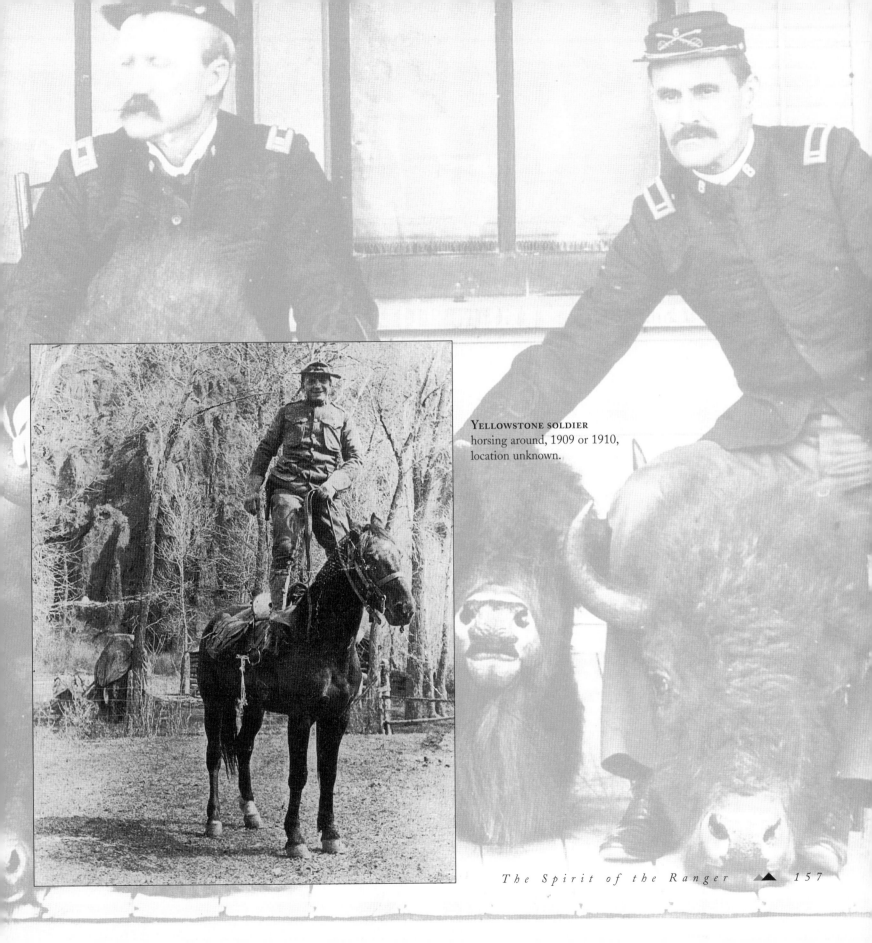

YELLOWSTONE SOLDIER horsing around, 1909 or 1910, location unknown.

U.S. ARMY BASEBALL team playing the Gardiner baseball team, 1911, at Mammoth Hot Springs.

INTERIOR OF FT. YELLOWSTONE post exchange, 1905. Many soldiers found life at this isolated post very difficult and did not appreciate the park's wonders, so any small opportunity for recreation or diversion was welcome.

INTERIOR OF CHESTER AND MAUDE LINDSLEY'S home at Mammoth Hot Springs, 1900. The Lindsleys can be seen at rear. Chester Lindsley was employed in the park as the superintendent's clerk beginning in 1894 and served under nine military acting-superintendents before becoming park supervisor in 1916. He served until Horace Albright was appointed superintendent in 1919. Thereafter Lindsley served as assistant superintendent under Albright until he became Yellowstone's postmaster in 1922.

Dinner at the acting superintendent's house, Mammoth Hot Springs, about 1895. Captain George S. Anderson served as acting superintendent from 1891 to 1897 and was instrumental in great improvements in park law enforcement, funding anti-poaching patrols from his own pocket when necessary. His unmarried sister served as his housekeeper. Here he sits at the far end of the table, and she sits to his right.

Captain Bloomburg with his two-year-old son at Fort Yellowstone about 1917. The U.S. Army left the park in October 1916, but was almost immediately called back when local political pressure prevented the funding of the new National Park Service. They finally left for good on October 31, 1918, so Bloomburg was one of the last officers to serve at Fort Yellowstone.

The firing of the sunset gun on Capitol Hill at Fort Yellowstone, on July 4, 1916. This was probably the very last firing of the cannon, signaling the close of army protection of Yellowstone.

THE NATIONAL PARK SERVICE'S first director, Steve Mather, an early hero of the American conservation movement, on horseback, probably near Hellroaring Peak in 1923.

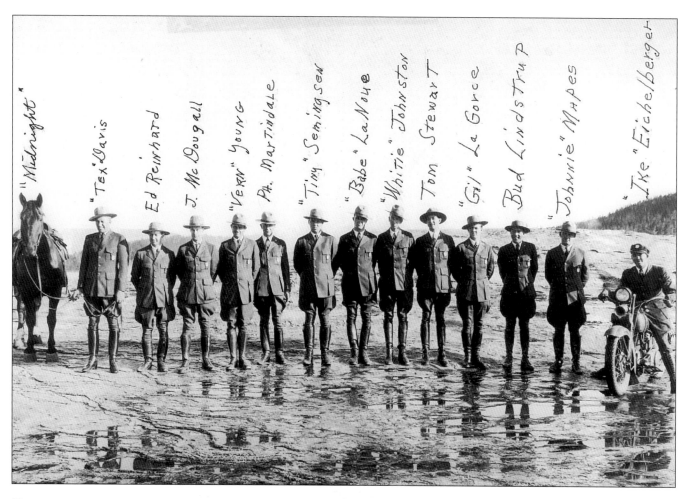

"Midnight" "Tex" Davis Ed Reinhard J. McDougall "Vern" Young Pe. Martindale "Tiny" Semingsen "Babe" LaNoue "Whitie" Johnston Tom Stewart "Gil" La Gorce Bud Lindstrup "Johnnie" Mapes "Ike" Eichelberger

THIS PHOTO, once owned by Chief Ranger Francis "Babe" LaNoue, shows the Old Faithful ranger force about 1936, on the Giantess Geyser formation. The rangers' names were inked in by LaNoue.

CHIEF RANGER JAMES MCBRIDE, about 1921. McBride, for whom a Yellowstone lake is named, seems to have arrived in the park in 1886 with a contingent of soldiers and stayed the rest of his life. He also served as chief of the army's civilian scouts in 1914. He retired in 1938 and died in 1942. He was buried in the Gardiner cemetery in his ranger uniform.

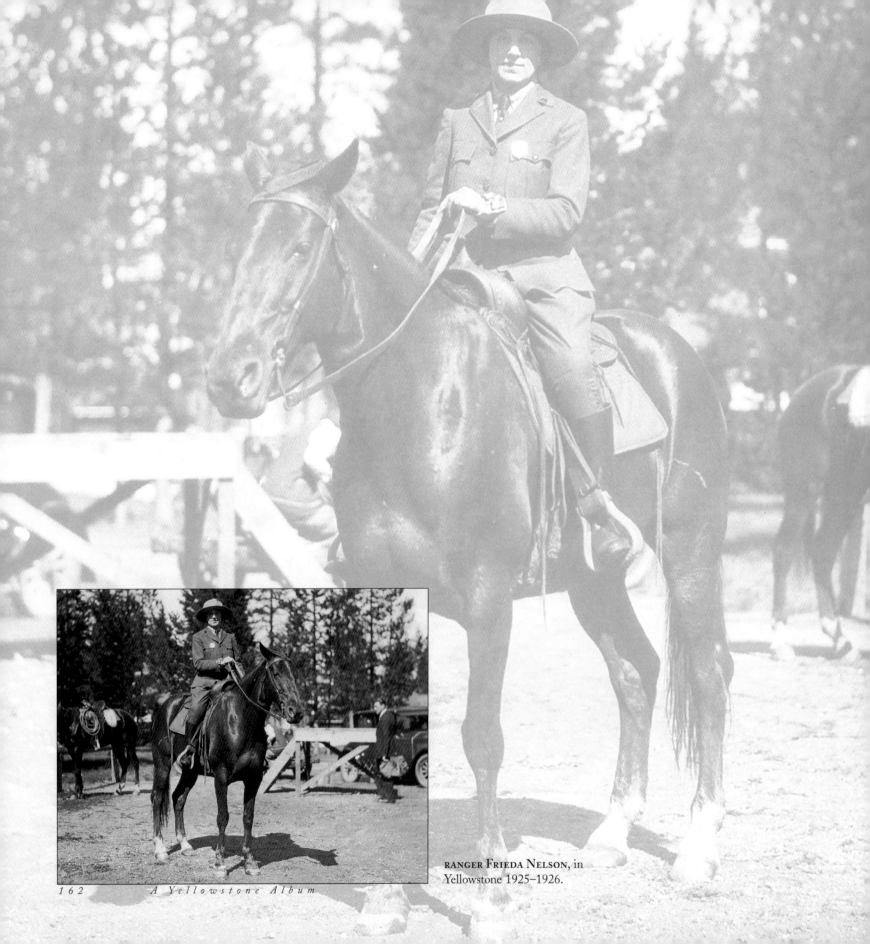

A Yellowstone Album

RANGER FRIEDA NELSON, in Yellowstone 1925–1926.

HISTORY AND GEOLOGY room, Mammoth museum, September 1930. The first museum of any kind in Yellowstone was G. L. Henderson's in 1885, a short-lived commercial affair. After that, there were no museums for many years. In 1919, the park's first chief naturalist Milton Skinner began collecting specimens in the present Horace Albright Building. In 1921, the first real park museum was established at Mammoth, with writer Emerson Hough giving his time and effort to help. It opened to the public in 1922, after partitions were torn out to rearrange the old bachelor officers' quarters.

A MOMENT OF WONDER: a young visitor encounters a mounted grizzly bear at Fishing Bridge Visitor Center, some time before 1969.

OLD FAITHFUL VISITOR CENTER courtyard, 1933. The first Old Faithful Visitor Center, sometimes called the Old Faithful Museum, was built in 1928–1929. Historian Aubrey Haines remembers it as "a very cramped place," and it included an open court and flower garden, a very uncharacteristic sight in modern parks but regarded as appropriate at the time. This building was replaced by the present Old Faithful Visitor Center in 1972.

NOON BUS STOPPING at Mammoth museum and Antler House in 1937. The Mammoth museum was established by the National Park Service in 1921 in the building that had formerly housed the army's bachelor officers' quarters, and it remains there today. At first the building also housed the park post office, and cottonwood trees were planted in front of it in 1926. The Antler House, built by chief ranger Sam Woodring in 1928, was a photographic staple for park visitors until the early 1960s. It was torn down to prevent giving visitors the idea that it was okay to collect elk and deer antlers, a practice long prohibited in Yellowstone. Shed antlers are a source of minerals for a variety of animals, including elk.

IN 1976, THE YELLOWSTONE Library and Museum Association sponsored the creation of a field school, the Yellowstone Institute, which has since held hundreds of courses on many Yellowstone subjects. From their base at the Lamar Buffalo Ranch buildings, these classes have covered the entire park to learn about the history and natural history of the area.

OPENING DAY of the new Norris Museum, 1930. Like the museums at Fishing Bridge and Madison Junction, the Norris Museum was built in 1929–1930 with funds from the Laura Spellman Rockefeller Foundation. The architect was Herbert Maier. Under this program, a museum was also built at Old Faithful (now gone) in 1928–1929. The park's museums and educational programs have been a collaborative effort since the Yellowstone Library and Museum Association, now the Yellowstone Association, was established in 1933 to foster public education in the park.

SEASONAL RANGER
George T. Ross at Old Faithful
Ranger Station, 1925.

RANGER NATURALIST WALTER PHILLIP Martindale and thirteen bears at lunch counter for bears only, 1931. The Old Faithful bear-feeding grounds was located southeast of the upper Hamilton Store from 1921 to the mid-1930s. Bear feeding shows were given for the public until World War II. Martindale gave his bear lecture on horseback, in what was called the "Sermon on the Mount," to visitors seated on rude benches behind a flimsy wire barricade, while bears foraged on the platform in a pile of hotel garbage. Bear feeding shows were finally restricted to the Canyon area and abandoned after the 1941 season because of growing disapproval among the scientific and conservation communities of the public display of garbage-feeding bears.

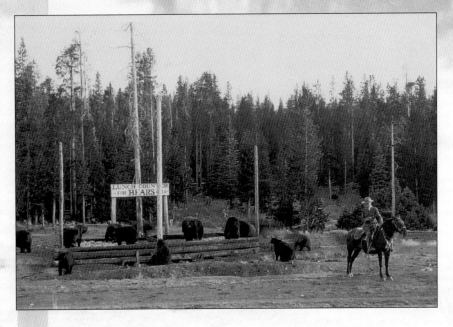

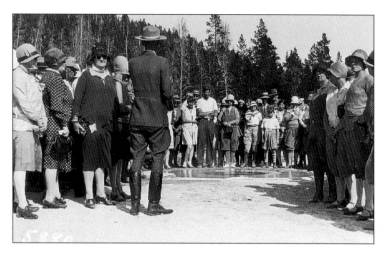

VISITORS WITH RANGER NATURALIST Flottman at Beach Spring, Upper Geyser Basin, 1929.

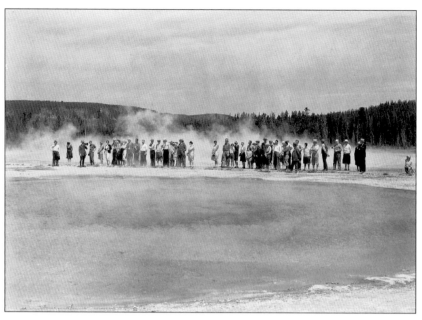

VISITORS WITH TWO RANGER Naturalists at Black Sand Basin, 1930s.

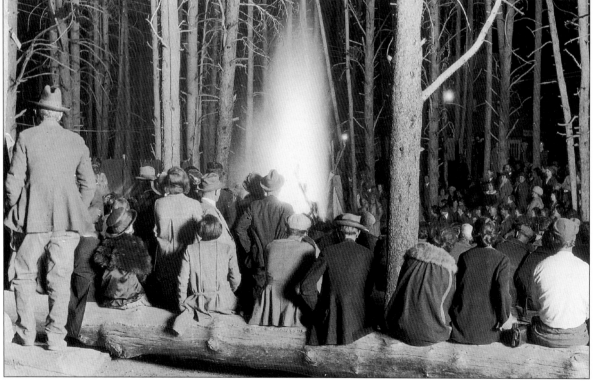

VISITORS AT EVENING campfire show performed by concession employees at one of the park's lodges in 1923.

OUTDOOR AMPHITHEATER slide show, probably at Mammoth, 1958.

OLD FAITHFUL Amphitheater, July 29, 1938. Then located just south of the present Visitor Center, this amphitheater was designed to present evening programs via lantern slides. It lasted into the 1960s.

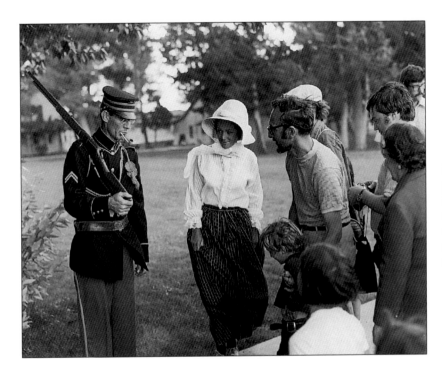

PARK VISITORS at a living history program at Mammoth Hot Springs, late 1970s, learn from ranger naturalists John Whitman, dressed as a Ft. Yellowstone soldier, and Susan Sindt, dressed as a park visitor of the early days.

RANGERS TED OGSTON and Sam
Woodring with what may be wolf
pelts, 1927, toward the end of
federal predator control in
Yellowstone and after most wolves
and mountain lions had been taken
from the park. Coyote trapping
continued in the park for several
more years.

RANGERS on winter ski patrol, 1930.

RANGER SKI PATROL TRACKS across Yellowstone Lake in February, probably 1969. Modern equipment and conveniences have not significantly lessened the skills and experience needed to patrol Yellowstone's vast backcountry, summer or winter.

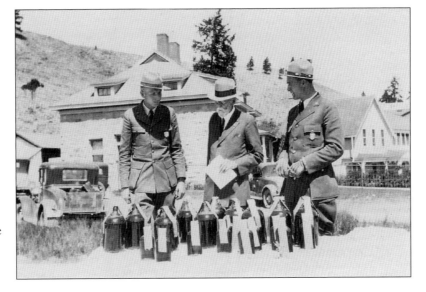

RANGERS EXAMINING confiscated liquor with Judge John Meldrum at the judge's residence, 1930. The Volstead Act of 1918 and the Eighteenth Amendment banned intoxicating liquors, and park rangers, being federal officers, were called upon to enforce the ban in and near Yellowstone until the amendment was repealed in 1933.

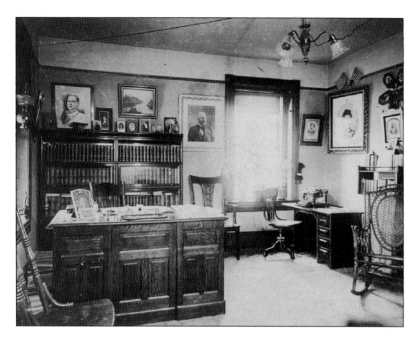

JUDGE MELDRUM'S office, Mammoth Hot Springs, about 1899. Note the picture of President William McKinley at left. Meldrum served as Yellowstone's first U.S. Commissioner from 1894 to 1936. Under his magistracy, poachers were first controlled in Yellowstone following passage of the Lacey Act by Congress.

MORNING GLORY POOL and debris removed from it in 1950. Arguably the park's most famous quiet hot spring, Morning Glory Pool was badly abused by thoughtless travelers who threw things into it, and by those who treated it as a wishing well and threw coins into it. Park geologist George Marler cleaned debris from it in 1950, as do park personnel since Marler, in order to return it to its former beauty. One 1880s visitor referred to it as a "diaphanous cupful of limpid sky." It has never entirely recovered from abuse.

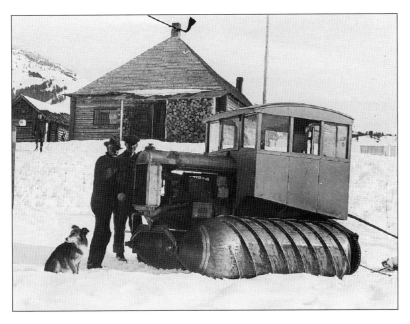

RANGERS WITH A screw tractor at the Lamar Buffalo Ranch, 1930s. This vehicle, a homemade one built by the National Park Service, was a chain-driven affair made from metal tanks with ridges welded onto them. It augured its way through snow and was one of the park's earliest snowmobiles.

DIPPING live elk to reduce parasites, prior to transplanting them into Montana, 1960s. The outcry caused by this reduction program led to a national controversy and eventually a new direction in park management, in which elk and other wildlife herds are regulated more by ecological processes than by human decisions over what is the right size for the herds. This approach has proven just as controversial, but recent research suggests that it works better than the "old" slaughter operations.

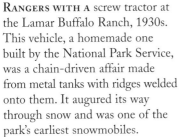

AFTER HALF A CENTURY of struggling with what was thought of as an out-of-control elk herd, park managers resorted to large-scale killing of elk in the 1960s. Here a helicopter drives elk toward a pen for shipment and slaughter.

PARK EMPLOYEES JIM BERENS and Ted Kocher examine one of the new bear-proof garbage cans, about 1968. Several experimental garbage disposal systems were tried before coming up with this one, which finally proved too much for the park's smarter-than-the-average bears to figure out.

GRIZZLY BEARS were at the center of a long controversy starting in the late 1960s, when the National Park Service began restoring wild conditions to the park. Many bears were killed in the process, and many others were relocated to isolated areas. Some of the bears that were moved soon returned to developed areas and got in trouble again, but others stayed away and thrived. In a small, isolated population of grizzly bears, it seemed worth the effort to try to keep as many of them alive and as far from trouble as possible. Helicopter translocation of bears has become a way of life for Yellowstone rangers.

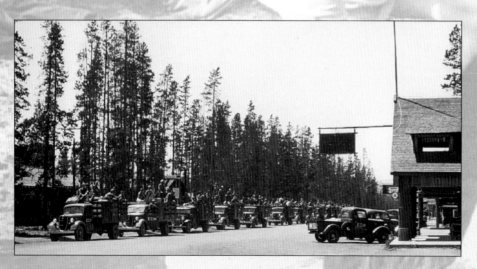

CIVILIAN CONSERVATION CORPS men at West Yellowstone loaded into trucks and heading for their park stations, 1935. The Civilian Conservation Corps was responsible for much work in national parks and other federal areas during the administrations of President Franklin D. Roosevelt. The CCC operated in Yellowstone during the summers of 1933-1941, repairing trails, bridges, walkways, and doing general park cleanup.

THE MAMMOTH CCC CAMP with streets laid out, taken shortly after the photo below, 1933.

ORGANIZING EMERGENCY Conservation Work Camp Number One at Mammoth, 1933. The Civilian Conservation Corps, called the ECW in Yellowstone, was responsible for much work in national parks and other federal areas during the period 1933–1941. This photo represents the origins of use of the area at Mammoth known today as the Youth Conservation Corps (YCC) or Young Adult Conservation Corps (YACC) Camp. The YCC Camp is still occupied today by park housing units and has been continuously occupied since the first summer of 1933.

THESE FIREFIGHTERS of the Civilian Conservation Corps took a rest stop August 24, 1940, while fighting a forest fire near Lewis Lake.

Youth Conservation Corps
crew building a backcountry
bridge, 1980s.

Young Adult Conservation
Corps crew shoveling out the over-
looks at the Grand Canyon, 1978.

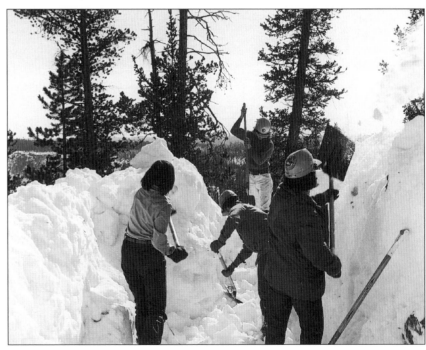

 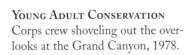

The World's Yellowstone

THE WORLD WATCHES AS THE UNITED STATES
STRUGGLES TO DEFINE A FUTURE
FOR THIS EXTRAORDINARY LANDSCAPE.

THE WORLD'S YELLOWSTONE

*A*s the world shrinks, and as human populations continue to increase, the remaining wild places take on a disproportionate importance in our lives. Yellowstone and its sister parks around the world are no longer just vacation destinations. They are barometers of global health, institutions that preserve our heritage, though their future is often threatened by competing human activities.

In Yellowstone a dialogue has revolved chiefly around the concept of a Greater Yellowstone Ecosystem, a region now thought to comprise upwards of twenty million acres and include Yellowstone and Grand Teton National Parks, parts of seven national forests, and a variety of other public and private lands. The world watches as the United States struggles to define a future for this extraordinary landscape.

The world watches just as intently as we face new dimensions and directions in preserving the ecological integrity of Yellowstone National Park. Recognizing that the park's ecological processes spill over park boundaries, managers have been compelled to develop longer-term planning initiatives, often among agencies and neighbors who are unaccustomed to such partnerships. No recent event more forcefully brought home the interrelatedness of Greater Yellowstone than the fires of 1988, the public's first real look at the kinds of ecological processes that nature might have in mind for its wildest landscapes if left free of human intervention.

But other events were almost as stirring and certainly as instructive. After decades of talk and planning, wolves were returned to Greater Yellowstone in 1995, signaling a worldwide shift in emphasis among wildland managers away from the husbandry of those traditionally most-favored wildlife species toward a broader, more tolerant approach that incorporated the public's increased appreciation for North America's spectacular native predators.

At the same time, Greater Yellowstone land managers began facing up to another challenge, one that might not make as many headlines as fire or wolves but could ultimately have a far greater effect on Yellowstone's neighbors and visitors. As winter visitation numbers skyrocketed in the 1980s and 1990s, the conservation community and park managers expressed serious concerns about the park's ability to absorb this new use. Attempts to come to terms with the park's ultimate carrying capacity for people, in order to preserve not only the

park's resources but also the quality of the visitor experience, have begun with the winter season, but must soon confront the far greater summer visitation numbers.

And behind all this turmoil and change, but essential to its resolution, Yellowstone's long tradition as a vital outdoor laboratory for researchers from many disciplines has been reinforced. Researchers, hundreds every year, continue to explore Yellowstone's secrets; their work has yielded countless lessons in wildland ecology, geology, and other disciplines, reaching far beyond Yellowstone's role as a global leader in conservation and into such world-changing fields as DNA research.

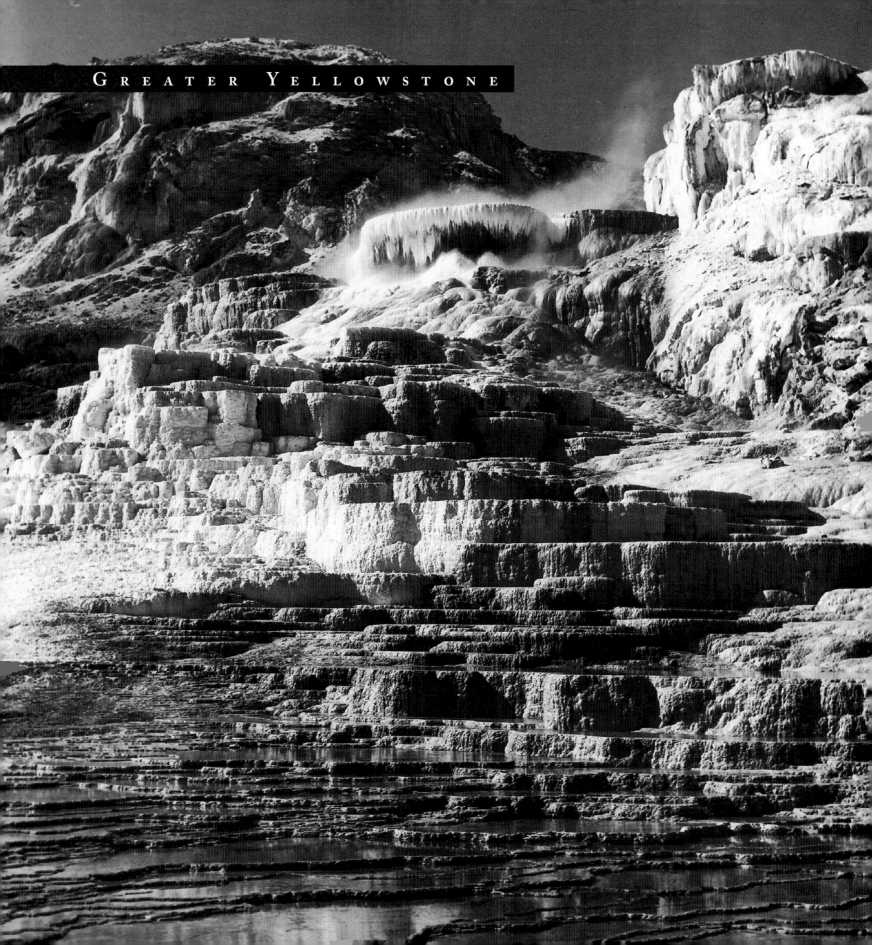

YELLOWSTONE'S GEOLOGICAL wonders, especially its hydrothermal activity, were the primary reason for the park's creation, and these unique features have become an important factor in decisions about the future of Greater Yellowstone. The vast and poorly understood subterranean aquifers that provide the water for the park's thousands of hot springs and geysers do not stop at the park boundaries. Outside the park, these aquifers have been threatened by a variety of developments, especially to the west and north of the park, where the conflicting needs of property owners and the well-being of the park have been at the center of controversy.

YELLOWSTONE NATIONAL PARK was designated a Biosphere Reserve in 1976, and a World Heritage Site in 1978. These designations heightened Yellowstone's century-long eminence in the global conservation movement. Since Yellowstone's establishment in 1872, many other countries have created national parks or similar reserves, most openly based on the Yellowstone model. But in recent decades, there has been growing concern for the conservation of the much larger ecological setting of which Yellowstone National Park is only a part, giving rise to the movement to protect the Greater Yellowstone Ecosystem, a politically complex area that includes parts of seven national forests, two national parks, and a variety of other public and private lands. The fate of Yellowstone National Park has been inextricably linked to the fate of this larger region, with its extraordinary resources and its rapidly growing human population.

ACCOMPANYING THE GROWING understanding of Greater Yellowstone's ecological integrity has been the public's intensified concern over the long-term fate of the region. Advocates of various management approaches are out-spoken and aggressive. Many of the management issues that were once dealt with individually by each land management agency, from wildlife management to road building to construction of new developments, are now all perceived as part of a larger and far more complicated issue, the management of an entire ecosystem.

THOUGH THE IDEA of Greater Yellowstone has been around for almost a century, in recent decades the need to protect this area has most often been highlighted by grizzly bear management. In the 1960s, the pioneering study of Yellowstone's grizzly bears by Frank and John Craighead's research team brought the Greater Yellowstone concept to the public's attention, when it became clear that only through ecosystem-wide cooperative management could this bear population be properly managed.

THE GRIZZLY BEAR became the symbol of Greater Yellowstone conservation; its tremendous needs for range and wild habitat suggested the ecological wholeness and inter-dependence of the lands in and around Yellowstone National Park.

SINCE THE LATE 1960S, the status of the Yellowstone grizzly bear population has most often been the central issue in public and scientific debates over Greater Yellowstone. Estimates of population size, with special emphasis on the number of breeding sows, became known as the numbers game, with competing theories providing a wide range of alternative population sizes. Though improved manage-ment and public education may have allowed the bear population to stabilize, it is threatened in the long term by ever-growing human use of the wildlands it depends upon.

RESPONDING TO THE CONCERNS of several conservation groups that believed the fundamental values of Yellowstone National Park were being threatened by growing human use of the region, potential development of various geothermal and mineral resources near the park, and other activities, representatives of the World Heritage Committee met in Yellowstone in September 1995 to review these issues. On December 5, 1995, the committee added Yellowstone National Park to its list of World Heritage Sites in Danger, setting off a new round of controversy over Greater Yellowstone and announcing to the world that this distinguished international body regarded America's care of its foremost national park to be inadequate.

THE ISSUE RECEIVING by far the most immediate attention from the World Heritage Committee was a proposed gold, silver, and copper mine at the New World Mine site near Cooke City, Montana, only a few miles from the northeast corner of the park. For several years prior to the committee's arrival, the development of this mine site on Henderson Mountain was hotly debated among management agencies and the public.

ON AUGUST 12, 1996, President Bill Clinton spoke at a special gathering at the base of Barronette Peak, in northeast Yellowstone National Park. Proclaiming that Yellowstone is "more precious than gold," the president announced an agreement to trade land under development for the New World Mine for other lands farther from the park.

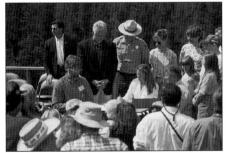

PRESIDENT CLINTON presided over the signing of an agreement in principle by which the mine site would be protected from further development. It remains to be seen if this milestone event is actually a turning point in the conservation of Greater Yellowstone.

FIRESTORMS

GROWING AWARENESS of fire's role in maintaining wild landscapes has led managers around the world to consider fire something other than a simple enemy. In 1972, Yellowstone joined a growing number of reserves that used or allowed fire to occur in some situations. In 1988, Yellowstone experienced the greatest drought in its written history, and the most severe test of its natural fire policy. As lightning ignited fires that in previous years would have grown only to a few hundred or thousand acres, a series of dry cold fronts pushed flames across hundreds of thousands of acres of the park and surrounding wildlands. Huge columns of smoke towered over the Yellowstone landscape.

LONG BEFORE the firefighting season was over, a national dialogue had begun over fire policy on many federal lands. As had happened so many times in the past, Yellowstone found itself in the spotlight in the political arena, as scientific and public debates raged over how wild landscapes should be managed.

AN INTERAGENCY fire-fighting effort, the largest in American history, eventually involved more than 25,000 people and 120 million dollars, but probably did not reduce the burned acreage significantly; the real heroism was in the protection of hundreds of structures in and near the park. The fires finally were stopped in early September by a quarter-inch of precipitation.

SATELLITE PHOTOGRAPHY on September 7, 1988, showed the magnitude of the western fire season. The black rectangle enclosed the state of Wyoming; note that the smoke plumes from the Yellowstone fires (upper left-hand corner of Wyoming) cross the entire state and to the Black Hills on the South Dakota border. Other fires were visible in Colorado, Montana, Idaho, and Utah.

AFTER YEARS of additional debate, several formal review panel reports, and much scientific research, the need for periodic fire in Yellowstone was reaffirmed, and a revised fire policy was placed in effect. But research indicates that Yellowstone's ecological setting has often depended upon extremely large fires like those occurring in 1988; no easy answer has surfaced for accommodating nature on such a spectacular scale in the modern world.

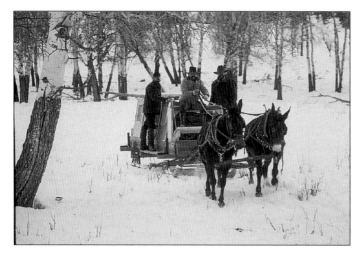

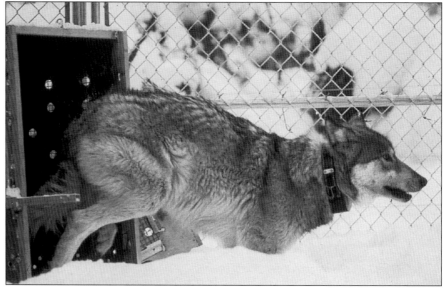

PERHAPS NO EVENT better symbolized changing attitudes toward nature in the American West than the twenty-year campaign to restore wolves to Yellowstone. National support for wolf recovery was overwhelming, but regional debates were intense. At dawn on January 12, 1995, in the midst of strident rhetoric and continuing legal challenges, the first new wolves, from Alberta, Canada, entered the park and were soon loaded on a mule-drawn sled in their individual containers for the ride to their acclimation pen.

THE RELEASE of additional wolves in 1996 made exciting times for park staff and many people in the region. As the wolves ranged across public and private lands, a few problems developed but most of the packs found homes in reasonably safe areas where they began to make themselves comfortable.

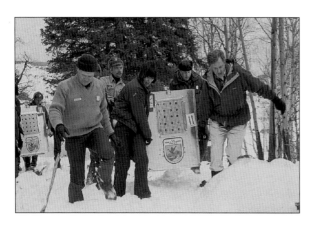

FROM LEFT TO RIGHT: Yellowstone Wolf Project Leader Mike Phillips, maintenance foreman Jim Evanoff, U.S. Fish and Wildlife Service Director Mollie Beattie, the wolf, Yellowstone Superintendent Mike Finley, and Secretary of the Interior Bruce Babbitt, on their way to the Crystal Bench pen site.

MEMBERS OF INDIAN tribes requested and were given permission to hold a brief prayer ceremony welcoming wolves arriving at the Blacktail pen site in January 1996.

SOON AFTER BEING RELEASED, the wolves became an exciting new visitor attraction, causing wolf jams in the Lamar Valley, where they have often been observed resting, playing, howling, and hunting.

ONE OF THE FIRST NEW WOLF pups known to be born in Yellowstone in sixty years. Against most expectations, wolves mated successfully in at least two of the acclimation pens in 1995.

ON AUGUST 25, 1995, the First Family participated in feeding the wolves at the Rose Creek pen. From left: Mike Phillips, President Clinton, Chelsea Clinton, and a Secret Service agent.

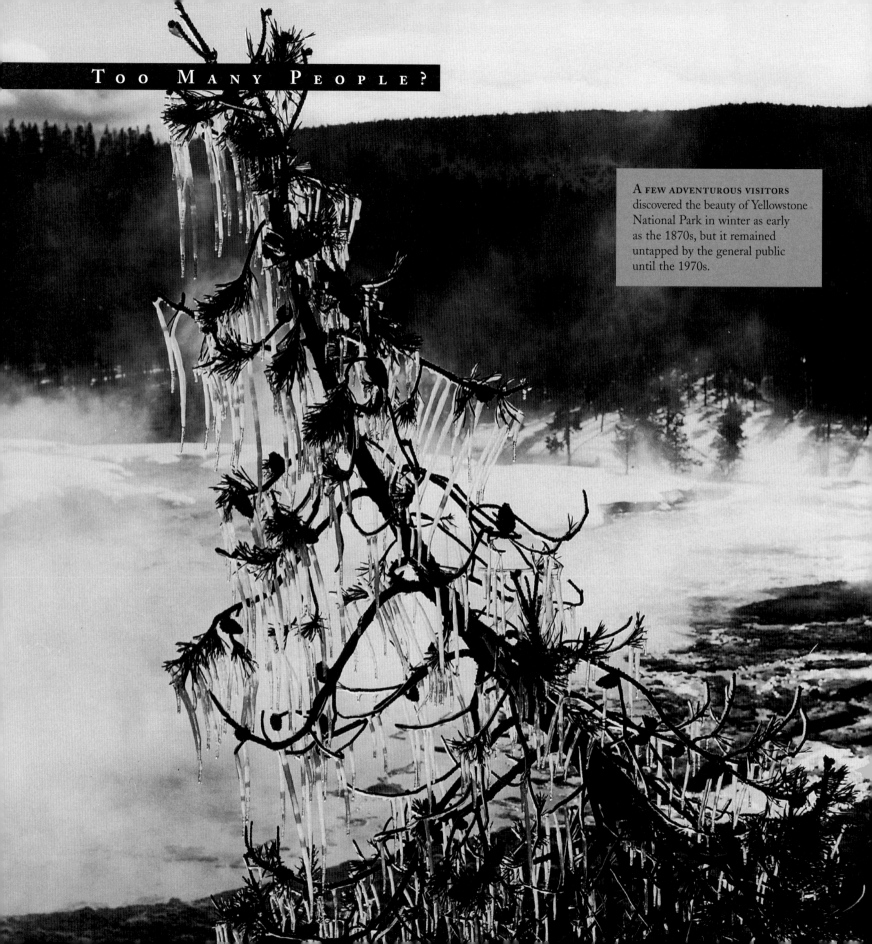

A FEW ADVENTUROUS VISITORS discovered the beauty of Yellowstone National Park in winter as early as the 1870s, but it remained untapped by the general public until the 1970s.

ADDING TO THE CUSTOMARY beauty of any high-country winter landscape were Yellowstone's geysers and hot springs, which created an endless variety of breathtaking ice-sculptures and ghost trees in the geyser basin.

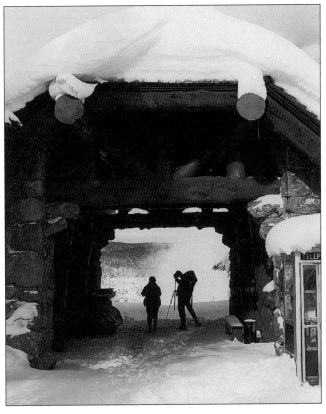

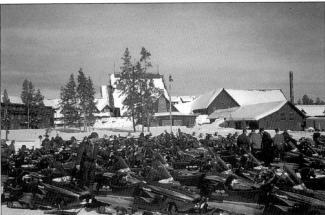

AS WINTER USE INCREASED in the 1970s and 1980s, more and more people came to enjoy this extraordinary collection of beautiful settings; park roads, groomed for oversnow vehicle traffic and park trails, open to crosscountry skiers, became busier each year.

BY THE 1990s, National Park Service managers, regional travel interests, and conservationists were embroiled in yet another debate over the park's future: how to manage the rapidly increasing winter use of the park, and how to ensure that it did not affect the park's ecological health or the quality of the park experience. The debate over winter-use management is seen as a prelude to a far larger exercise: coming to terms with the effects of millions of visitors who come to the park every summer. As with several other issues, Yellowstone faces an uneasy and contentious future in setting a course for visitors in the twenty-first century.

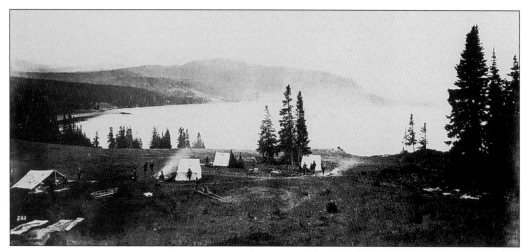

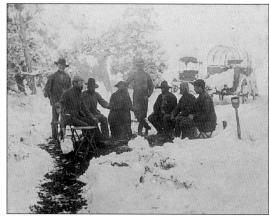

THE EARTHQUAKE CAMP of the Hayden Survey at Yellowstone Lake, 1871. Yellowstone has been an important scientific research site since 1871, when the first serious study of the area began. Ferdinand Hayden's survey brought concrete photographic, artistic, and scientific evidence of the wonders of Yellowstone to civilization. Photographer W. H. Jackson noted that survey members named this camp, near present Steamboat Point, from "several slight shocks of the earthquake which were experienced at this place on the night of the 19th of August, 1871." Note the wheeled odometer, used for measuring distance traveled, in the foreground and the frame of their boat *Anna*, on the left.

HAYDEN was followed into Yellowstone by hundreds of other scientists. Among the notable early ones was Arnold Hague, a geologist and conservationist, second from the left in this picture, at the close of the 1885 season. Hague's survey teams operated almost continually in the park from 1883 to 1902, producing a vast quantity of important information, some of which is just now being published for the first time.

A GATHERING OF RESEARCHERS and park officials at Myriad Geyser in the Upper Geyser Basin in 1929. From left to right: Roger Toll, Superintendent Horace Albright, Harold P. Fabian, Dr. Hermon C. Bumpus, Kennery Chorley, to secretary of the interior Ray Lyman Wilburn, A. L. Day a leading hot spring expert and co-author of the milestone work *Hot Springs of the Yellowstone National Park*; William Nichols (officer of the Yellowstone Park Company), and V. L. Butler. Researchers had just drilled a test borehole at Myriad Geyser to study geyser functions.

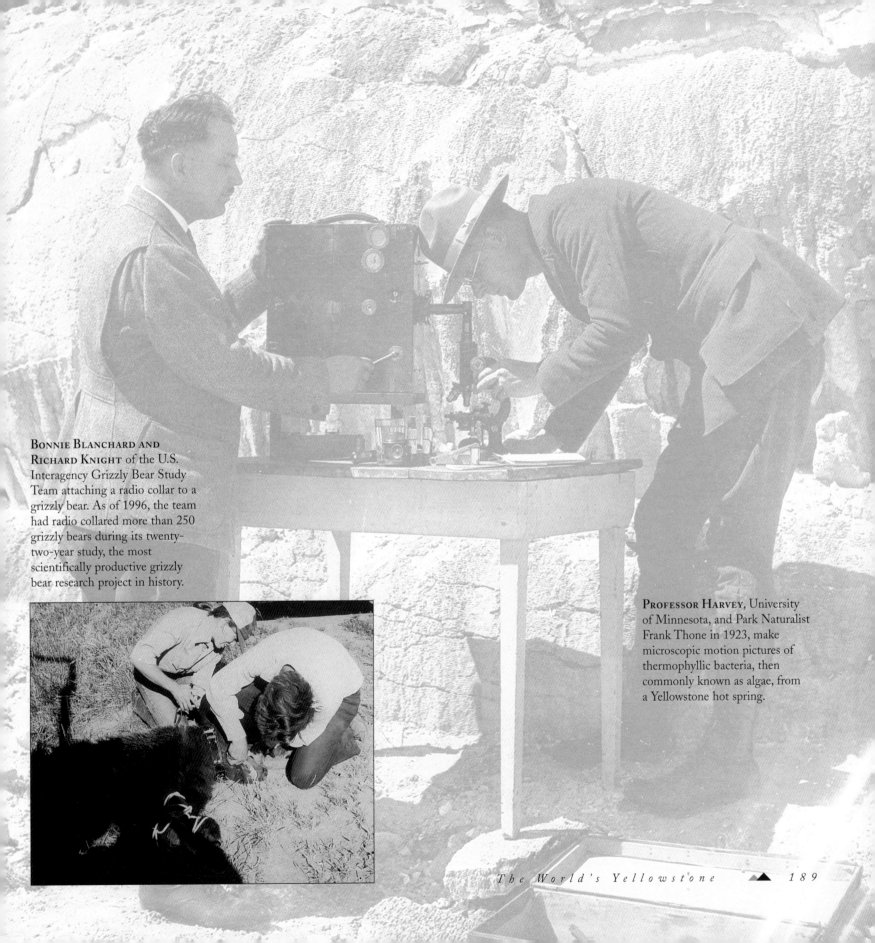

BONNIE BLANCHARD AND RICHARD KNIGHT of the U.S. Interagency Grizzly Bear Study Team attaching a radio collar to a grizzly bear. As of 1996, the team had radio collared more than 250 grizzly bears during its twenty-two-year study, the most scientifically productive grizzly bear research project in history.

PROFESSOR HARVEY, University of Minnesota, and Park Naturalist Frank Thone in 1923, make microscopic motion pictures of thermophyllic bacteria, then commonly known as algae, from a Yellowstone hot spring.

PARK PHOTOGRAPHER JIM PEACO
and geothermal geologist Roderick
Hutchinson paddle a specially built
hot-water boat on the steamy
waters of Grand Prismatic
Spring, 1994.

IN RECENT YEARS, microorganisms
in Yellowstone's hot springs have
been recognized for their extraor-
dinary scientific and social values.
A single-cell organism, *Thermus
aquaticus,* identified in Mushroom
Pool, shown here, was used by
scientists to develop many fields of
DNA technology, including DNA
fingerprinting. Scientists estimate
there are many more organisms yet
unidentified in the park's hot
springs, with enormous potential
for scientific advances that could
benefit the world in many ways.
The park's value to the world
continues to increase after 125 years.

NATIONAL PARK SERVICE
ecologist Frank Singer weighs
a newborn elk calf prior to
radio collaring and releasing it
during a study in the 1980s.

A Thousand Wonders

CALLED BY SOME THE AMERICAN SERENGETI,

THE PARK IS OFTEN DESCRIBED AS THE ONLY PLACE

IN THE LOWER FORTY-EIGHT STATES TO RETAIN THE FULL

ASSORTMENT OF NONHUMAN PREDATOR AND PREY

SPECIES THAT EXISTED THERE WHEN COLUMBUS LANDED

IN THE NEW WORLD 500 YEARS AGO.

A THOUSAND WONDERS

"*W*here may the mind find more stimulating, quickening pasturage?" wrote the great wilderness defender John Muir more than a century ago. "A thousand Yellowstone wonders are calling, 'Look up and down and round about you!'" These wonders could never all be portrayed in a book, much less in a chapter of a book, but here are a few that have been judged by the experience of many visitors to be especially durable.

It is not just that Yellowstone is such an amazing collection of uncommon and beautiful things. The Yellowstone landscape itself is a wonder, an artifact of some of the world's great prehistoric volcanic explosions, and a place of continuing rapid change. As geologist T. A. Jaggar wrote in 1922, "Anyone who has spent summers packing in a place like Yellowstone comes to know the land to be leaping The mountains are falling all the time and by millions of tons. Something underground is shoving them up." Jaggar was right; the whole place sits atop the Yellowstone Hot Spot, a great heat source that the earth's crust has been sliding across for millions of years. When you look out over the Yellowstone landscape from some eminence, keep in mind that the tranquility of the setting is only a product of short human memories and perceptions; this place is changing faster than most on earth, and through a geologist's eyes the signs are clear.

But on a more manageable scale we can enjoy the effects of all this instability in the park's tortured topography, which has given us more than 130 waterfalls, many of which are rarely seen by people. Waterfalls signify the newness of a landscape not yet worn down to smooth, low-energy drainages, just as geysers and hot springs signal a landscape not all that far from volcanic activity. The molten rock is close enough to the surface in Yellowstone to provide heat sources for many geyser basins, and here we offer a few of the park's hundreds of geysers in action.

Last, because so many people think of Yellowstone as a place of great, free native wildlife, the dynamic nature of the park's predator-prey system is celebrated with a selection of some of the stars of that show. Called by some the American Serengeti, the park is often described as the only place in the lower forty-eight states to retain the full assortment of nonhuman predator and prey species that existed there when Columbus landed in the New World 500 years ago. That alone makes the park a significant nature reserve and is yet another reason to celebrate 125 years of inspiration and wonder drawn from its magic.

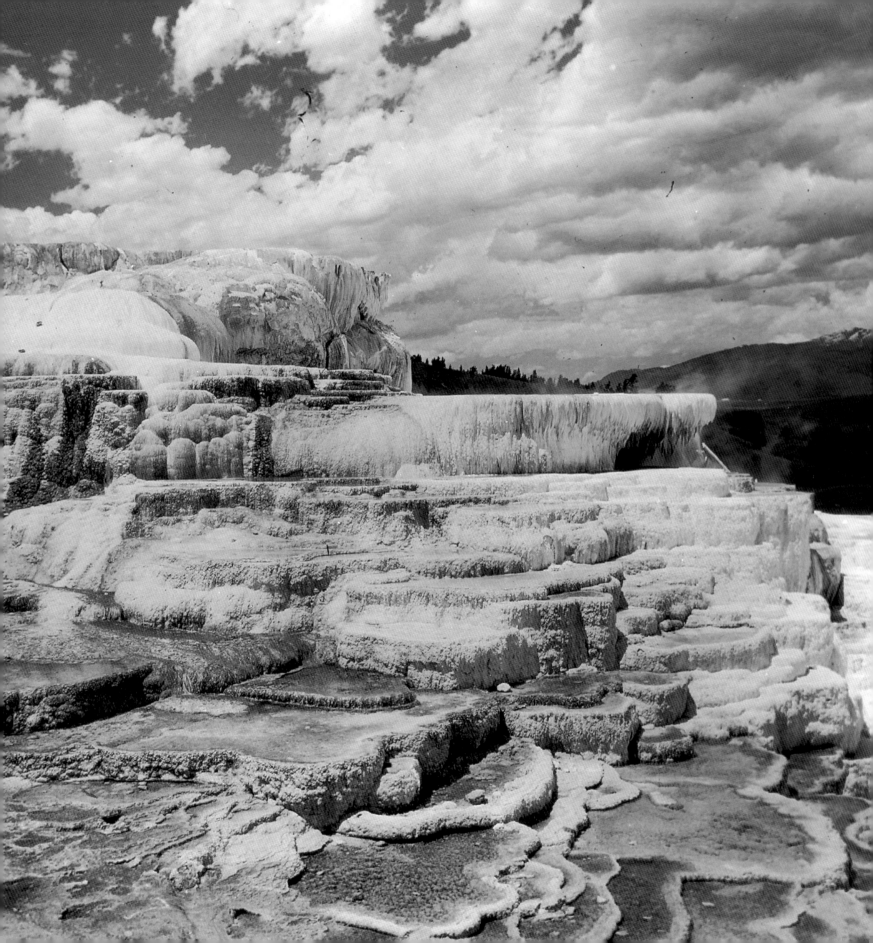

YOUNT'S PEAK and the headwaters of the Yellowstone River, about 1919. The Yellowstone River begins with the joining of two streams known as the North Fork and the South Fork, about thirty miles south of the park in Teton National Forest.

SODA BUTTE CREEK issuing from Round Prairie, with the Absaroka Range in the distance.

AN OPEN TEXTBOOK in geological processes: Looking south from Mount Washburn in central Yellowstone across the floor of the Yellowstone caldera. The unforested meadowland on the right is Hayden Valley, the floor of an ancient lake bed; Yellowstone Lake is visible on the left near the horizon, and the Teton Range rises on the horizon in the distance to the right.

Shadow, mist, and light in the Grand Canyon of the Yellowstone River.

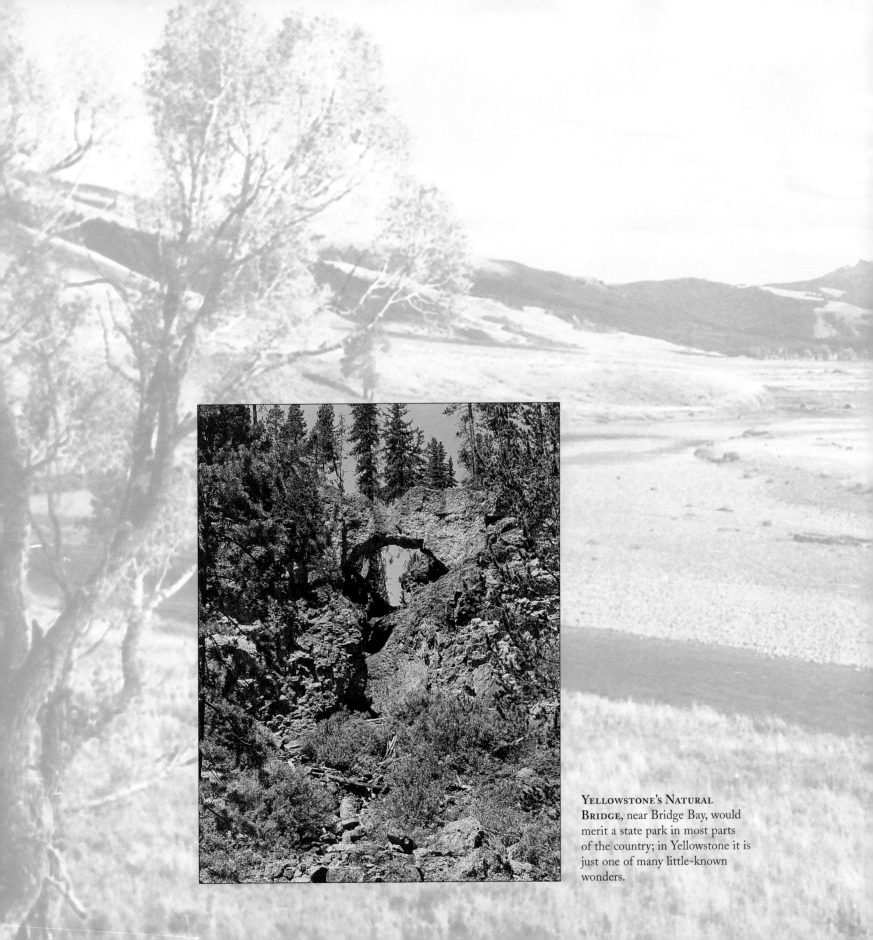

YELLOWSTONE'S NATURAL BRIDGE, near Bridge Bay, would merit a state park in most parts of the country; in Yellowstone it is just one of many little-known wonders.

CATACLYSMIC GEOLOGICAL processes that were responsible for the original burial and petrification of trees have more recently exposed the remains of those trees on Specimen Ridge.

YELLOWSTONE'S MANY VOLCANIC episodes and other earth-moving events resulted in many fossils that are exposed by erosion and road-building activities.

MYSTIC FALLS on the Little Firehole River, 1933. This falls is reached by a trail through Biscuit Basin.

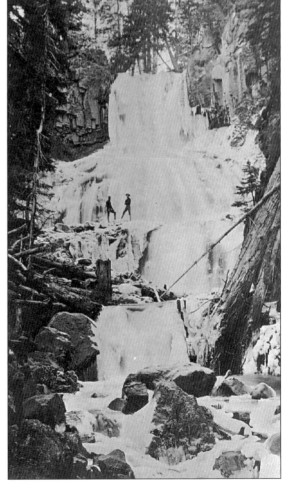

UNDINE (pronounced Undeen) Falls near Mammoth Hot Springs, originally called East Gardner Falls, was named by geologist Arnold Hague, for mythical water spirits called undines, who lived near waterfalls. According to German mythology, these spirits could acquire a human soul by marrying a man and bearing children.

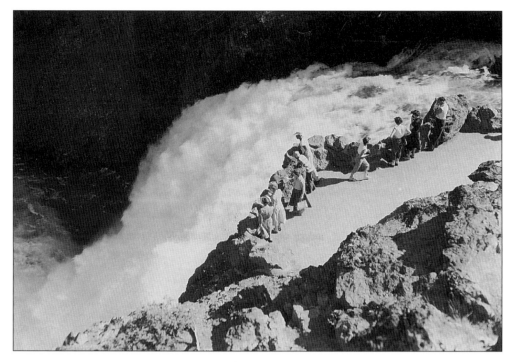

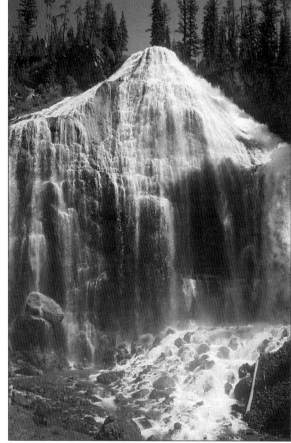

CRYSTAL FALLS, on Cascade Creek, is 129 feet high. It can be viewed from Uncle Tom's Point at the Grand Canyon of the Yellowstone, with Upper Falls to its right and Lower Falls to its left. Yellowstone's second superintendent, P. W. Norris wrote a poem in 1875 in which he rhapsodized about Crystal Falls: "Nevermore do I wish to leave it, my lovely last retreat."

UNION FALLS, height 250 feet, is the park's second highest straight falls; Silver Cord Cascade is higher, but is a cascade rather than a single continuous falls. This spectacular falls, located on Mountain Ash Creek in the Bechler region of the park, was named from the fact that two creeks come together here to form one waterfall.

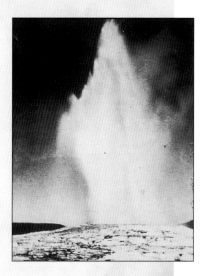

GIANTESS GEYSER rarely erupts today, but before 1913 it erupted about every two weeks. This H. B. Calfee photograph from the 1870s is the earliest known image of this spectacular geyser in action.

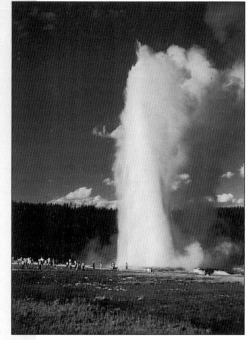

GIANT GEYSER, 1951. Giant is one of the park's tallest, erupting at unpredictable intervals, often in autumn. Historic records give its height as 200 to 250 feet.

ONE OF OLD FAITHFUL'S many moods.

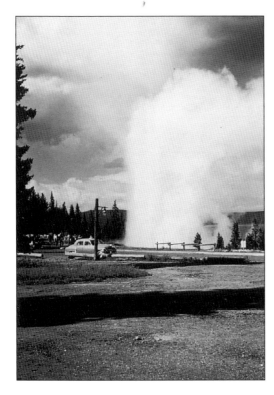

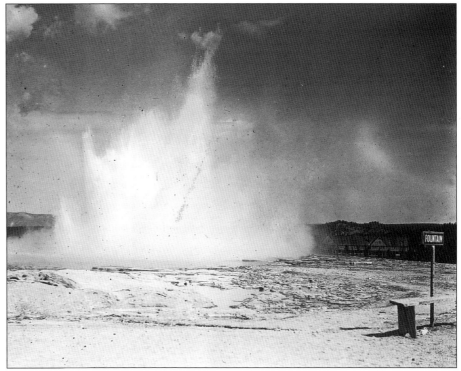

TWIN GEYSERS, in the West Thumb Geyser Basin, photographed in July 1950; this unpredictable geyser has a height of 75 to 120 feet.

MORNING GEYSER, behind Fountain Geyser, was not yet named when photographed here in 1914. The Fountain Hotel is visible at the far right. Visitors at the hotel reported the original known eruptions of this geyser in 1899 and referred to it as the New Fountain Geyser.

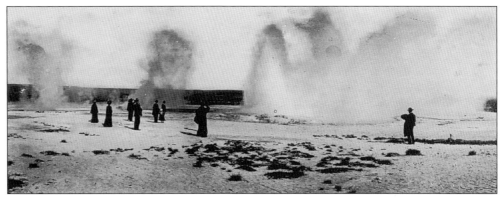

UNUSUAL even among Yellowstone's many oddities, Cold Water Geyser (photographed in 1952) was known to erupt from about 1932 until about 1986. Unlike the heat-driven eruptions of hundreds of other park geysers, Cold Water Geyser's eighteen-inch eruptions are powered by carbon dioxide gas.

VISITORS at an eruption of Fountain Geyser, 1908, with the Fountain Hotel at the far right.

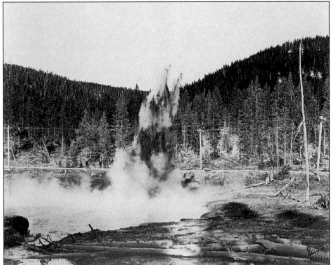

SEMI-CENTENNIAL GEYSER, just north of Madison Junction, was known to have erupted once in 1918, but began erupting more frequently on August 14, 1922, so it was named in honor of the park's fiftieth anniversary that year. Erupting to a height of 300 feet, it threw rocks, sticks, mud, and water onto the nearby road (note men in left background) and was reported in newspapers around the nation for several weeks as its power declined. It never erupted again.

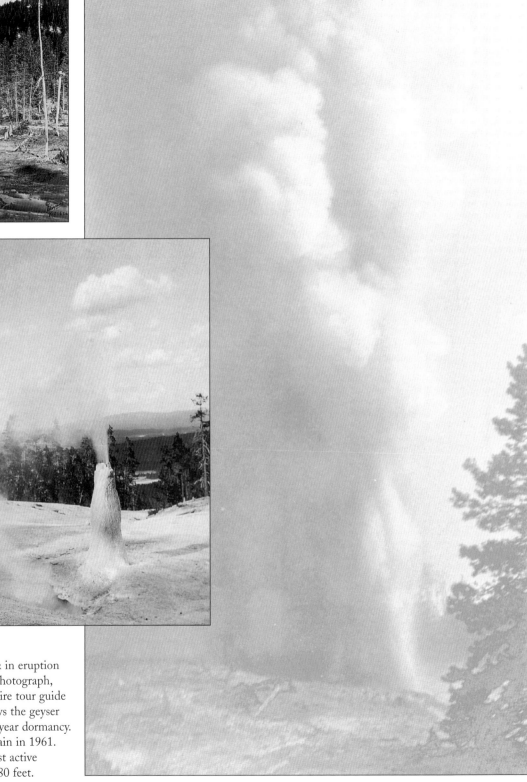

MONUMENT GEYSER, also known as Thermos Bottle Geyser, eruption at Monument Geyser Basin in 1929. Monument Geyser erupted at least periodically from the 1880s to the 1970s, but has been dormant since then.

STEAMBOAT GEYSER in eruption in 1911. This early photograph, taken by concessionaire tour guide Rexford Sheild, shows the geyser on the eve of a fifty-year dormancy. It began erupting again in 1961. It is the world's tallest active geyser, erupting to 380 feet.

A BISON is the symbol of the
Department of the Interior and
one of the great conservation
success stories in U.S. history;
Yellowstone is the only place in the
United States where bison have
continually roamed free since
prehistoric times. The restoration
of the Yellowstone bison herd has
long been regarded as one of the
first big victories of the American
conservation movement. Success is
never simple, however; now the
movement of those same animals
onto lands beyond the park has
become a great controversy.

THE PRODUCTION of nutrients in Yellowstone is a complex web of vegetation, grazers, and carnivores. What is not eaten by the predators is consumed and recycled by a remarkable assortment of scavengers, from the largest grizzly bear to the smallest microorganism, all of which will also be recycled into the nutrient chain.

ALMOST WIPED OUT along with the wolves early in this century, Yellowstone's mountain lions have staged a comeback and now occupy large home ranges across much of the habitat of their preferred prey, elk.

THE EARLIEST ACCOUNTS of northern Yellowstone describe abundant mule deer, still a numerous resident on the northern range in and north of the park.

THE COYOTE is one of the West's most misunderstood and persecuted animals. They have been protected in Yellowstone, for more than sixty years, long enough for scientists to discover that, while coyotes are effective predators on animals as large as elk, they pose no threat to the survival of the species. Coyote numbers may decline due to competition with the newly introduced wolves.

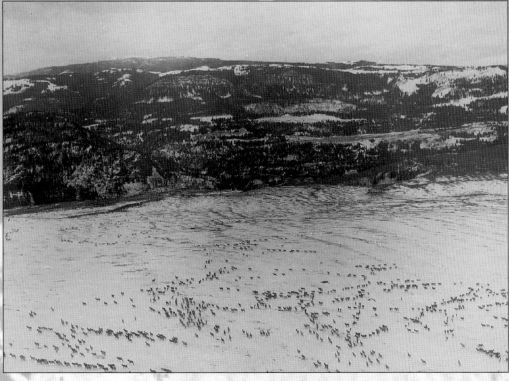

YELLOWSTONE has one of the largest prey bases of any large nature reserve in the world, exemplified by the northern Yellowstone elk herd, shown here on their winter range in the 1960s.

MANY OF YELLOWSTONE'S most effective predators wear not fur but feathers. From the smallest swallows to the great eagles, they are consummate predators; the bald eagles in Yellowstone thrive on both fish and ducks.

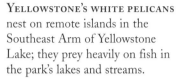

YELLOWSTONE'S WHITE PELICANS nest on remote islands in the Southeast Arm of Yellowstone Lake; they prey heavily on fish in the park's lakes and streams.

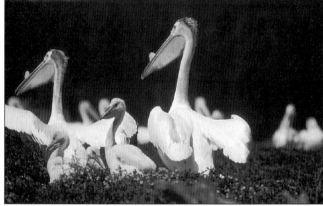

BLACK BEARS, long thought to be ineffective predators, are in fact skilled hunters of a number of other park animals, and are observed hunting recently born elk calves in the park's open meadows in spring.

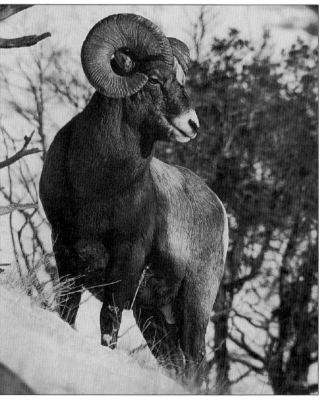

BIGHORN SHEEP may be less common in Greater Yellowstone than when the park was established, due perhaps to early overhunting and the arrival of European livestock diseases, but they are still frequently observed on cliff faces across northern Yellowstone.

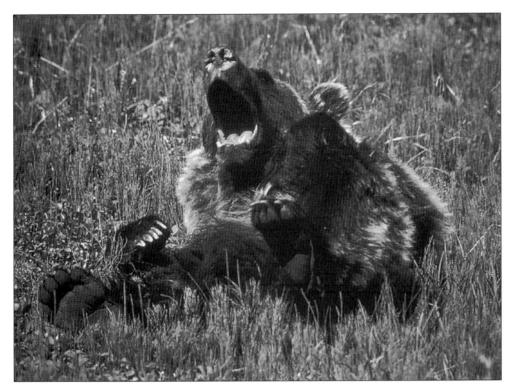

YELLOWSTONE is the last great inland stronghold of the Yellowstone cutthroat trout, much of whose other habitat has been destroyed or commandeered by introduced fish species. Cutthroats, like this one leaping a low falls in LeHardy Rapids on its way to the spawning grounds, were overfished in the park for many years. Changes in fishing regulations over the past twenty-five years have restored their numbers, but they are now threatened by an invasion of non-native lake trout, a superior predator, in Yellowstone Lake.

BUT MOST OF THE TIME, though vigilance never ceases, life has a slightly more relaxed pace.

PREDATION is not often seen. More often all we find are a few scattered remains, or some other evidence of a fatal encounter, like the lightly brushed wingtip marks of a hunter in the snow.

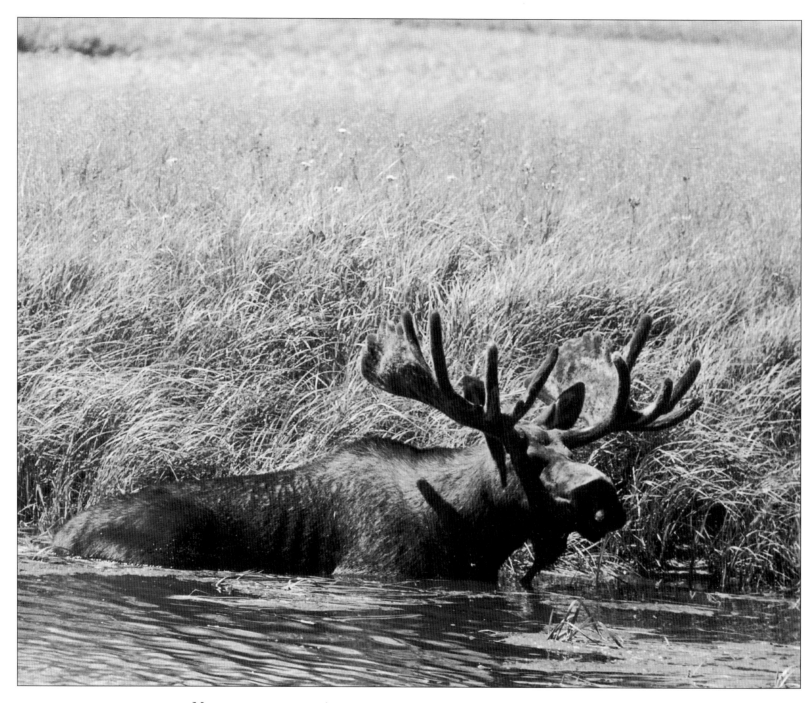

MOOSE WERE UNCOMMON in most
of Yellowstone when the park was
established in 1872, but have since
spread and increased in appropriate
habitats.